Private Gardens of the Hudson Valley

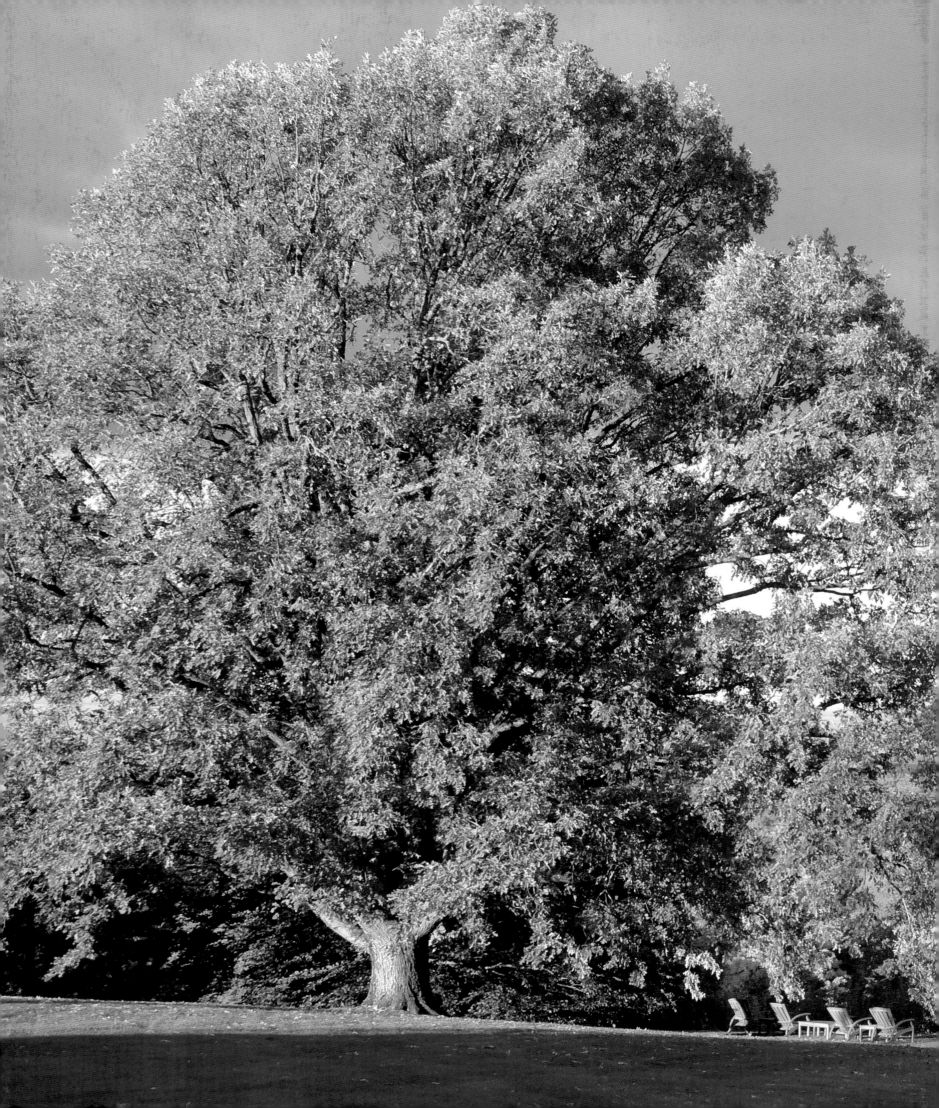

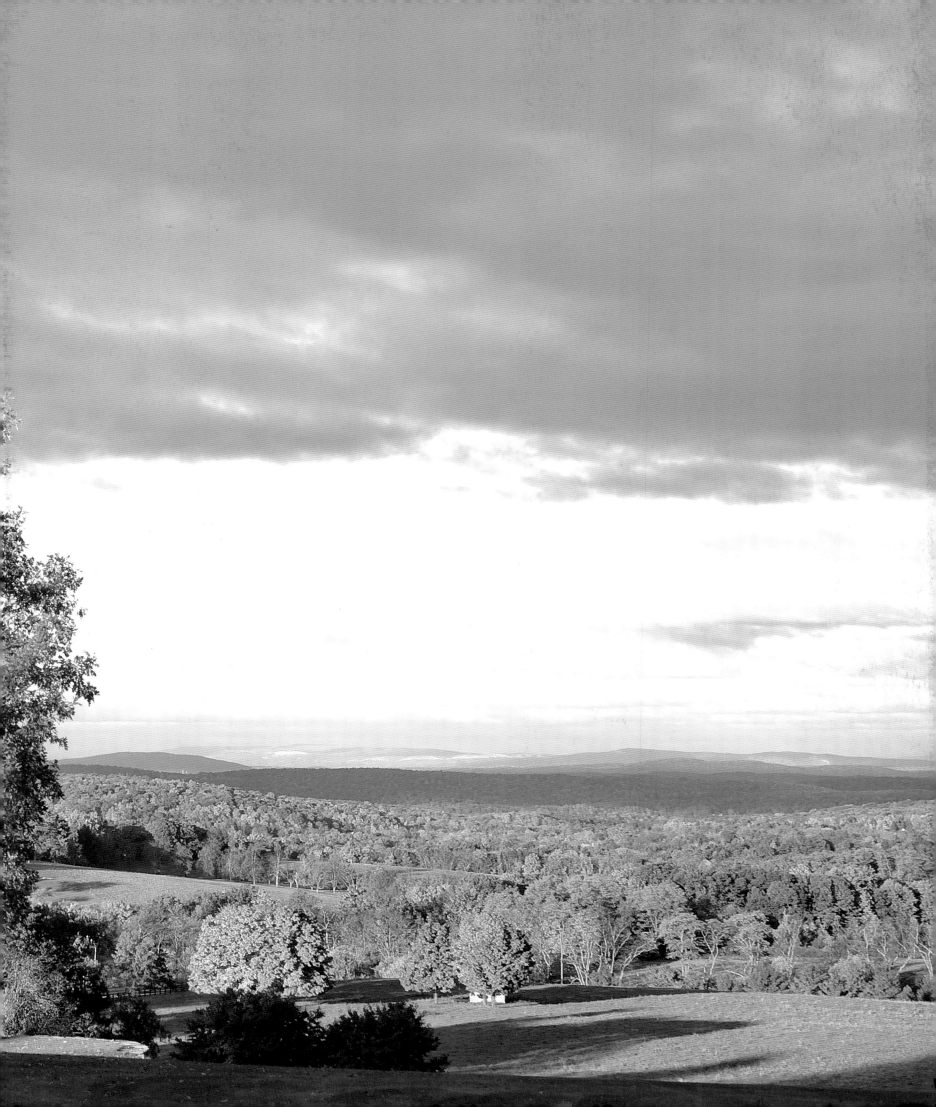

Private Gardens of the Hudson Valley

Jane Garmey ❧ *Photographs by John M. Hall*

THE MONACELLI PRESS

Published in the United States by The Monacelli Press

Library of Congress Control Number 2013935923
ISBN 9781580933483

10 9 8 7 6 5 4 3 2 1
First edition

Designed by Susan Evans, Design per se, New York
Printed in China

www.monacellipress.com

The Gardens

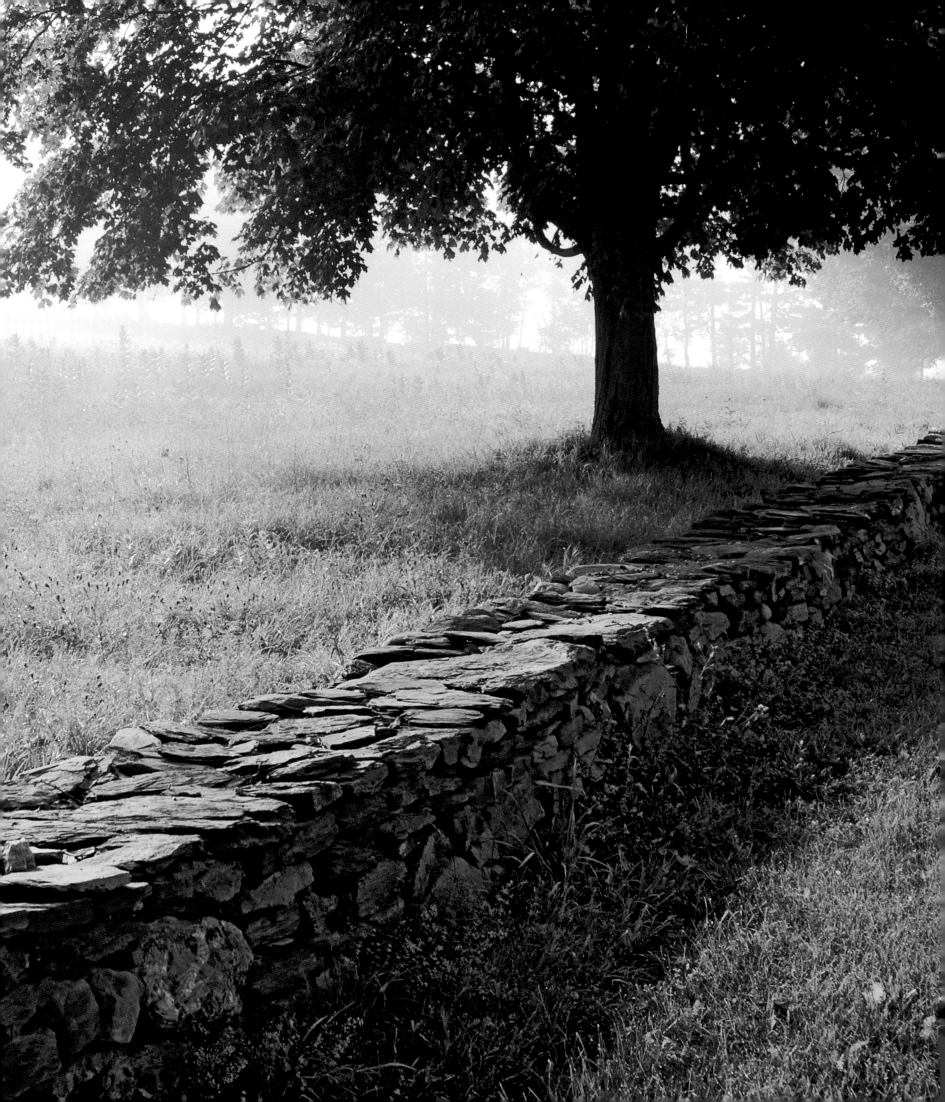

Introduction

Oscar Wilde is credited with stating that England and America are divided by a common language. The truth of this observation was made clear to me when I first arrived in the States many years ago and saw the blank uncomprehending look on the face of a cab driver after I asked him if he would put my trunk in his boot. In England, the English have gardens, Americans, as I have now learned, *make* theirs. It's a subtle but telling distinction, and one that I've been reminded of again and again in the course of talking to the owners of the gardens featured in this book. English gardeners have an easy time of it, but for gardeners in the Hudson Valley, who have to contend with below freezing temperatures in winter and intense heat and frequent drought conditions in summer, gardening is a much tougher business. Gardens in this part of the world take a great deal of *making*.

The Hudson Valley has name recognition and historical significance far beyond what its size would seem to merit. In the eighteenth and nineteenth centuries, the Hudson River, navigable from New York to Albany, served as one of the most important waterways in America. It became a conduit for trade and commerce, bringing great wealth and a class of privileged landowners, who built themselves houses, farmed the land, and were patrons of one of the great schools of American painting. The scenery of this part of New York State, which encompasses riverfront meadows, mountainous hills, and long open valleys, is inherently dramatic. Although the area has been home to many historic gardens, the gardens in this book, all situated to the east of the Hudson River and all private, offer a new chapter in the art of garden making.

In recent years, a lot of attention has been focused on gardens in Long Island and Westchester but almost none on those in Dutchess, Columbia, and Putnam Counties. Having written about private gardens in Connecticut, it seemed a logical next step to venture across state lines and look at those in the Hudson Valley. I am often asked how I go about selecting gardens. The truth is that because my choices are personal and idiosyncratic, the search is an unpredictable journey that begins with making a lot of inquiries and talking to as many people as possible—friends, friends of friends, and total strangers. Once the ball gets rolling, gardens and gardeners have a fortuitous way of leading one to another. Gardens whose owners have delegated all decision-making to a designer don't fit the bill, but I am always on the look out for geographical diversity and a range of size and styles. I find myself drawn to gardens with age and maturity, and especially to those that strongly reflect the sensibility of their owners. This is a hard quality to define, but one that is very apparent when not in evidence.

When I began work on this book, I didn't know how intensely rural this part of New York still is. I was also unprepared for the grandeur of the landscape. The sweeping valleys and large open tracts of land are remarkably different from the gentler, more protected countryside of Connecticut. Inevitably, terrain plays a role in making a garden, and dealing with the transitions between a cultivated garden and its natural surroundings is a problem that had to be confronted and solved in nearly every one of the gardens profiled here.

All the gardens in this book, with the exception of John Driscoll's garden in Garrison—a gloriously eccentric creation of the designer Paul Mayén—have been entirely made by their current owners. What is remarkable is that so few of these garden-makers were in any way knowledgeable when they started out. Many had never gardened before and some, like Madeline Hooper, didn't even know how to put a seedling in the ground. Most admit that at first they were entirely focused on their houses and gave little or no thought to the surrounding land and its suitability, or lack thereof, as a gardening habitat. There are, of course, some exceptions. Betsey Ely who had grown up in Canada, knew she had to have water. Scott Canning, Wave Hill's director of horticulture, always went house hunting with a spade in hand to test out the soil. Richard Eagan's criteria, when looking for a house in Hudson, was to find the one with the largest possible outdoor space, and Peter Bevacqua and Stephen King say that it was the Lord and Burnham greenhouse in the garden that clinched their decision to buy their house in Claverack.

It has been a rare experience to work again with John Hall. He is an extremely gifted garden photographer with a strong vision and immense enthusiasm, and there is no way to adequately thank him for the long hours and unstinting time he has given to this project. When one begins a book like this, one has no sense of where the journey will lead. Now it is finished, I am in awe of the diversity of the designs and the range of garden styles that John's camera has captured so brilliantly. All of these Hudson Valley gardens are private and all of them are personal. In my conversations with their owners, I am always struck by how differently people go about making a garden and how each of these gardens has its own story to tell. Whether it's a formal garden like Gil Schafer's, or a more traditional approach— the Scherers' comes to mind—a refashioned landscape such as Stephen Mazoh has created, or the naturalistic invention of Duncan Brine, all of the gardens, be they as huge and ambitious as the Kovners', as imaginative as Frederic Rich's or as charmingly diminutive as Nicholas Haylett and Tim Husband's, have much to tell us about the complexity, problems, and, finally, the unforgettable pleasure of *making* a garden.

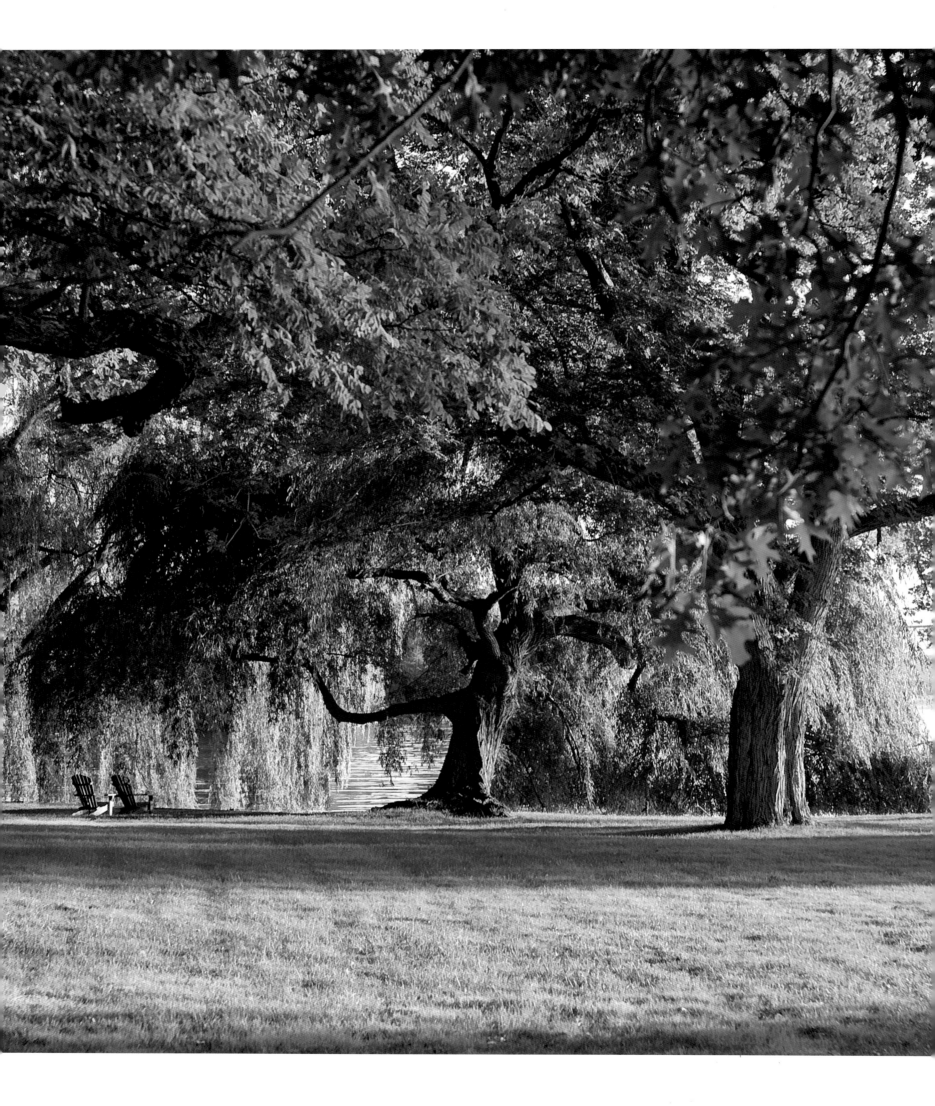

RICHARD JENRETTE ❦ BARRYTOWN

Purely Romantic

Edgewater, which Richard Jenrette purchased from Gore Vidal in 1969, is a Federal house built by the Livingston family in the early 1820s. The house faces due west and sits on a small peninsula of land jutting into the Hudson. There is water on three sides and the railroad track from New York to Albany effectively cuts off the property from the mainland. Designed to be seen by ships navigating the Hudson the riverfront facade has six monumental Doric columns. Remembering the day he first saw Edgewater, Jenrette has written, "The late afternoon sunlight was shimmering on the tall columns and reflecting off the gentle waves of the broad river. The whole scene seemed to me like Camelot, or perhaps something out of *Gone with the Wind*." At the time, there was not much of a garden other than the willows and some locust trees, planted by the Livingston family to serve as lightning rods. Today, Jenrette insists that "there is still not much of a garden." But although the landscape may still look untouched, he has done a great deal to enhance it and has made some significant changes.

When Jenrette came to Edgewater, cars were parked directly in front of the east side of the house, but he has changed all that. After leaving their cars in a new parking area discreetly hidden behind a hedge, visitors now approach the house on foot, entering through a courtyard garden, which Jenrette wanted to be reminiscent of an in-town Charleston garden. A sixteen-foot wall, covered with climbing hydrangea, blocks the noise from the railroad (which comes within forty yards of the house), and forms an effective backdrop to the new garden. There is a fountain and small pool in the center and weeping quince trees set in a beds of low boxwood in each of the four corners. Large urns are filled with brugmansia, artemisia, begonias, and white euphorbia. In front of the wall, a bust of Julius Caesar, flanked by two imposing obelisks, presides magisterially over the scene.

When he was able to purchase more land, Jenrette rerouted the original riverfront drive. A long narrow driveway affords breathtaking distant glimpses of the house almost hidden by huge willow trees, drooping languidly into the water. It then proceeds inland, passing a succession of serpentine beds, presided over by statues of four goddesses representing the seasons, before arriving at the east side of the house.

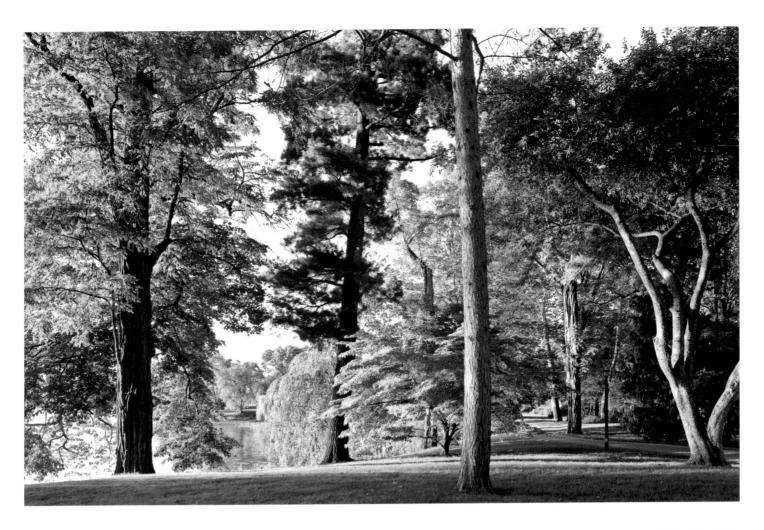

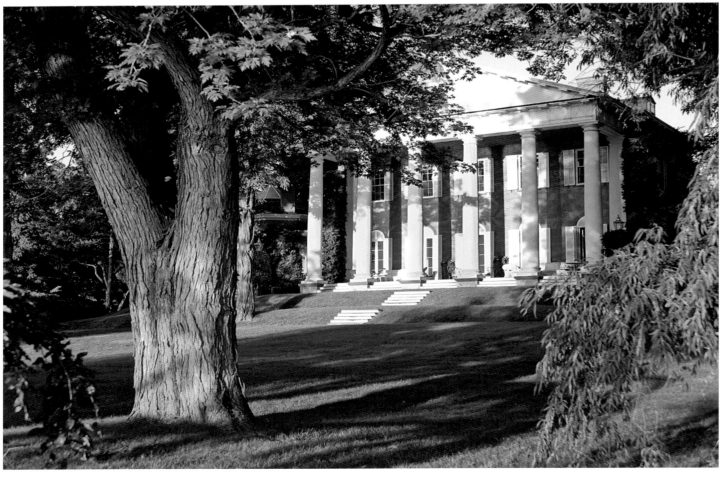

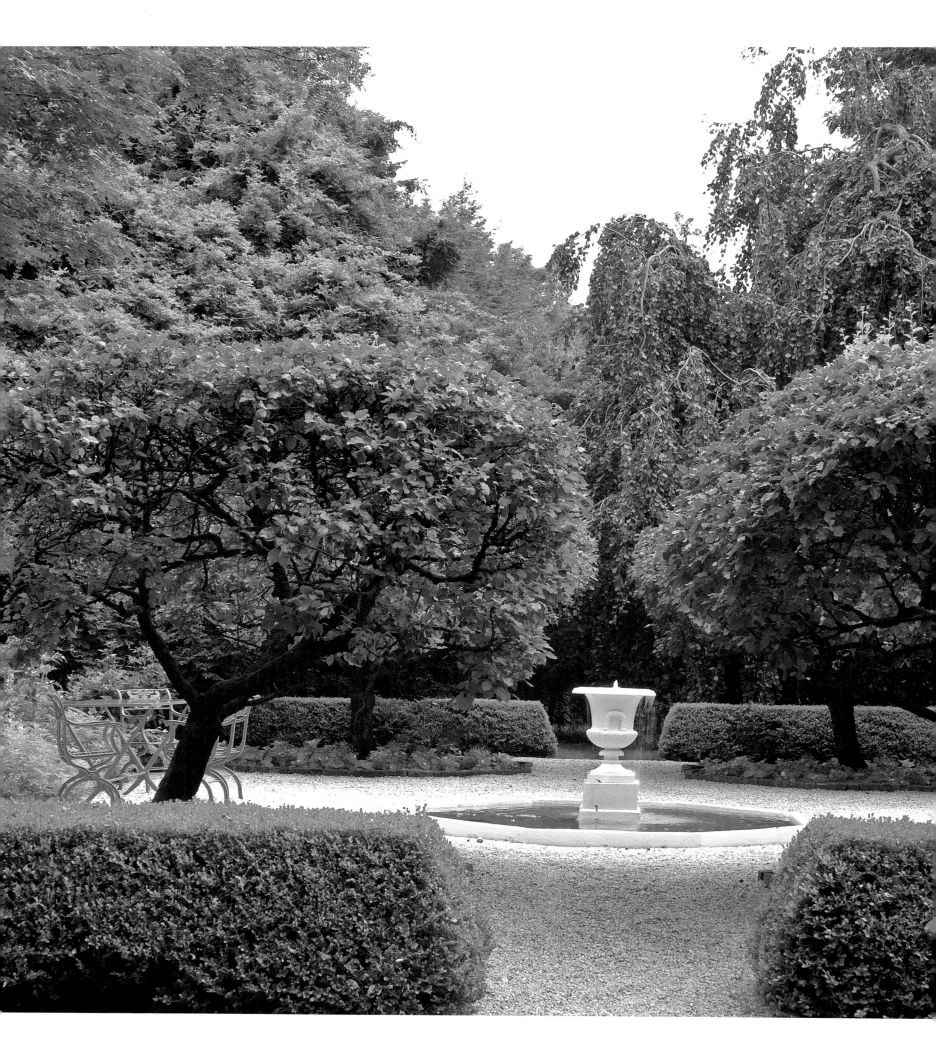

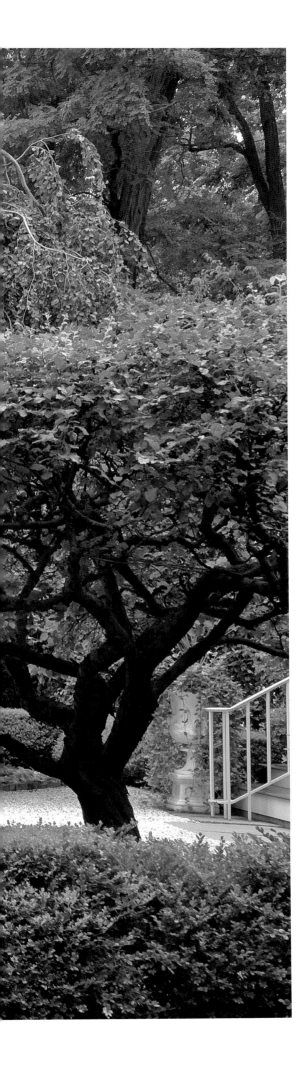

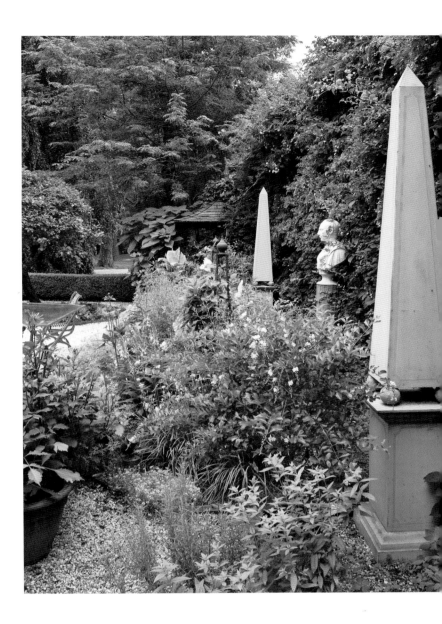

Being, as he says, of the Capability Brown school and wanting to enhance the natural landscape, Jenrette has added a great many trees, including some large hemlocks and two huge weeping beeches. Kousa dogwood and rhododendrons hide a swimming pool and pool house that he built in the 1980s, and he has planted weeping birches and a ginkgo tree close to the river. The remains of an ice house has been transformed into a small grove, approached by a series of stone steps and now home to a statue of Hermes. It is a reminder of the follies and classical allusions so prevalent in the great eighteenth-century English landscape gardens of Stowe and Stourhead, two gardens that Jenrette much admires.

Jenrette spends from May till the end of October at Edgewater but confesses, "Once the trees lose their leaves, they lose their magic, and then I am off." No matter! When he returns the following year, the trees will have new leaves and he will find himself once again in the thrall of the powerful spell of Edgewater's romantic landscape.

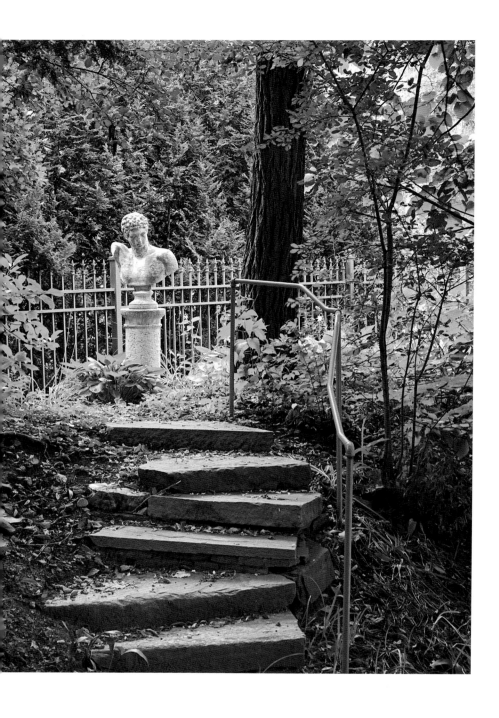

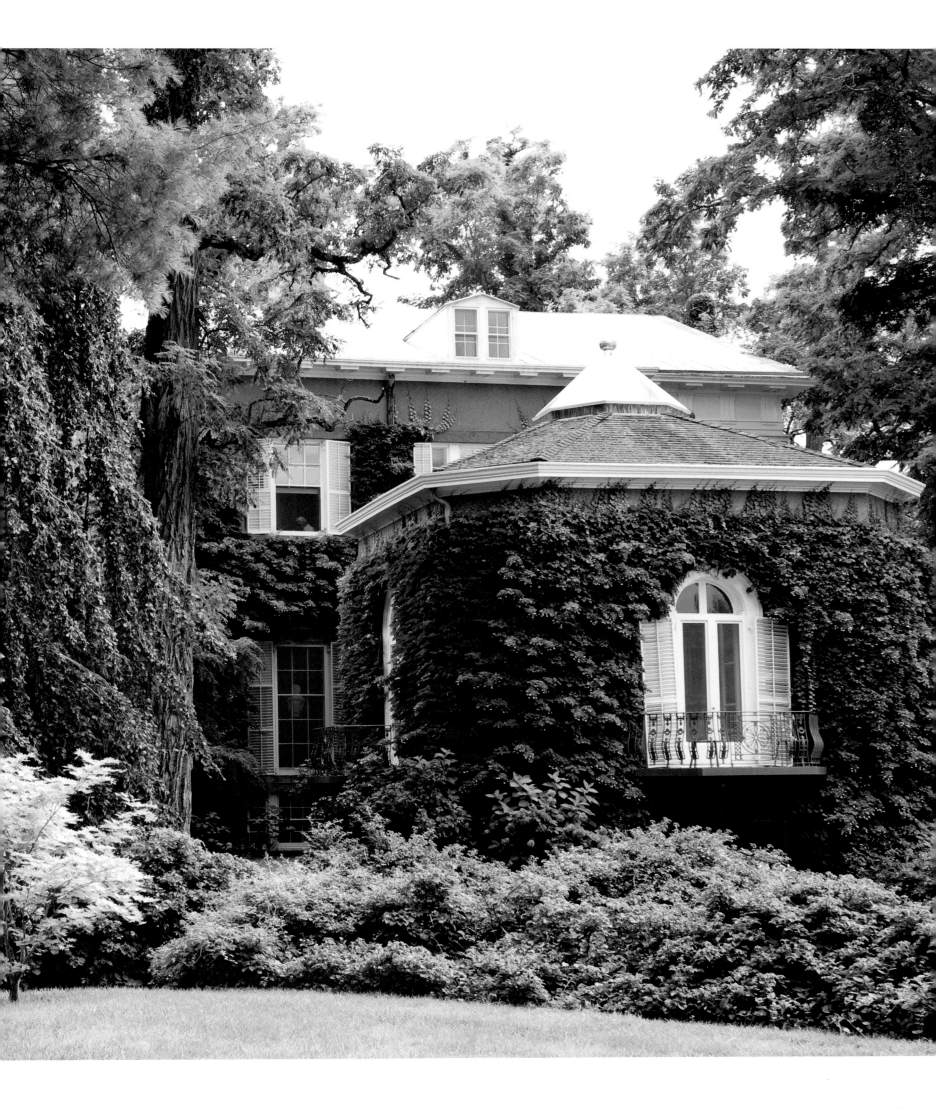

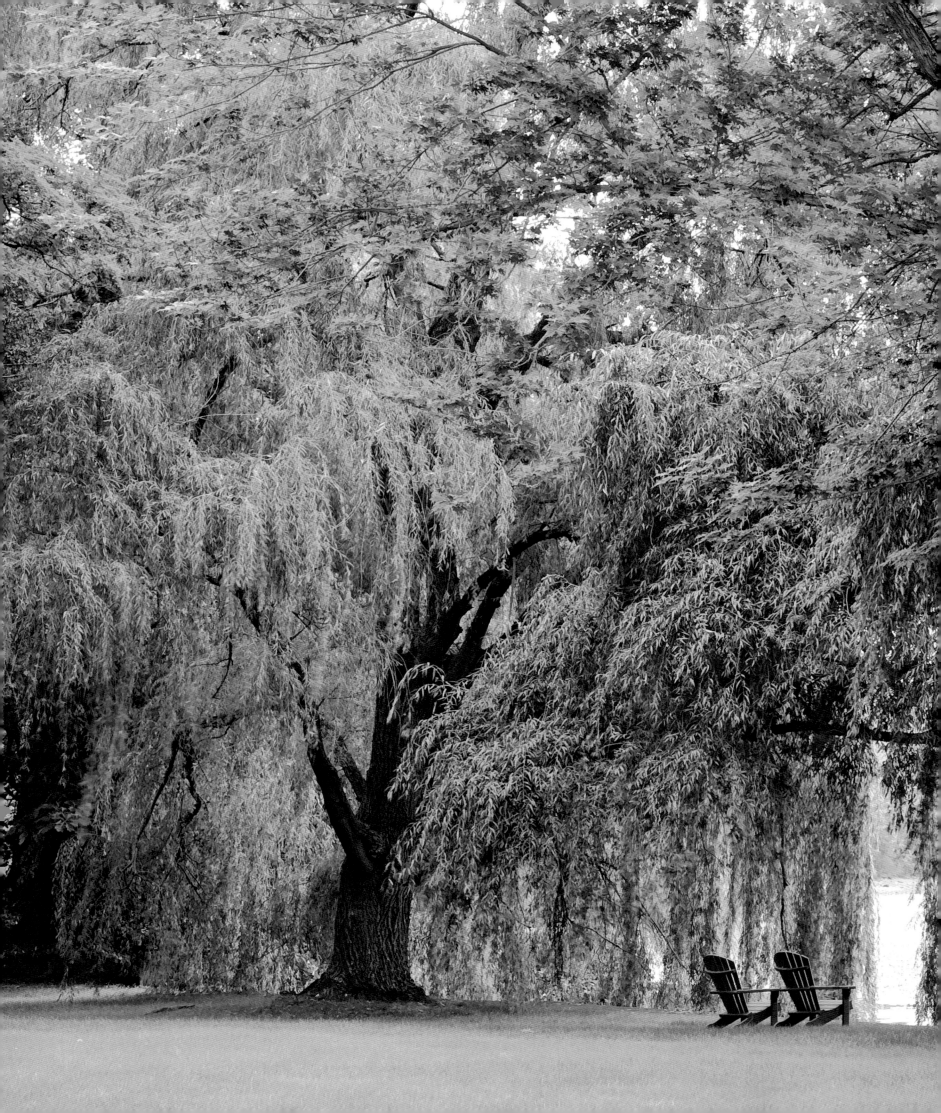

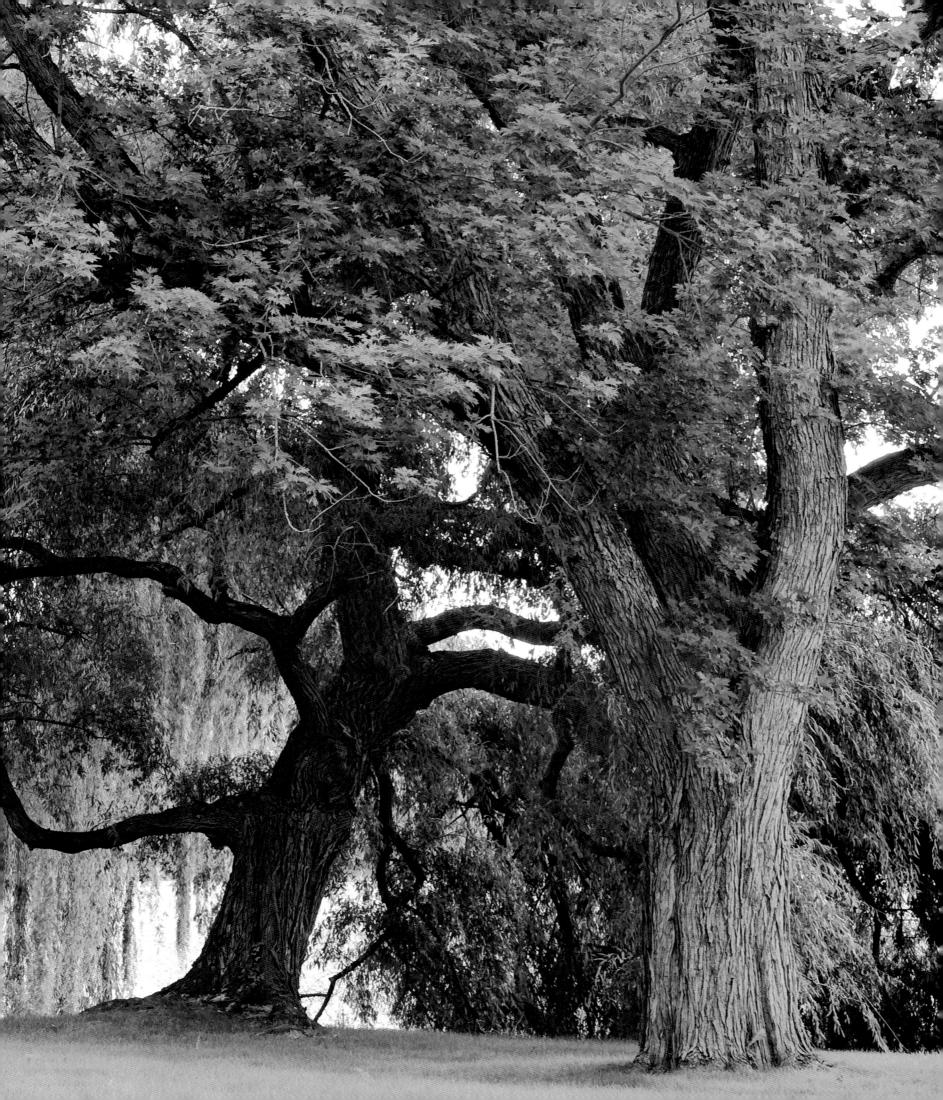

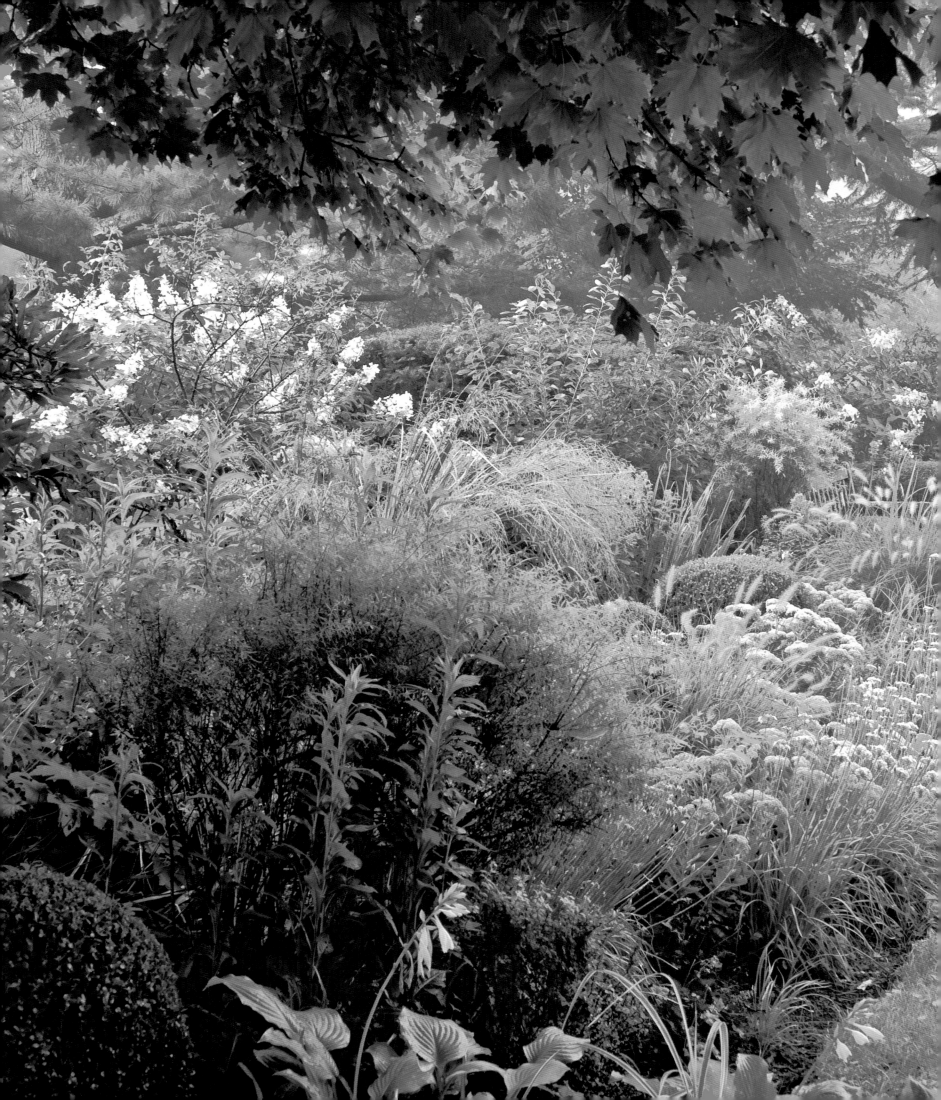

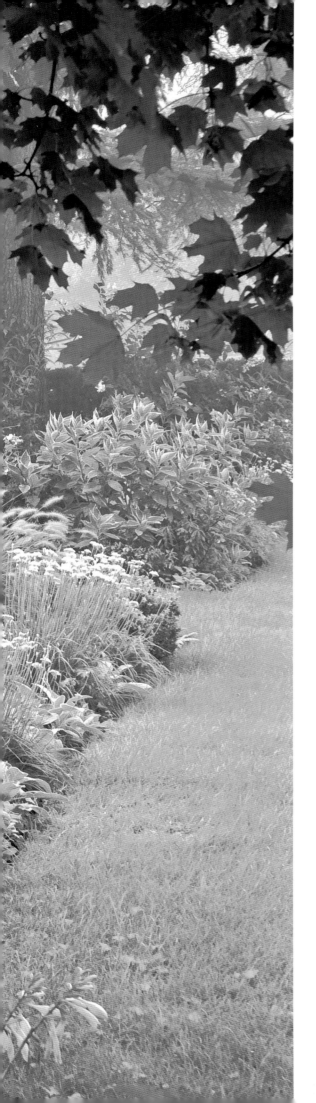

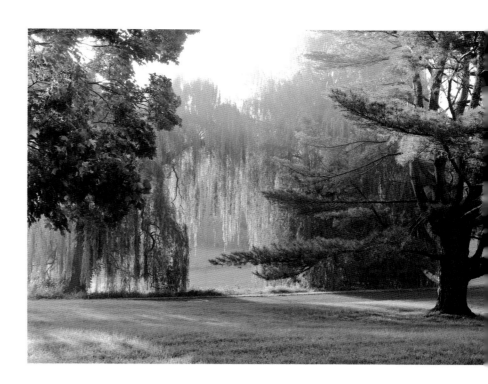

ARVIA MORRIS 🍃 RHINEBECK

A Cheerful Occupation

"I have lived here since I was thirteen years old, and I love this garden," says Arvia Morris with great conviction. Listening to her speak, one understands how deep and enduring this relationship to place has been in her life and how her garden has become even more of a solace and a refuge since the recent death of her husband, Bill, who gardened with her for more than forty years. The property, once a lilac farm, originally belonged to her father and stepmother. In the 1960s, they hired Robert Zion, a respected landscape architect, to site a swimming pool, plant some trees, and to recommend an architect to design a distinctively modern pool house.

When Morris and her husband took over the house in 1969, there were some magnificent trees but not much else besides the landscaping around the pool. Wanting to make more of a garden, Morris attended classes at the New York Botanical Garden, but she insists that most of her real learning was done on the job. She and her husband planted a great many trees, built a terrace at the back of the house, and laid out a traditional double border between the pool and the terrace. "I have always thought you need to be able to look out of the house and see your garden," says Morris, pointing out that hers "has never been on axis because the pool house was already there. But I've always liked things to be slightly off center." Today, the beds are thickly planted with phlox, peonies, stachys, amsonia, helianthus, day lilies, thalictrum, verbascum, and nepeta, and interspersed and held in place by cotinus, *Cornus sericea*, and *Hydrangea paniculata* 'Tardiva', with boxwood balls for winter and spring interest.

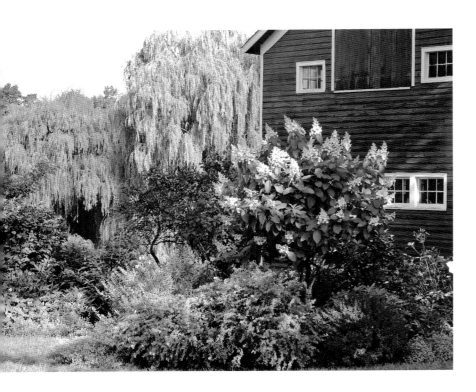

A vegetable garden to the right of the border was begun almost fifty years ago by the Morrises' son, Spencer, when he was nine years old. Morris remembers that he even bought himself a book on organic gardening and learned how to compost. Beyond it is a wetland garden that her husband began to make in the early 1980s. It has a meandering path around a large lake, and is planted with iris, ligularia, penstemon, eupatorium, lysimachia, redbud, spicebush, thousands of spring bulbs, and huge clumps of bamboo. Morris helped design bridges, a rustic summer house, benches, and a gate, but she always considered it to be his creation and his terrain.

There is a large apple orchard on a hill, and selling apples is an important part of Morris's garden calendar. Around Labor Day, she sets up a table and a cash register, and for a few weeks the orchard is open to the public to come pick and buy.

"I've always enjoyed having my hand in the soil. I love weeding and I can't think of many other things that give me such instant satisfaction. It feeds my imagination and gives me such pleasure," remarks this inveterate gardener, who likes to garden because it is "such a cheerful" occupation. For inspiration, Morris reads constantly and relishes visits to other gardens. Not for a moment could one doubt the depth of feeling she has for her garden, but were any such assurance needed, it would surely come from her charmingly forthright admission: "I think I am better with my plants than I was with my children. I always think of Vita Sackville-West and her advice to gardeners: 'If you don't like it, chuck it.' After all, you can't do that with children."

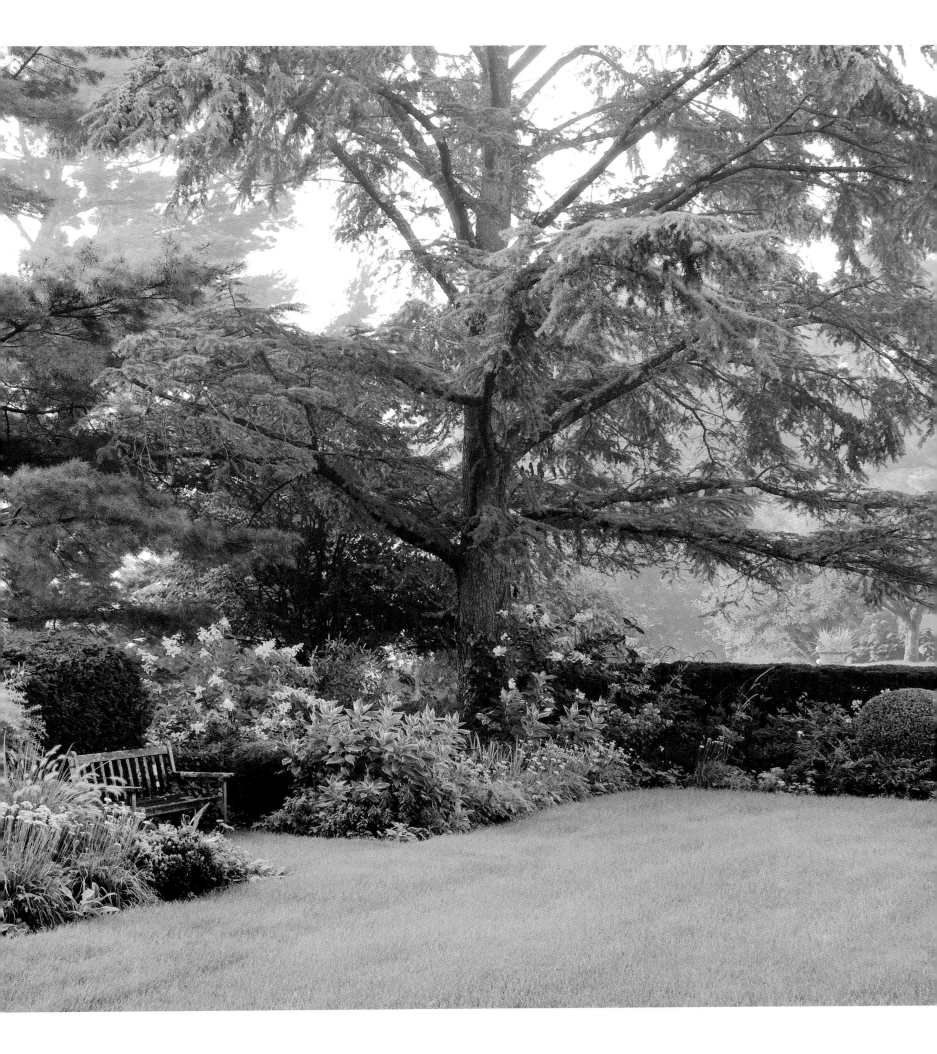

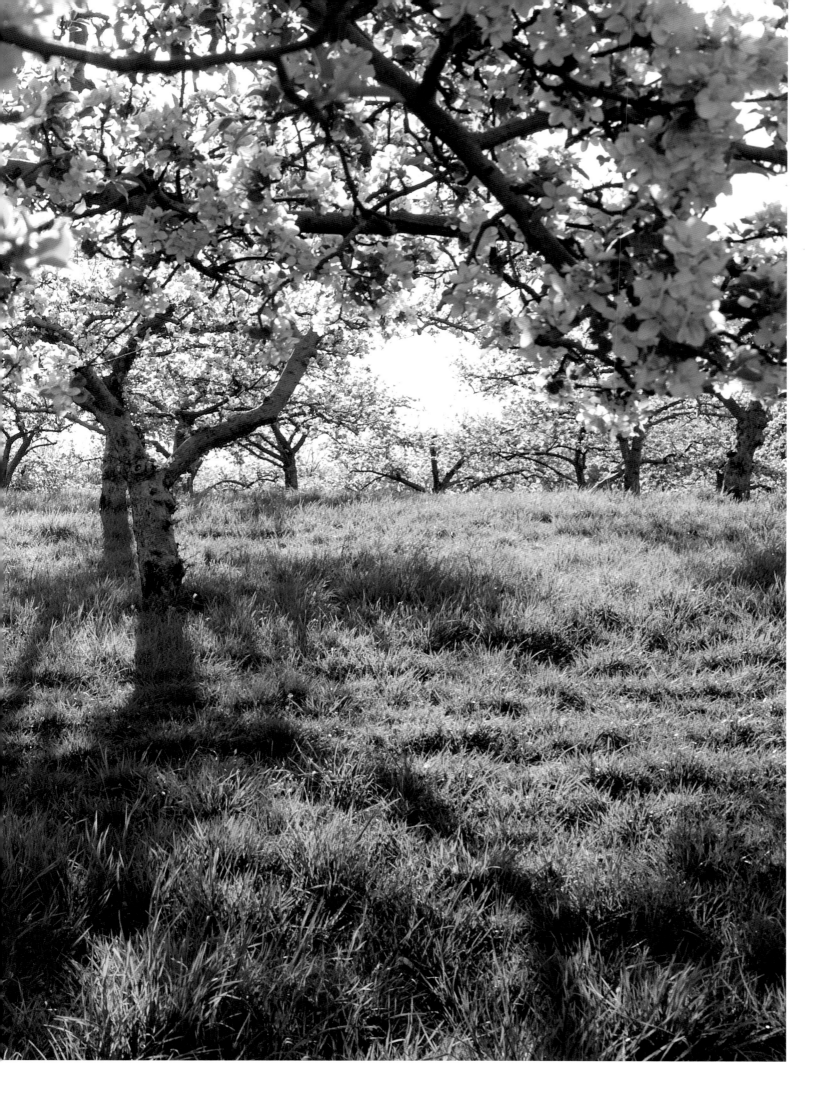

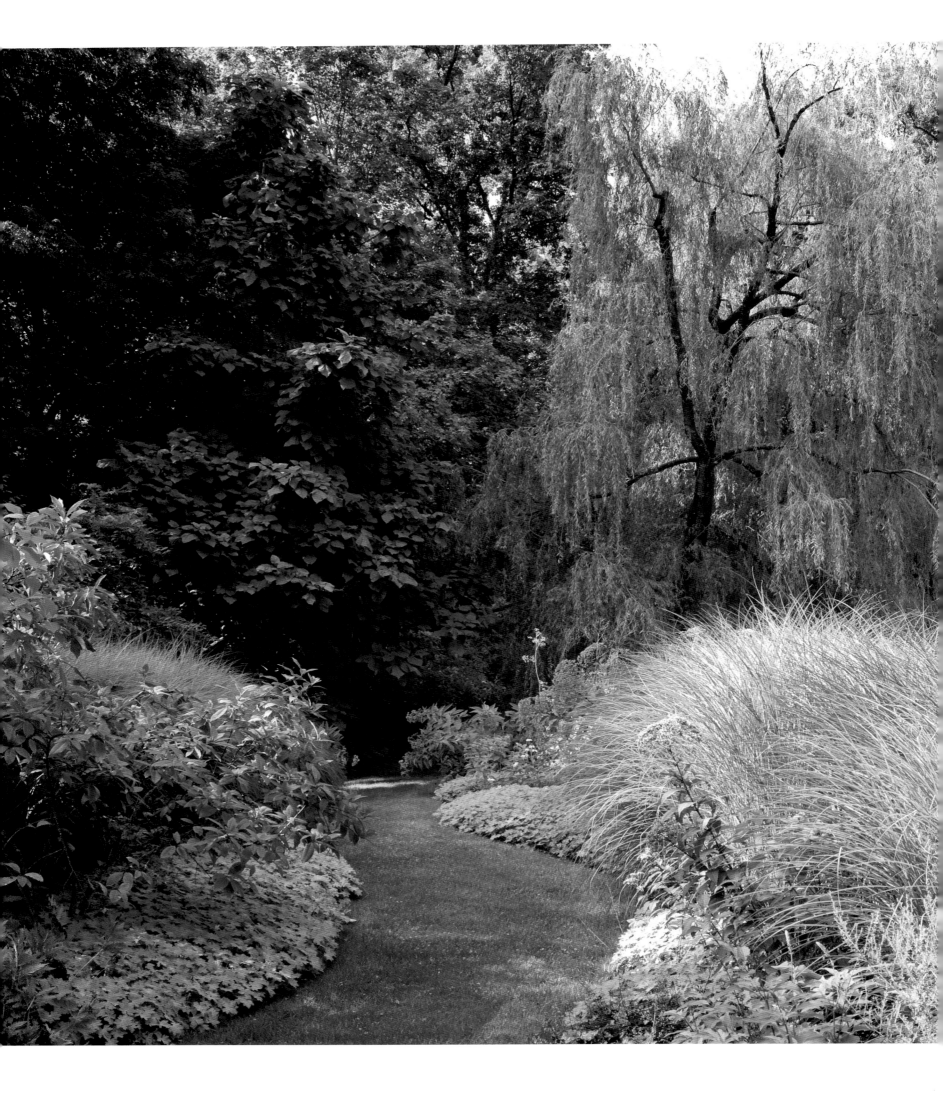

A Grand Creation

Starting from scratch to landscape a five-hundred-acre property and create a formal garden within it might seem a daunting prospect. Since it demands a balance of scale and restraint, it comes as no surprise to learn that Stourhead, the famous eighteenth-century English landscape garden, is one of Bruce and Suzie Kovner's favorite gardens, and Sissinghurst, the masterpiece created by Vita Sackville-West and Harold Nicholson, is another. It seems appropriate that these two iconic gardens would provide inspiration for such an ambitious American undertaking.

In 1983, when Kovner was looking for property in Dutchess County, he spent the night at Altamont, a once-grand house but then somewhat rundown and operating as a bed-and-breakfast. The porticos were gone, the terraces had crumbled, and a once-elegant pond had become a junkyard filled with old cars and machinery. There was a large parking lot in front of the house and any view of the surrounding hills was blocked by a copse of tall pines. Yet, when asked by the owner how his real estate search was progressing, Kovner responded that this house appealed to him more than anything else he had seen. A conversation ensued and shortly thereafter, the owner sold him the property and ninety acres of land, to which Kovner has, over time, added considerably more acreage.

The original house of fieldstone and wood was built in 1870 for Thomas Lamont, secretary of war under Grover Cleveland. When it burned down in the 1920s, Lamont's daughter built the present house, which Kovner and his wife have now restored to its original elegance. Raised in Los Angeles, Kovner is the first to admit that when he purchased Altamont, he knew very little about gardening or landscape design. However, he is by nature a problem solver, and was smart enough to know that if he was going to bring a touch of Capability Brown to upstate New York he needed to work with someone who possessed a lot of horticultural and design expertise. A friend suggested the English designer John Brookes, and once they met, Kovner realized that this was the person he needed.

Brookes has designed gardens all over the world, and when asked in an interview some years ago with the BBC to explain his design style, replied: "I hope it is capable of changing from situation to situation. I like to be bold and simple in my approach to a design, with comfortable spaces, well constructed, then heavily overlaid with plant material. The size and scale—town or country—doesn't

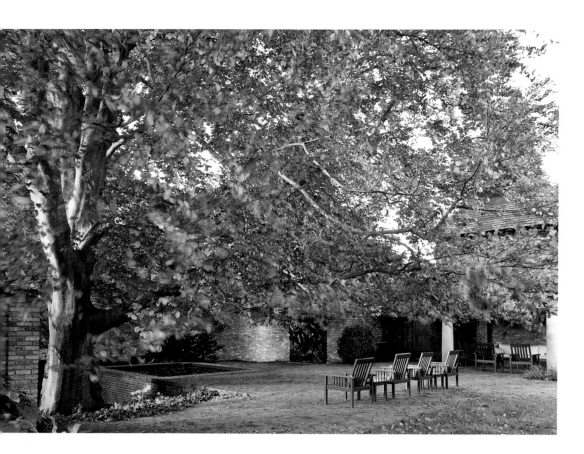

matter. I'd like to hear, 'That's handsome', rather than 'that's pretty', and definitely not 'that's cute.'"

There is certainly nothing cute about the landscape and garden that Brookes, working closely with the Kovners, has created at Altamont. When he came on the scene, there was a magnificent beech tree rising up behind the first of a series of four interconnecting walled gardens that had no obvious connection to the house. Brookes decided to open up the walls of the garden closest to the house and to include the tree in a new spatial configuration. A brick terrace, cantilevered on top of a steel suspension bridge so as not to disturb the roots, was constructed around a small formal square reflecting pool, and a "folly" was added on the far side to balance the tree and provide a place for sitting.

From this garden room, a series of steps leads down to a butterfly garden, planted with buddleia to attract butterflies. "We had to fight with John on that as Suzie and I wanted a slightly wild and tousled look to this garden whereas he preferred a more formal planting arrangement," Kovner admits. Sculpture is judiciously placed among the plants. "I love secret things that you almost don't know are there, and I like to put in furniture and sculpture that is discreet and has a connection to the traditional," he explains. A nearby Lutyens bench was his idea.

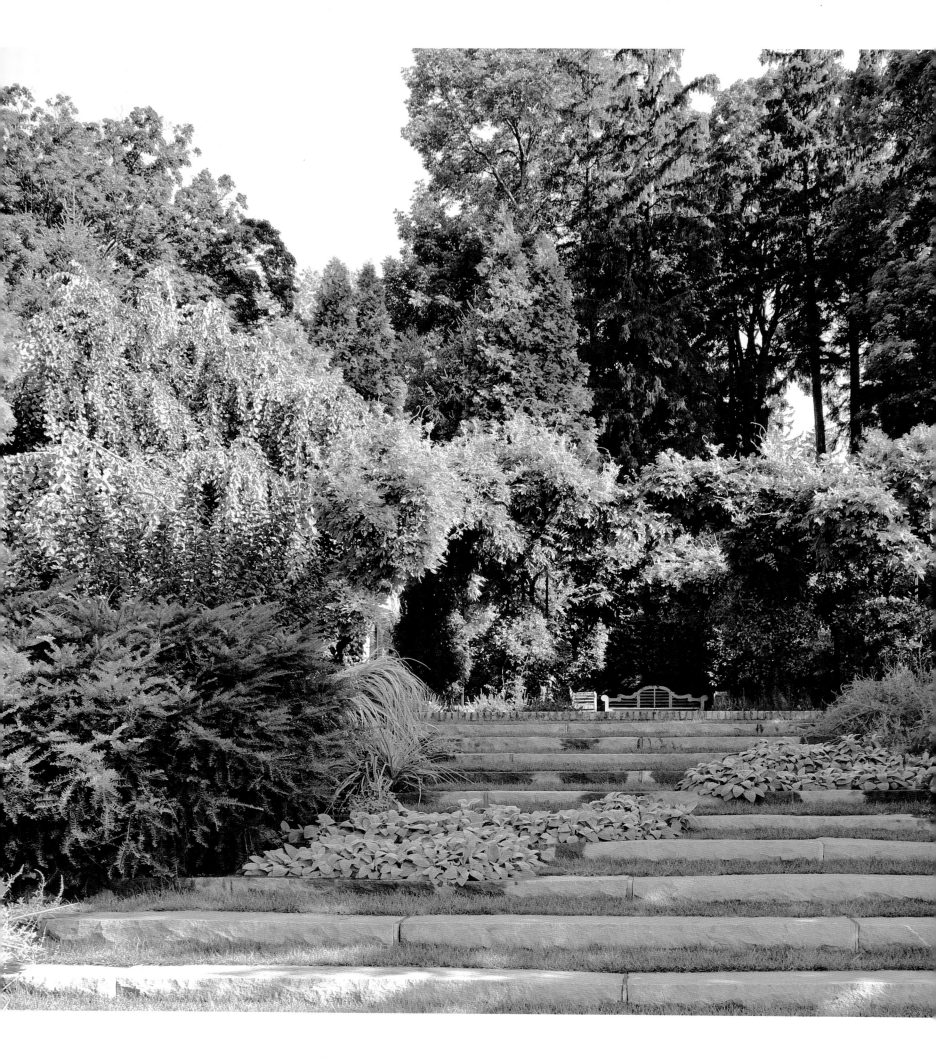

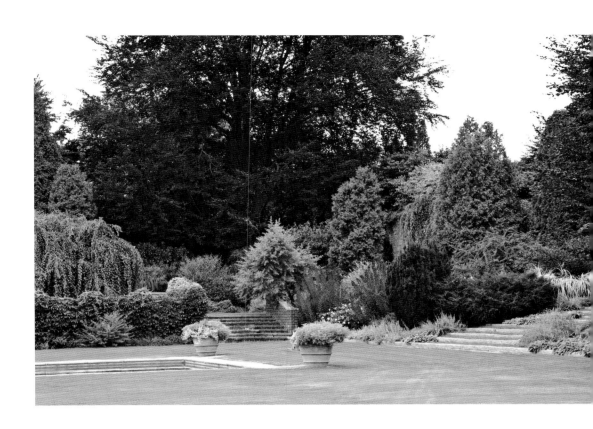

To the right of the butterfly garden, there is a long rectangular swimming pool cut into the open field, its only decoration in midsummer being huge pots of feathery white artemisia. From the pool there is a view back to the butterfly garden and beyond it is a steep flight of shallow granite steps. Originally, there were two arbors on either side of the pool, but Kovner and Brookes felt they distracted from the view of the steps, which are dramatically framed by *Katsura* trees and a copper beech. Stachys and perovskia, planted seemingly at random, tumble freely across the treads and mitigate the long straight lines of this garden staircase that leads into one of the walled gardens. An intimate space, it is planted with salvia and white clematis. A Gothic-style gardening shed with a pointed door offers the gentle suggestion of an Edwardian English garden. This garden room opens into a second walled garden, planted with buddleia, rosemary, white Siberian iris, and Russian olive trees. With a predominantly white color scheme, it is known as the Mediterranean room, and a small opening in the wall reveals a Juliet balcony overlooking the butterfly garden. Retracing the route to the house, one arrives at the last of the walled gardens, which the Kovners think of as their meditation garden. Japanese tree lilacs, underplanted with ginger, shade a long rill of water, reminiscent of the Alhambra, and steps on the far side lead through a gate back into the first cantilevered garden.

Leaving these gardens, all within a short walking distance of the house, one enters into the larger garden—acres of magnificent parkland on a scale seldom seen in

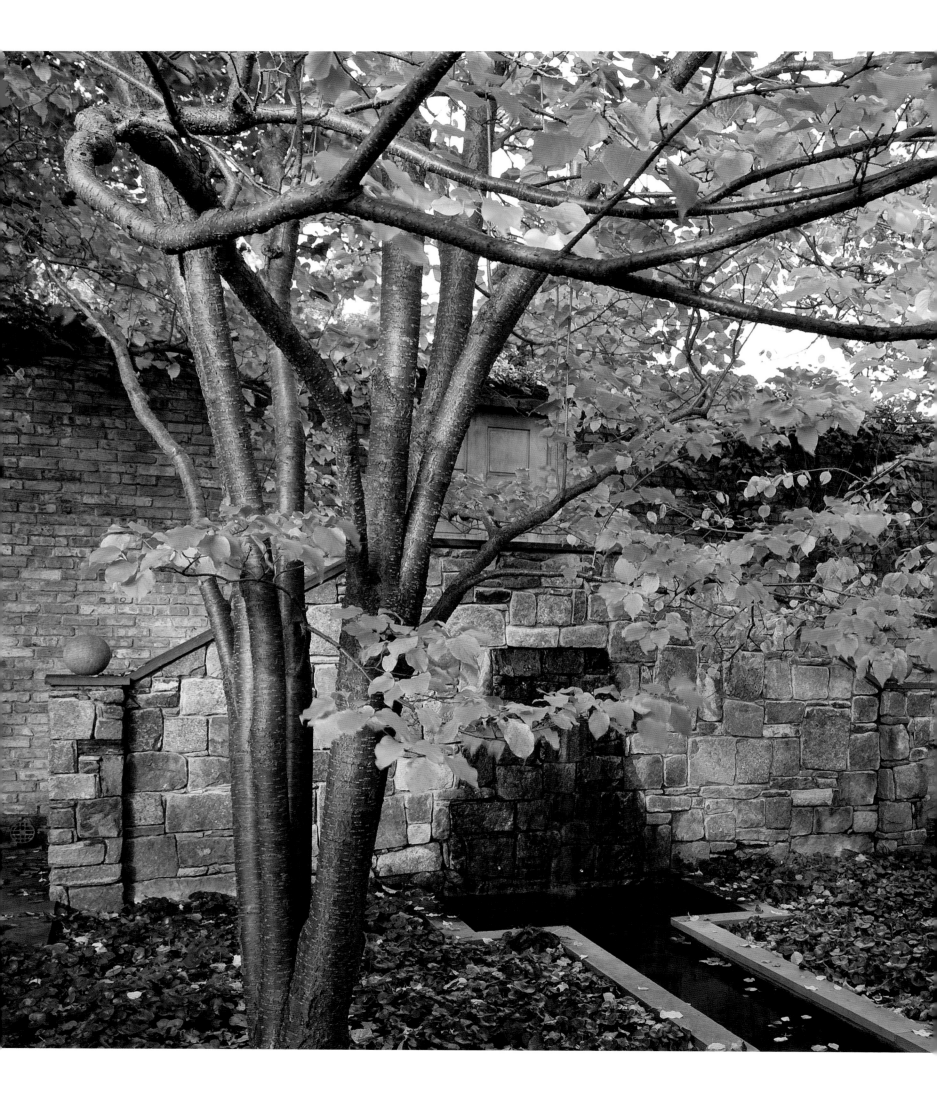

this country. A shaded woodland garden meanders over two acres and is planted naturalistically with bulbs, woody plants, trees, and shrubs. A walk around the property encompasses streams, marshland, forests, and even a belvedere, and passes by a succession of lakes and ponds. A re-circulating feature pumps water through a series of pools to arrive at a large lotus pond and then plunges in a steep waterfall into the lower pond.

The copse of pine trees blocking the view from the house has long since gone, revealing an unobstructed view of the gloriously unspoiled countryside. A ha-ha effects a seamless transition between the cultivated garden and the natural landscape and also keeps a small herd of Choctaw horses and some cows from wandering into the garden proper. At the front of the house, Brookes lowered the driveway so that it cannot be seen from the house and moved the parking away from the front door, which now opens onto a simple courtyard garden filled with bulbs, annuals, and

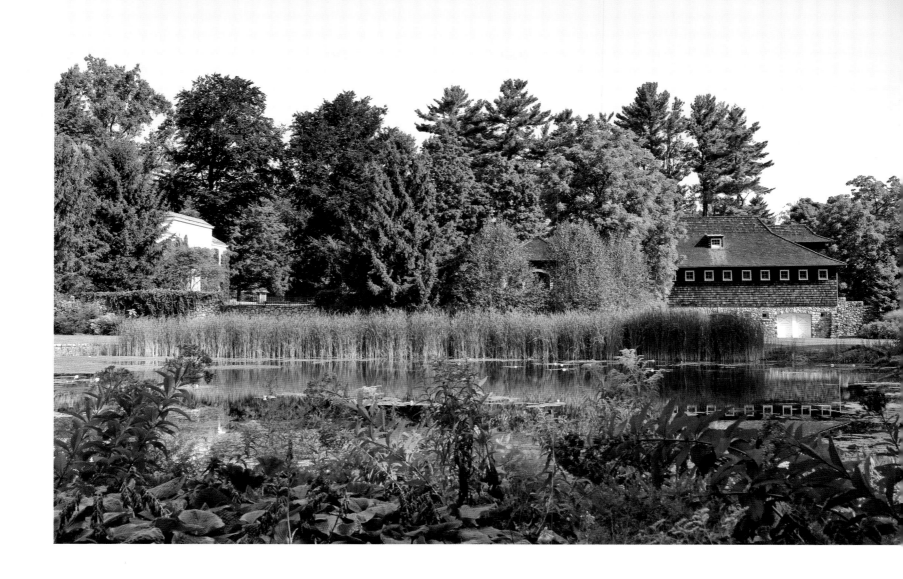

perennials. Container pots placed near to the house are an important decorative feature, and plantings include bush cinquefoil, salvia, lantana, and artemisia.

Taking daily walks around their property is one of the Kovners' great pleasures. Accompanied by their dogs, they take delight in pointing out birds and plants to a first-time visitor, explaining the how and why of a recent improvement, and stopping to check on the well-being of a newly planted tree. "This garden is all about scale and finding ways to humanize it so as not to make it seem too institutional," explains Kovner. "I like a wild quality that's not too disciplined and a soft palette. Above all, I am striving for simplicity." Brookes's work at Altamont is now essentially finished, but he is invited back every few years to make suggestions and recommendations. A garden landscape of this scope is always evolving, and both Kovners know that preserving the spirit of Stourhead and Sissinghurst at Altamont profits from their constant attention and his eye for invention and re-invigoration.

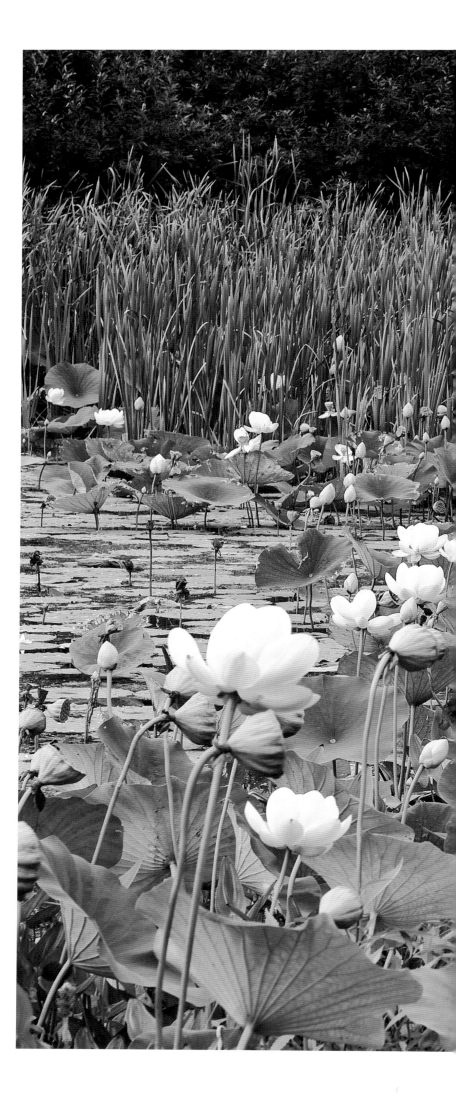

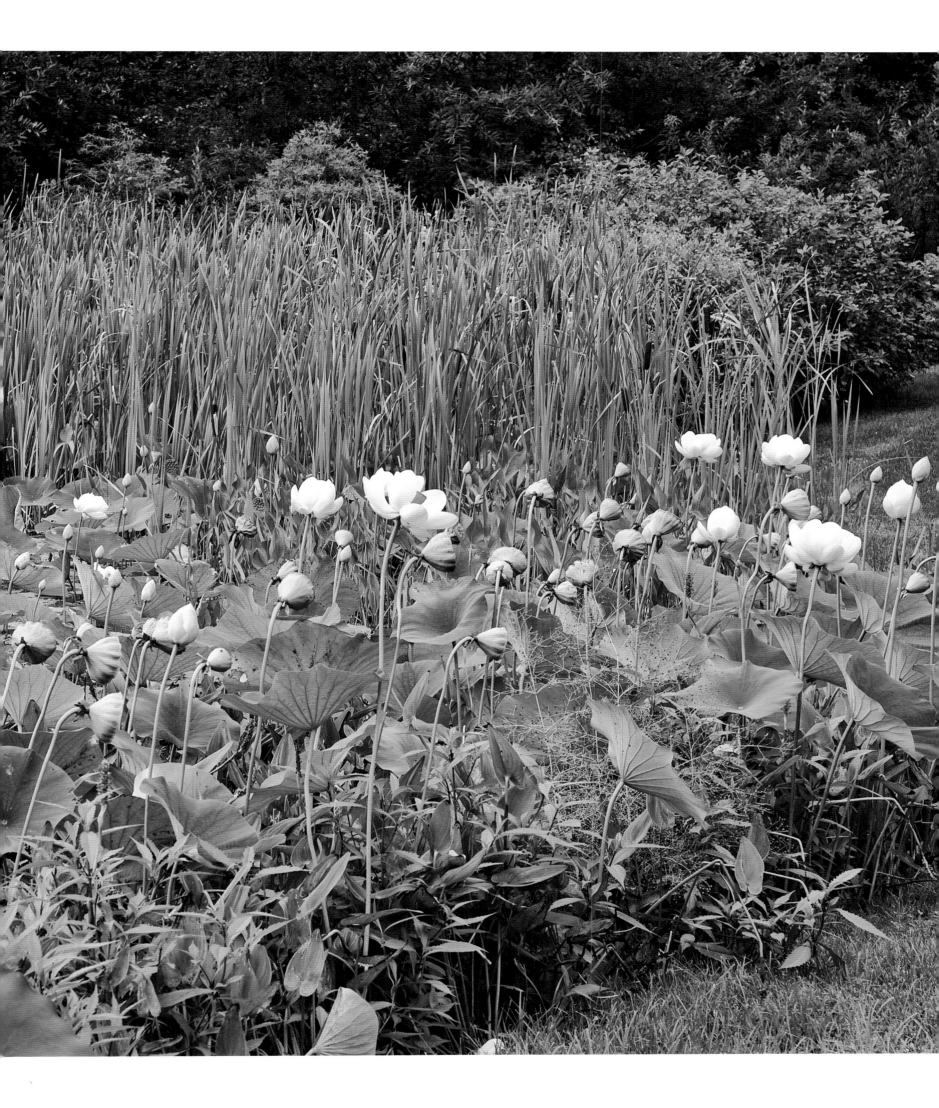

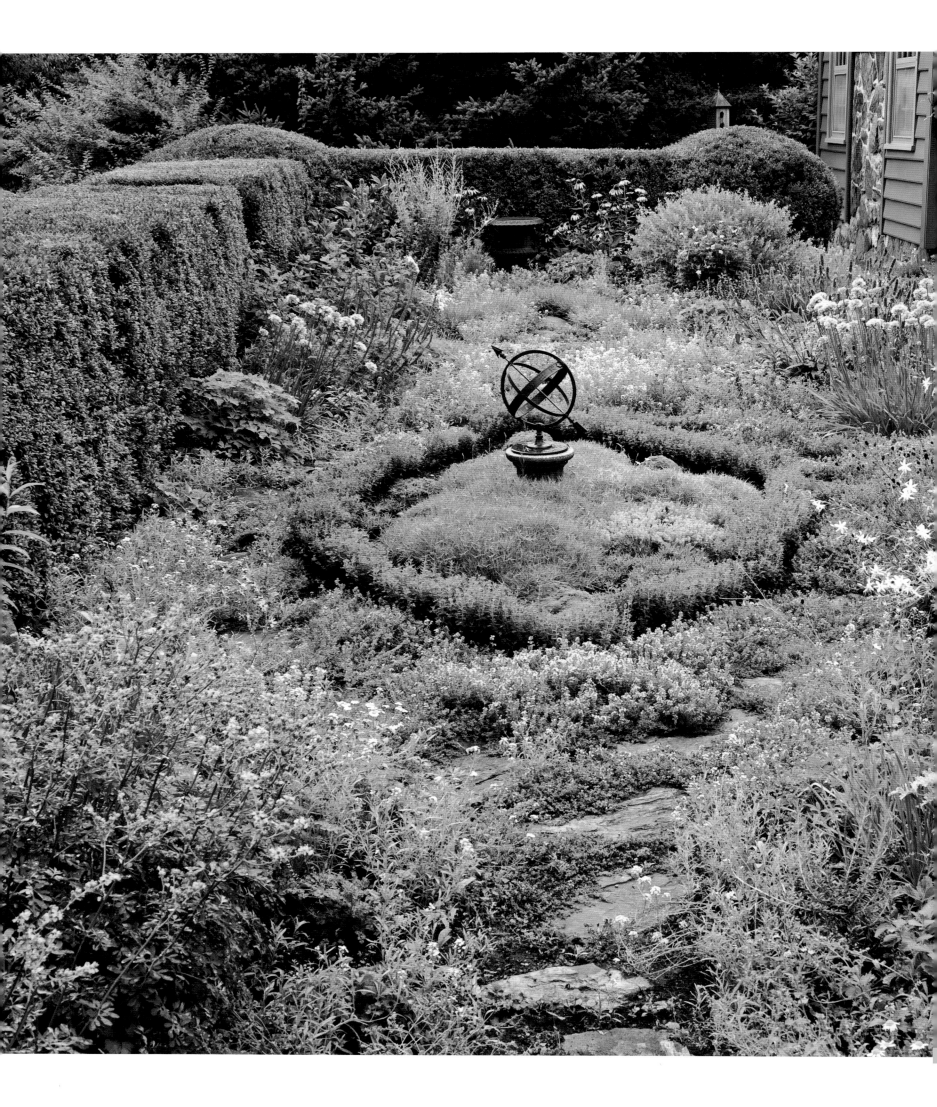

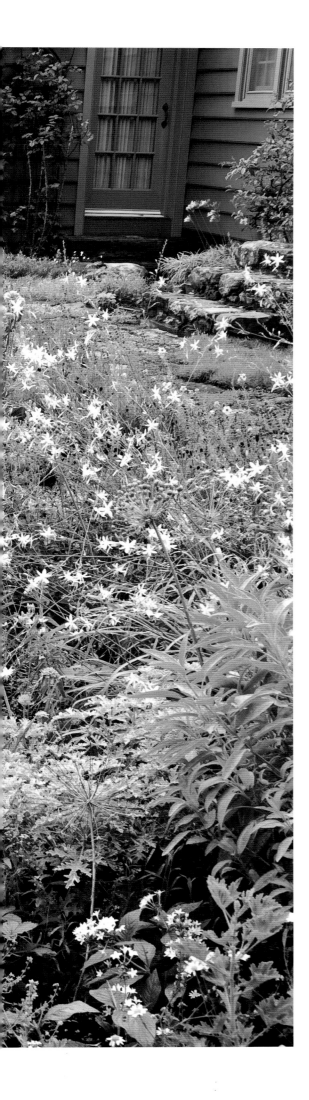

Scent and Sensibility

After a long, fruitless search for an old house in Quaker Hill, Stanton and Kathy Scherer decided on a different approach. They bought and dismantled a two-hundred-year-old Cape house that they found advertised for sale in the *Maine Times*, and reconstructed it on four-and-a-half acres of land. A few years later, they found two small buildings from Nova Scotia and used them to make an addition.

When it came to creating a garden, the Scherers wanted one that would look naturalistic but would still be in keeping with an eighteenth-century house. At the time, they were weekenders and knew they would need help. Stanton's uncle had friends whose daughter was just starting out in garden design, and that was how they met Robin Zitter and became her first clients. They gave her a blank slate, and she has worked in close collaboration with them ever since.

The Scherers' house is approached by a drive bordered on one side by a meandering spring bed planted with rhododendrons, ferns, and an abundance of spring-blooming bulbs. In front of the house, a long curving bed filled with coreopsis, buddleia, bee balm, and lilac merges into the woods beyond. Over the years, Zitter has encouraged the Scherers to increase the depth of this bed by interplanting sedges and grasses among the perennials and shrubs. "At first, we were dubious about doing this," admits Stanton, "but now we are converted." Beyond the house is a neat Chippendale-style fenced-in vegetable garden with raised beds made from local cedar wood. Paths wander through a woodland area beyond the driveway, one of them leading to a hidden rocky area where a swimming pool is built into steep ledge. "Everyone told us that we would never be able to grow anything here but we've succeeded beyond all our expectations," says Kathy. "We have creeping potentilla, sedum, thyme, and euphorbia, and we like to think of it as our own piece of the South of France."

Everything about this garden is easy to like, but the stone terrace garden that the Scherers have created at the back of their house is the pièce de resistance. It is intensely planted with a sweet-smelling profusion of low perennials and herbs, including lavender, iris, many different alliums, dwarf baptisia, and dianthus that all combine to give a magical tapestried effect. Pots of rosemary are placed in the

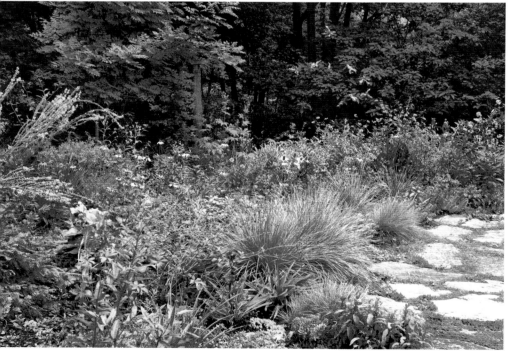

ground every spring and brought in each winter, and year by year the creeping thyme spreads further into the cracks between the stones. Neither over-sophisticated nor contrived, the terrace has a dreamy quality and is the crowning glory of a delightful cottage garden.

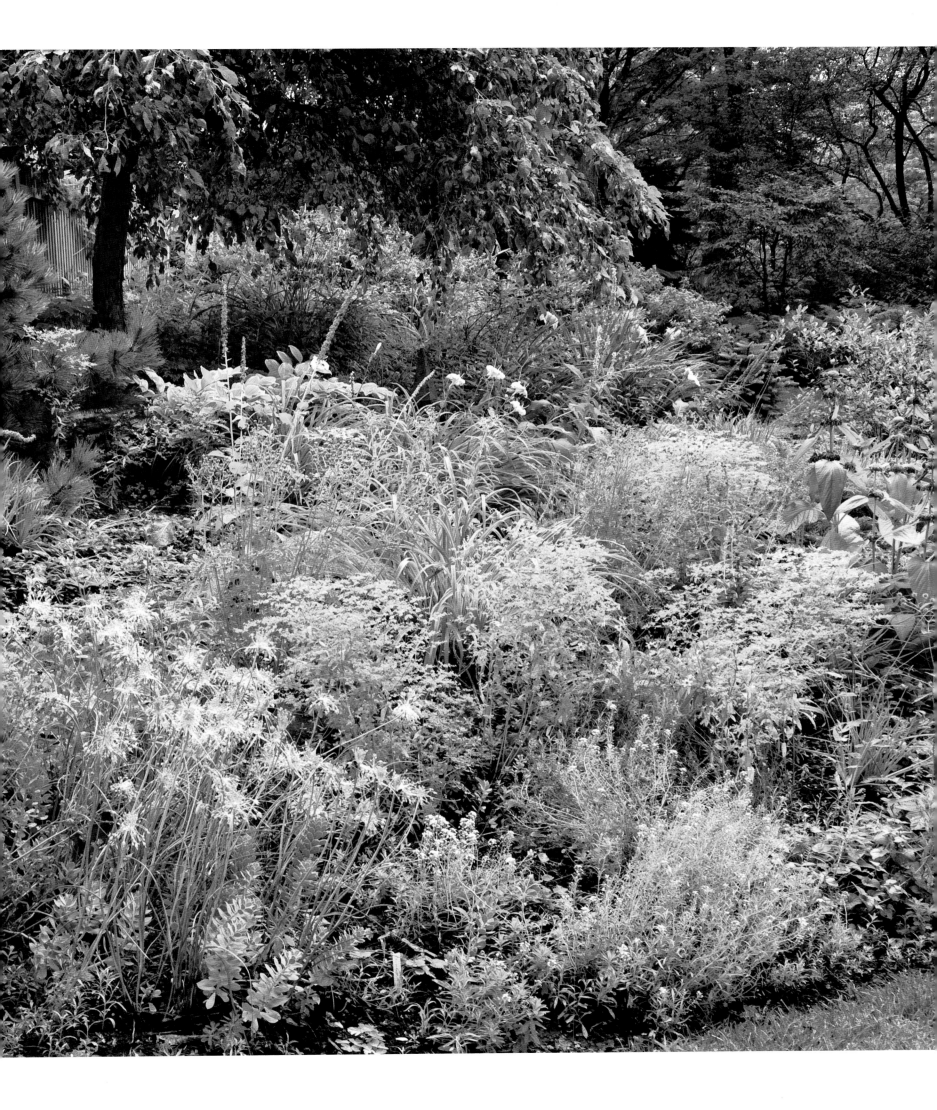

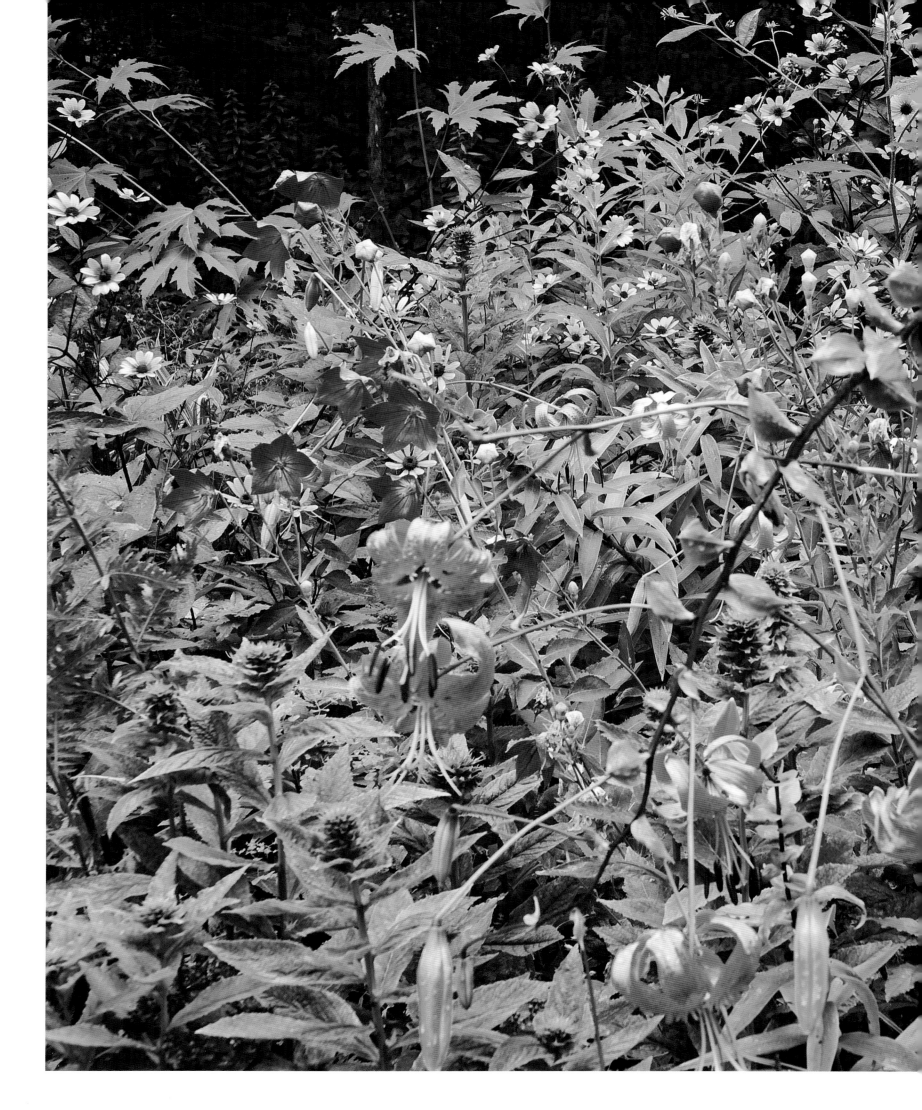

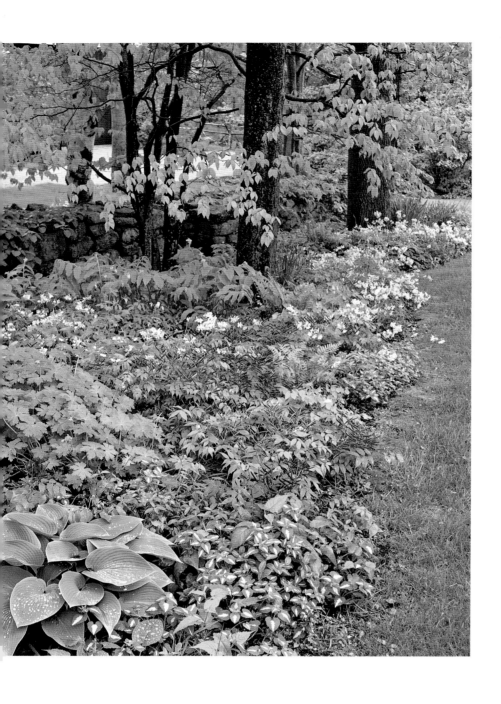

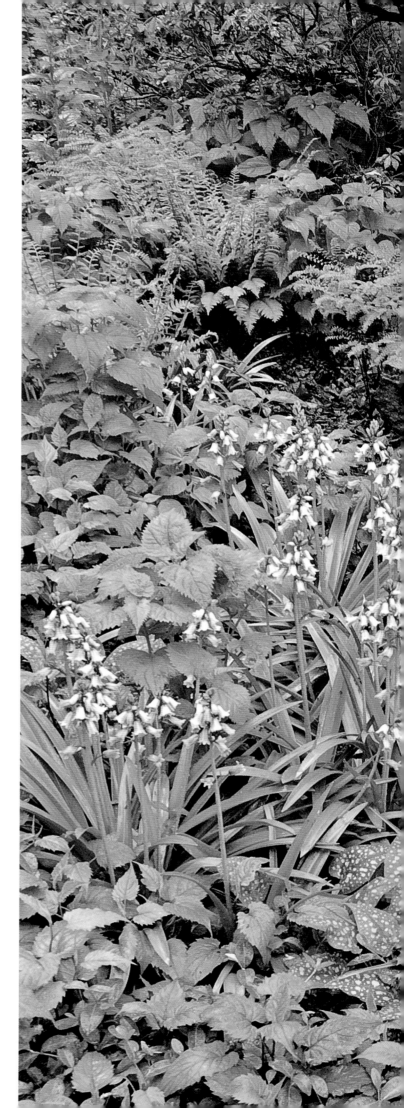

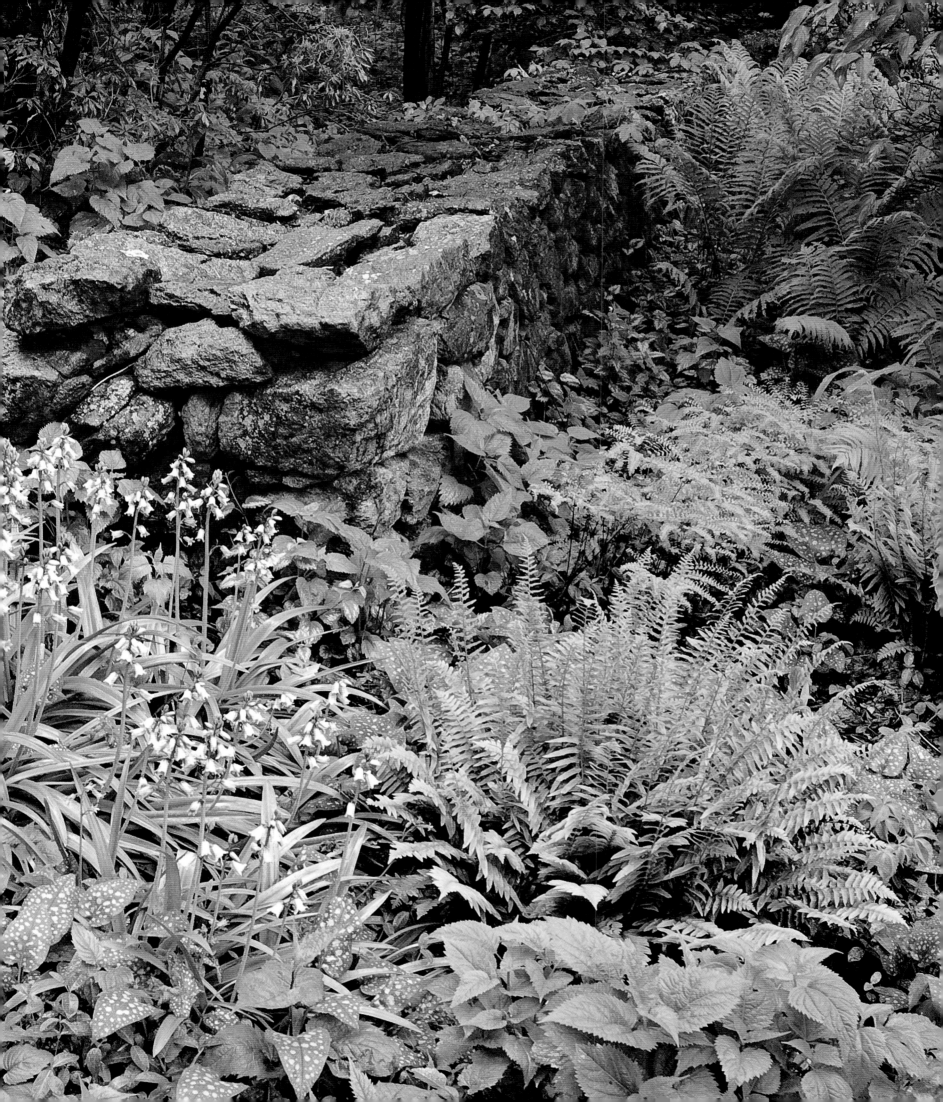

GREGORY LONG AND SCOTT NEWMAN
❧ ANCRAM

Natural Good Looks

Gregory Long and Scott Newman don't like to rush things. In 1988, after two years of house hunting in the Hudson Valley, they ended up buying an 1840s Greek revival farmhouse with an unusual Doric porch running the full length of the front facade. It was the first house they had been shown, and had been sold in the meantime but was now back on the market. "We were finally ready to buy!" explains Newman. The new owners felt that, given the house's distinctive design and the natural beauty of its setting in the open countryside, a conventional garden was not the right approach. Long, who is president of the New York Botanical Garden, feared such a garden would look pretentious, and Newman, who is an architect, wanted to "read the landscape."

Their first decision was to remove an existing drive and parking area next to the house so that the only access from the road would be a narrow footpath, creating, as Long calls it, "an anti-motor court." Cars are now discreetly parked out of sight on the other side of the road, hidden behind a small red horse barn. Since it is all too rare these days for a house to be approached only on foot, this was a radical decision and one that gives a clear signal of the owners' commitment (even at the cost of their own convenience) to maintaining the authenticity and spirit of an earlier time.

There was a small pond behind the house, which Long and Newman greatly enlarged, giving it the feel and appearance of a small lake, at once stately and dramatic. Graced by a huge willow and encircled by a wide swath of grass, it has become a major focal point in the landscape. Long and Newman pushed back the encroaching woods and to the far side, working with Native Plants of Great Barrington, they created a huge square meadow of wildflowers. Green-eyed coneflowers, hibiscus, rose mallow, monarda, lobelia, helenium, penstemon, Joe Pye weed, and mountain mint all co-exist happily, providing bloom, texture, and vibrant color throughout the summer months.

Closer to the house, the foundation of a barn, long since gone, has been covered with a simple gravel terrace, its only decorative element being four large pots of agapanthus. A long bed of lavender runs the length of the right side of the house and there is a quince tree at either end. "Wherever we've planted, we have inten-

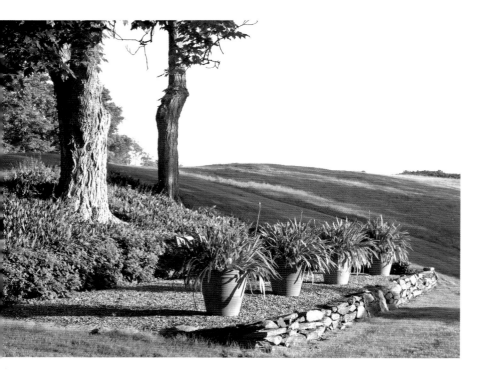

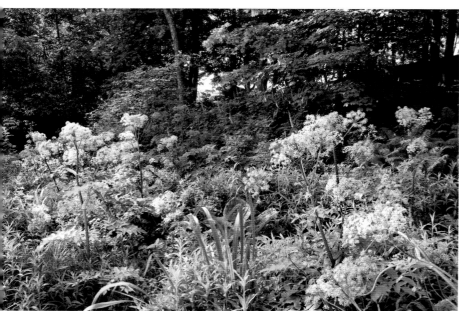

tionally avoided having a big mixture of plants since we didn't want anything that felt too much like a border," explains Long, pointing to a cloud-shaped bed closer to the road, thickly planted with cinnamon fern and underplanted with Virginia bluebells. Other examples of this technique are a mass planting of lily of the valley under a maple tree and a bed of ostrich ferns to the left of the house.

A stream running along the foot of a hill to the right of the house was the impetus to make a woodland garden. Long and Newman began work on this project in 2000, clearing the river and pushing back its banks to allow the stream to run unimpeded around the hill, before dividing into two paths that flow around a miniature island

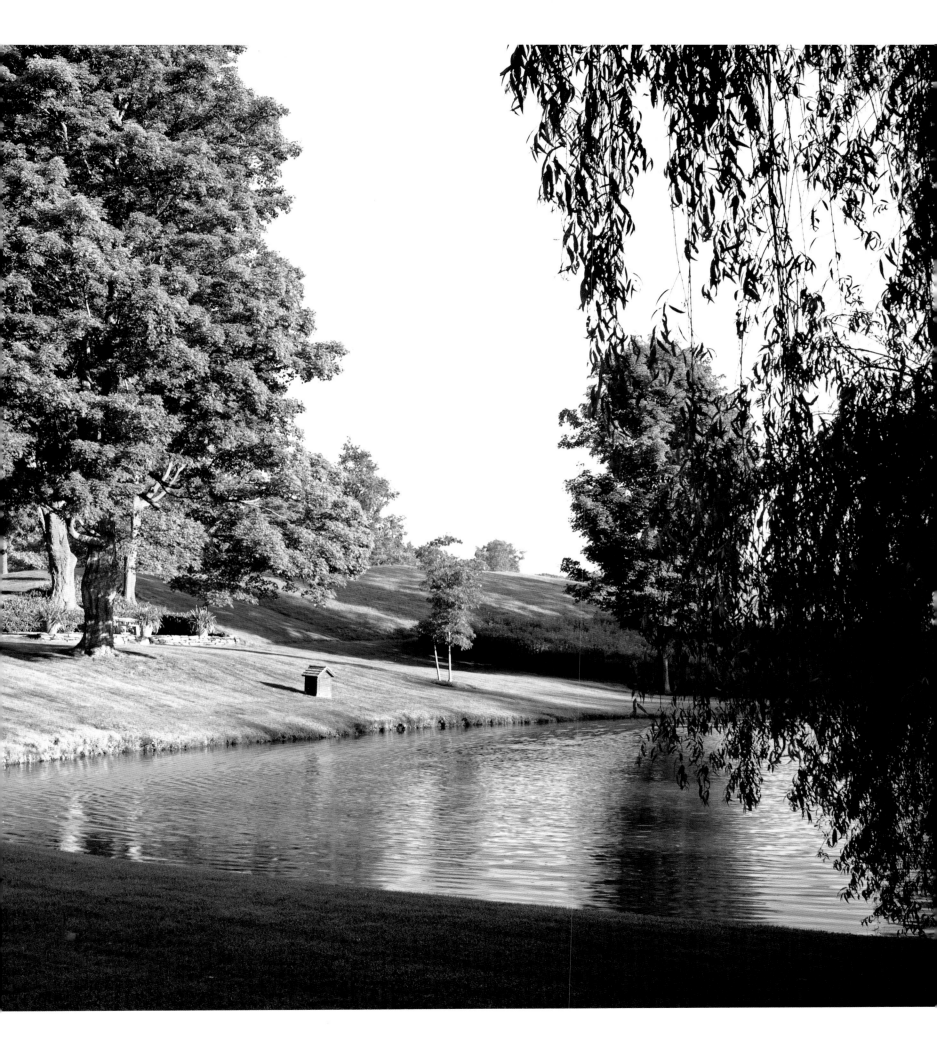

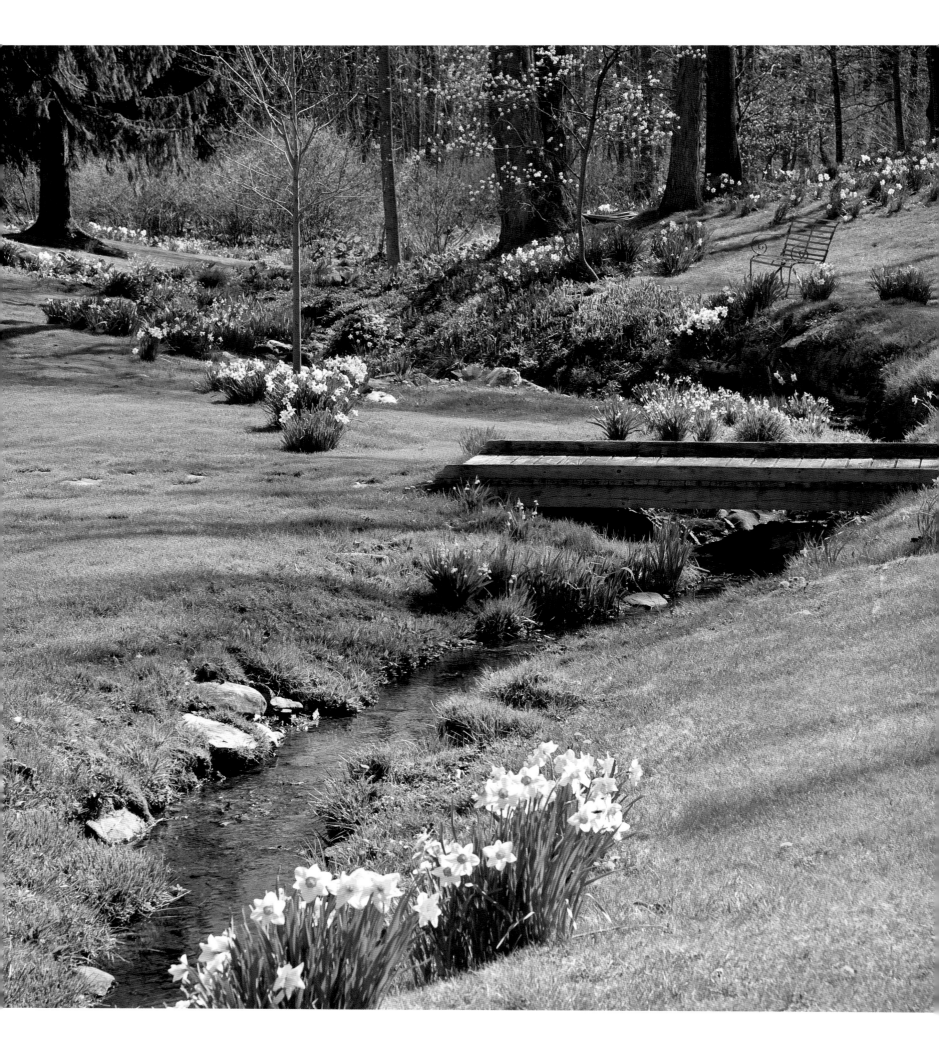

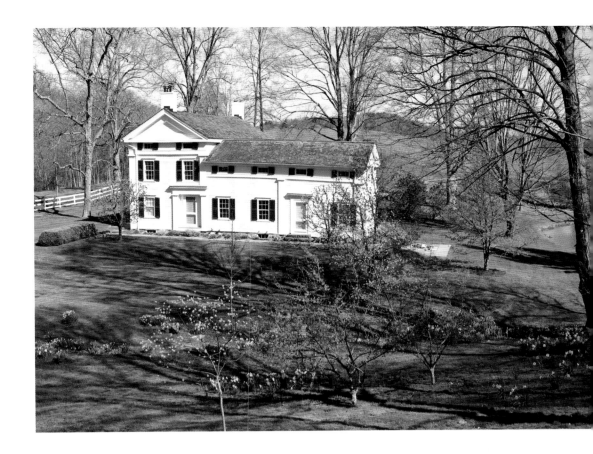

and then pass under a simple wooden bridge. Each year, Long and Newman add more bulbs to the hillside, and last year they recorded blooms from the beginning of February, when the first snowdrops appeared, to early November, when the last few cyclamen were still gallantly holding up their petals. Pussy willow, daffodils, leucojum, foxgloves, columbine, filipendula, and asters all have their moment of glory, and what began as a cultivated garden is increasingly becoming a natural habitat.

Trees are an important feature of the landscape. Faced with having to take down a number of diseased elms, Long and Newman have planted a grove of dogwood trees, a row of red oaks near the road, and tulip trees, sweet gum, white swamp oaks, and river birch. They have also planted an orchard of standard apple, peach, and pear trees.

Long remembers Henrietta Lockwood, a doyenne in the world of gardening, taking him around her garden many years ago and telling him in no uncertain terms that it was not a garden but a place. The phrase stuck with him. Today, looking at the trees, the pond, the exquisite woodland garden, and the wide expanse of grass giving way to the fields beyond, the notion of place seems a perfect metaphor for this gentle landscape being created so unhurriedly by Long and Newman.

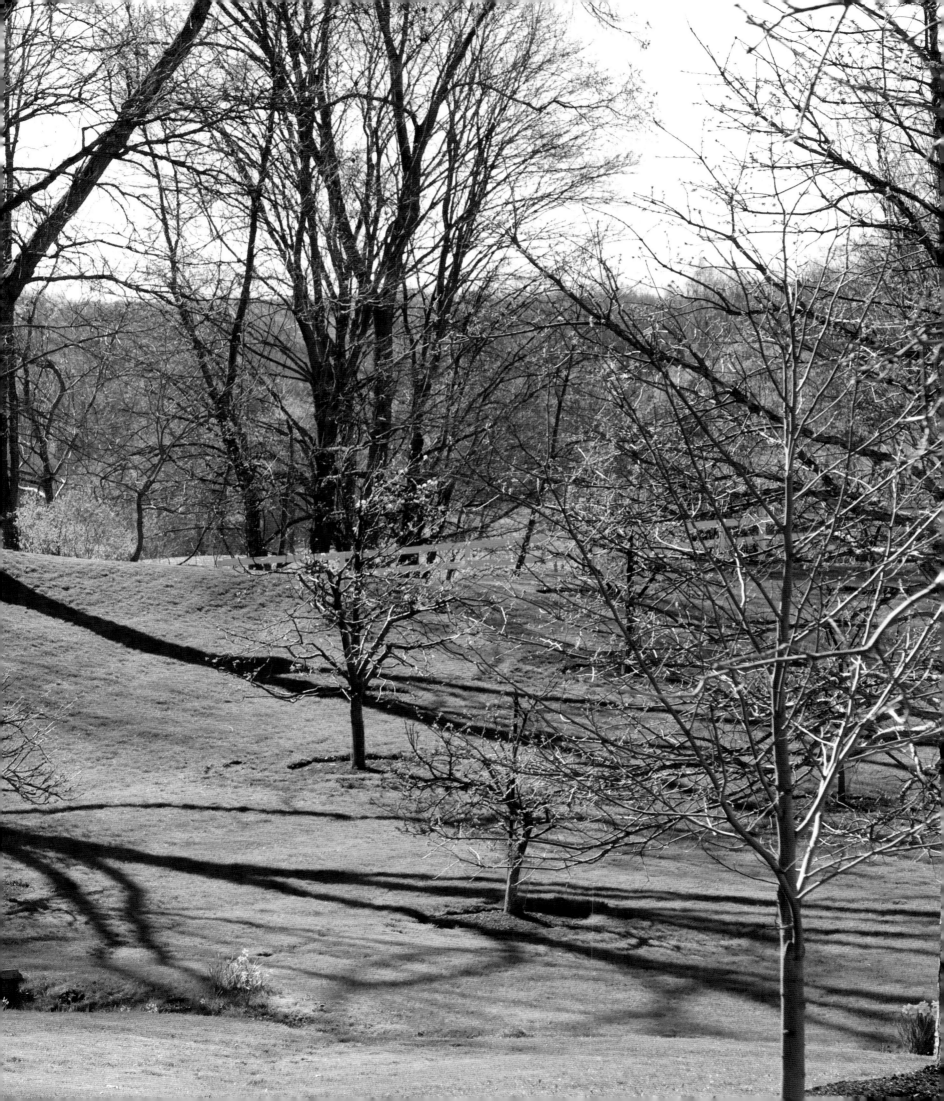

IAN AND MADELINE HOOPER ❧ CANAAN

Simply Sensational

It takes but the briefest conversation with Ian and Madeline Hooper to discover they are passionate gardeners. "Our garden is the place I most want to be," says Madeline. "The center of our lives," adds Ian. Yet when they purchased Rockland Farm in 1980, neither of them knew a rake from a trowel, and they certainly never dreamed that thirty years later they would be master gardeners, contentedly spending four to five hours a day at work in their garden.

At the time, they were looking for a weekend escape from the city (they now live here year round). "We were incredibly ignorant about the area and found the house through a newspaper ad," Ian explains. There was no garden, and the property was surrounded by trees and heavy scrubland. At first, their focus was on reclaiming the house. It was not until a few years later that, wanting to push back the tangle of encroaching trees and not knowing how to go about it, they asked Fred Callander, a local landscape designer, to come up with a solution that would also give them a small garden to be seen from the house. He suggested taking down some scrawny pine trees and installing a simple shade garden in the clearing. It would be planted with hosta and fern and bisected by a meandering path. After the trees were chopped and the soil prepared, Madeline remembers him arriving with a truckful of plants and asking if she would like to help him with the planting. "He literally had to show me how to put a plant in the earth," she says, "but I was immediately hooked."

Today, Fred's Garden is just one of the Hoopers' many garden rooms, which are often named after the person most involved in their creation. At every step of their gardening learning curve, the Hoopers found people, like Callander, who were willing to share their skills and allowed them to serve as apprentices. "It was a piece of incredible luck, and it's how we learned everything we know," Madeline explains.

Fred's Garden became the catalyst for making a garden all around the house. Earlier, the Hoopers had put in a swimming pool, hoping it might encourage their children to visit more often—"A ploy that didn't really work," Madeline admits. They decided to focus on making a lavender garden and a garden around the pool. "Two years later, we made a vegetable garden," says Ian, explaining that the axis between each garden is a little "off" since "it was always a case of one project leading to another rather than the garden being planned as a whole." Next came a lake, dug with the help of

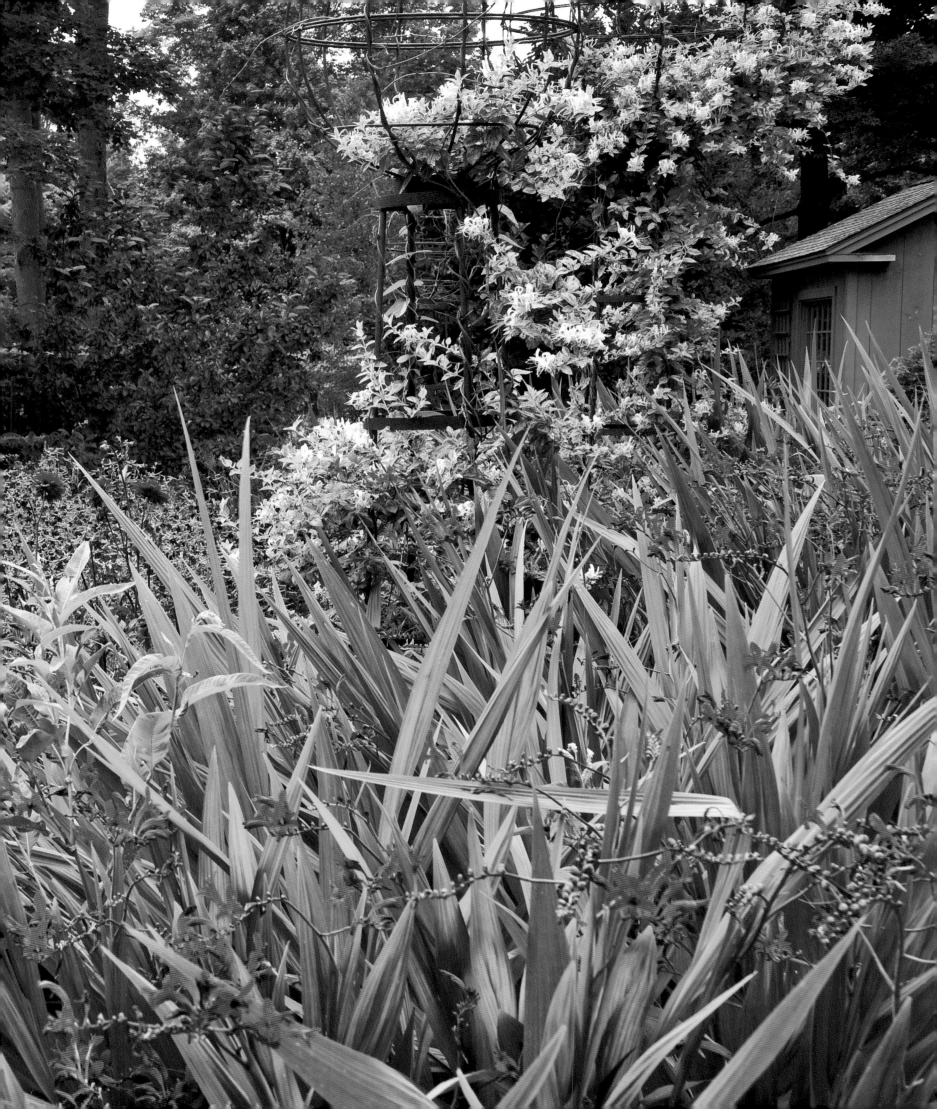

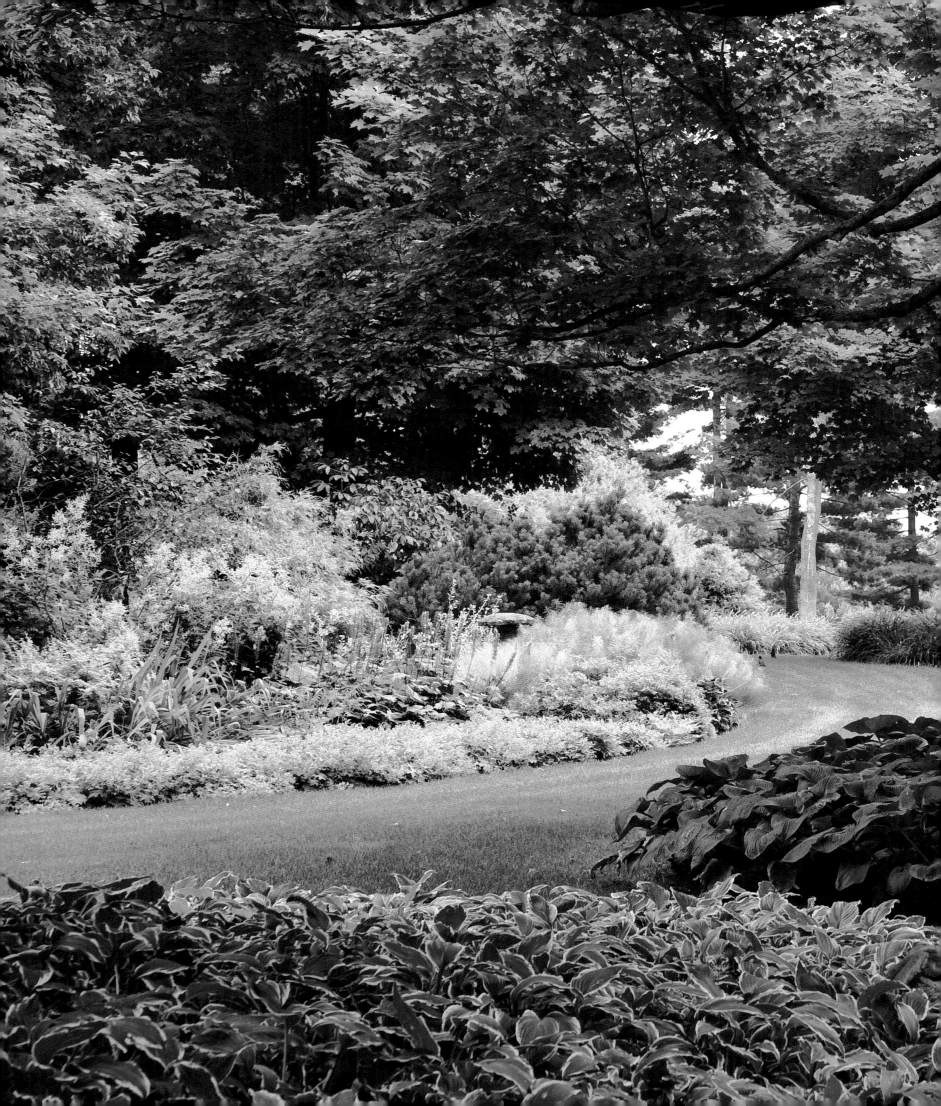

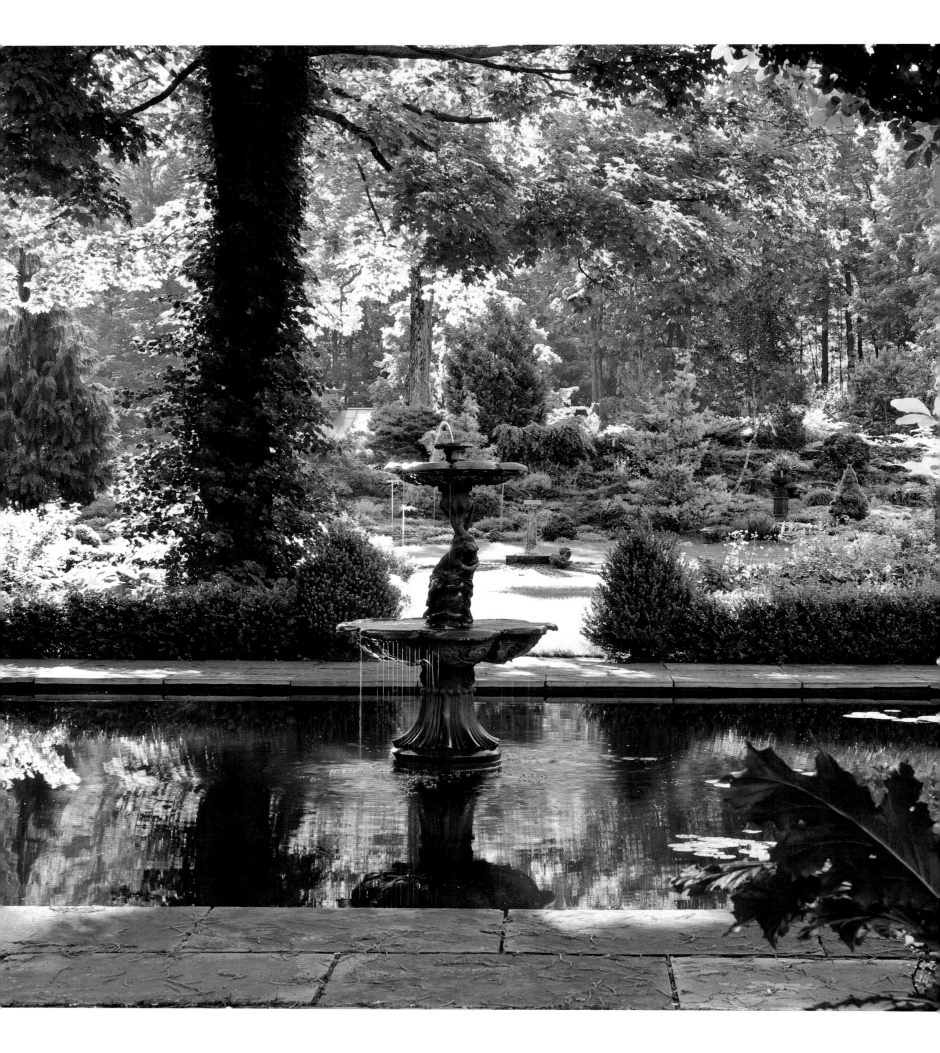

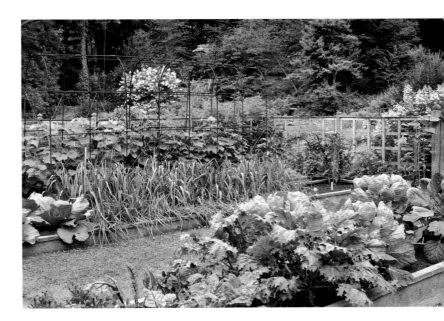

Anthony Archer-Wills. Their newest creation is a vibrant red sundial garden, the result of a friend's insistence that they must buy a lead sundial he had seen at an antiques show. This garden features a heady mix of Bishop of Landau dahlias and *Crocosmia* 'Lucifer' planted against an ironwork trellis.

One of the interesting things about the Hoopers is seeing how they work together. Madeline loves the weeding and digging while Ian focuses more on the trees and shrubs, deferring to her on the perennials. They both love visiting other gardens and, when they see something they like, are firm believers in Pope's adage that imitation is the sincerest form of flattery. Their stunningly simple lavender garden with its walls of hornbeam and beds of heuchera was inspired by the many hornbeam hedges they had seen in England, while an evergreen border of blue spruce, balsam, Canaan and Fraser firs, limber pine, cypress, arborvitae, and junipers, made to hide a neighbor's drive, was an idea copied from White Flower Farm.

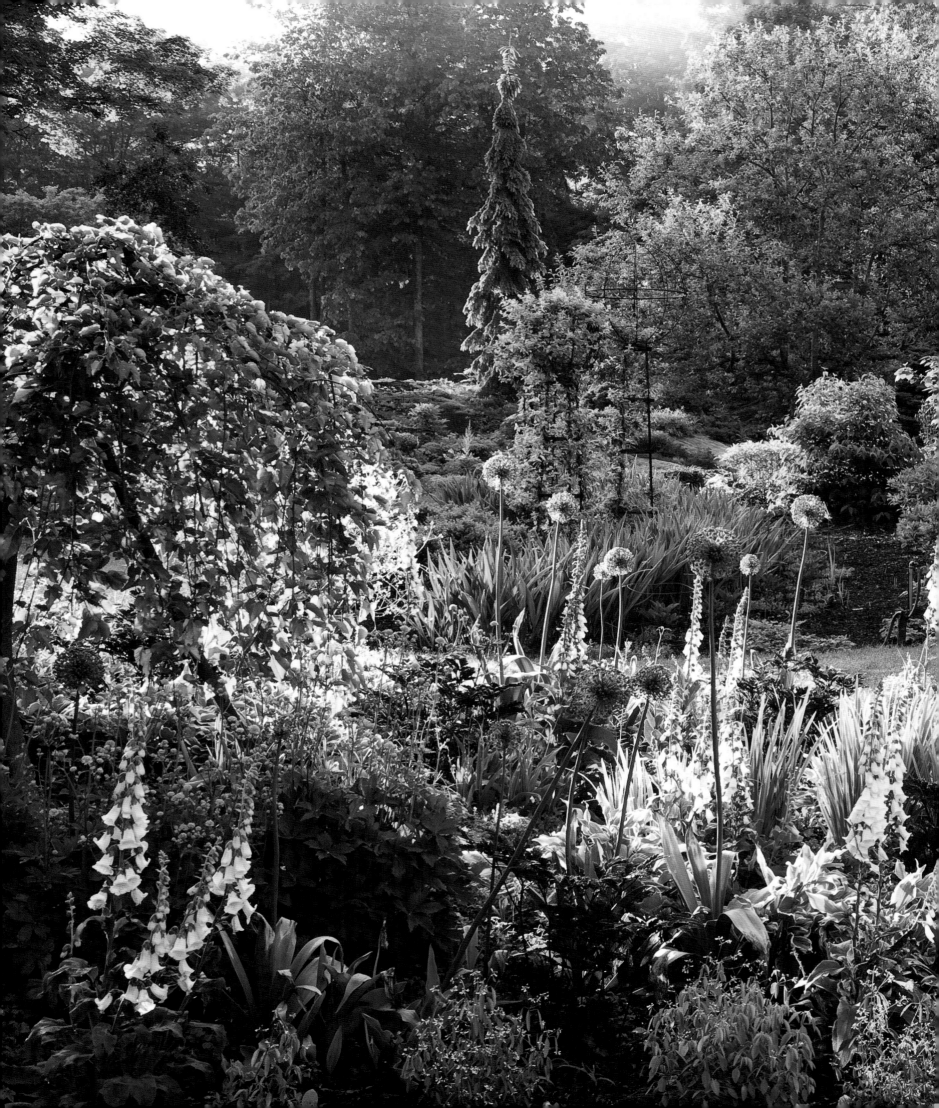

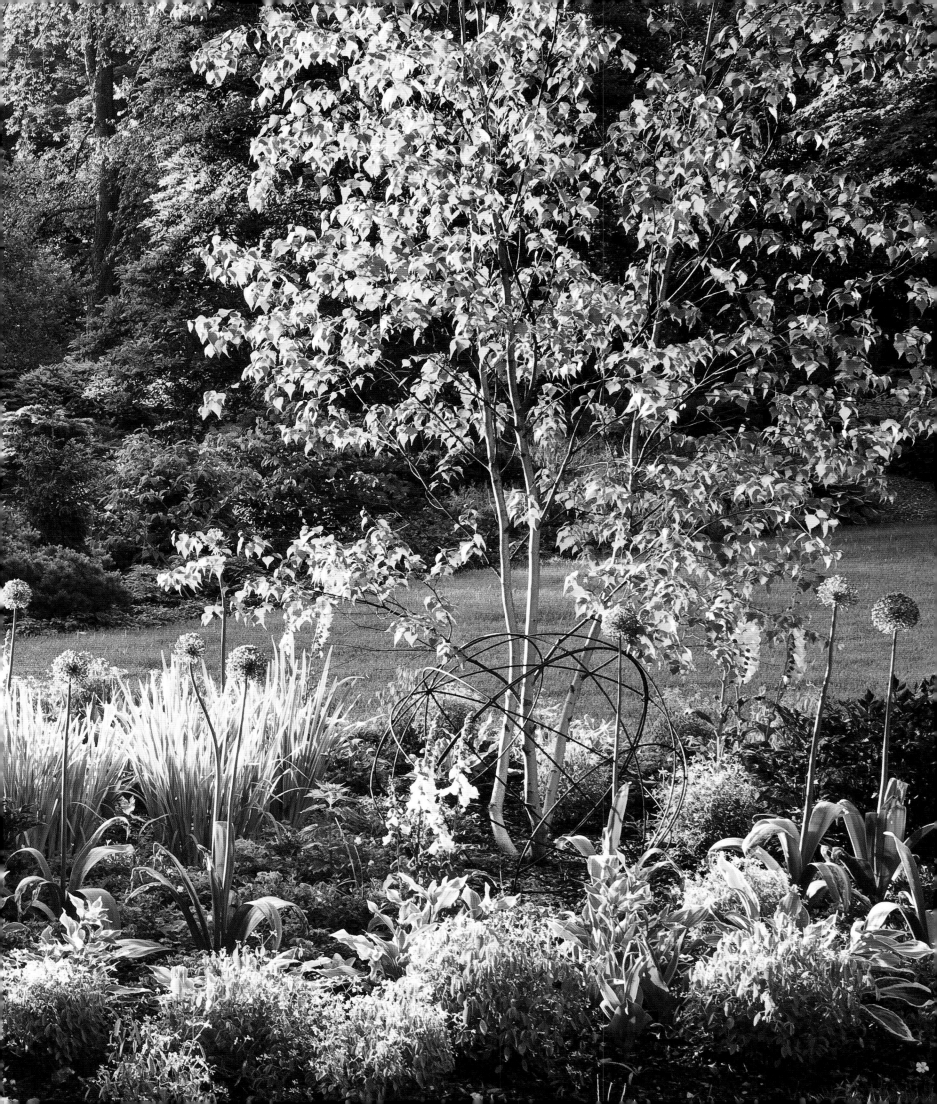

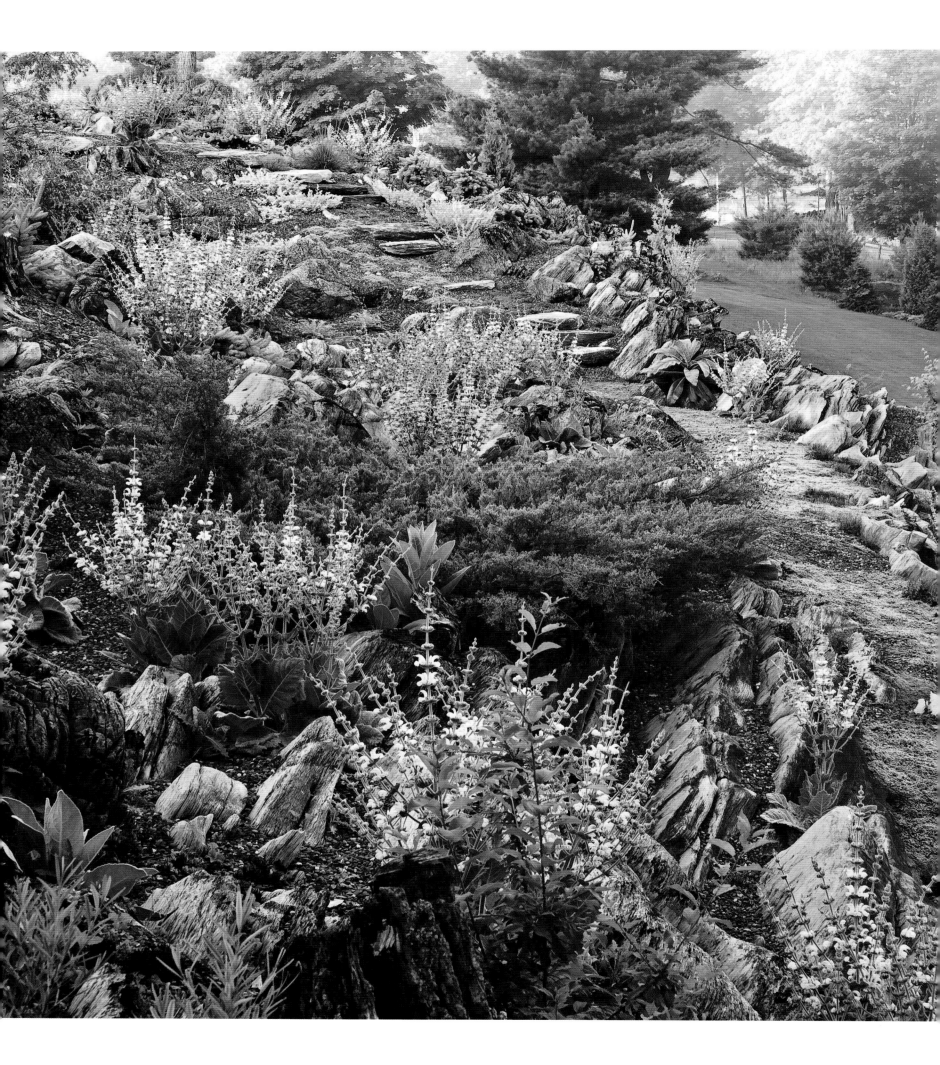

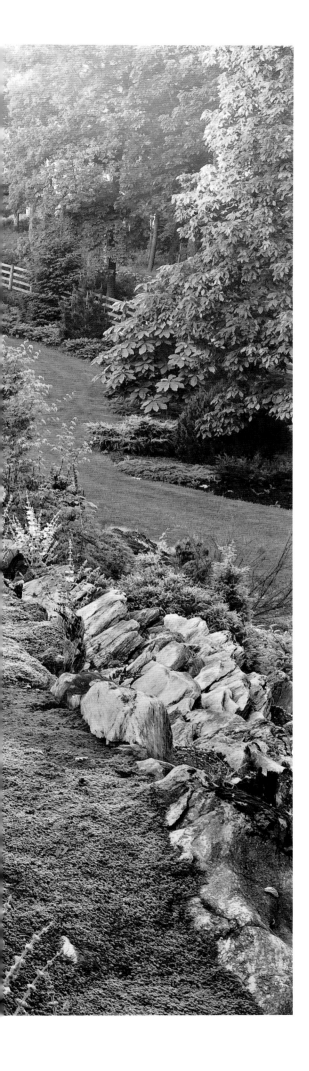

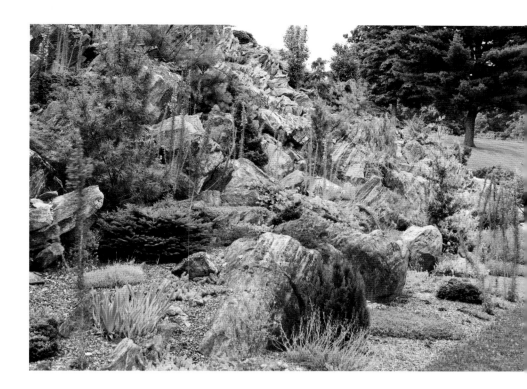

The most dramatic part of the Hoopers' garden is a huge rock ledge that can be seen rising out of the ground as one approaches the house. It is named Liz's Ledge after Liz Toffee, who spent thirteen years uncovering the rock and planting peat moss in its many crevices. "Again I was lucky," says Madeline, "as she wanted me to work with her." Liz's Ledge is actually two connected ledges and far too big to be considered a classic rock garden. It's a steep hike to the top, but once there the perspective is astonishing. To provide structure and to soften what resembles a flat moonscape, Madeline and Liz have planted Russian olive trees and filled in some of the ledges with *Yucca filamentosa*, snow-in-summer, verbascum, and dianthus.

The Hoopers are quick to say that what makes their garden special are the people who have worked on it Tragically, their long-time gardener was killed in a car accident, and they are now at work creating a garden in her memory. This consists of a gently winding woodland walk that ascends a steep hill behind the vegetable garden and goes past a nuttery before arriving at its final destination—a small classical-style building that is, in fact, a fanciful outhouse purchased at an exhibition held at the Berkshire Botanical Garden. Through the arched window of this delightful folly there is a` superb view of the garden, lake, and fields beyond.

Both of the Hoopers insist that this will be their final garden creation. However, listening to them talk and hearing Madeline remark how much she loves beginnings, it's hard to believe that this pair of insatiable gardeners will ever stop extending the parameters of their vibrant and ambitious garden.

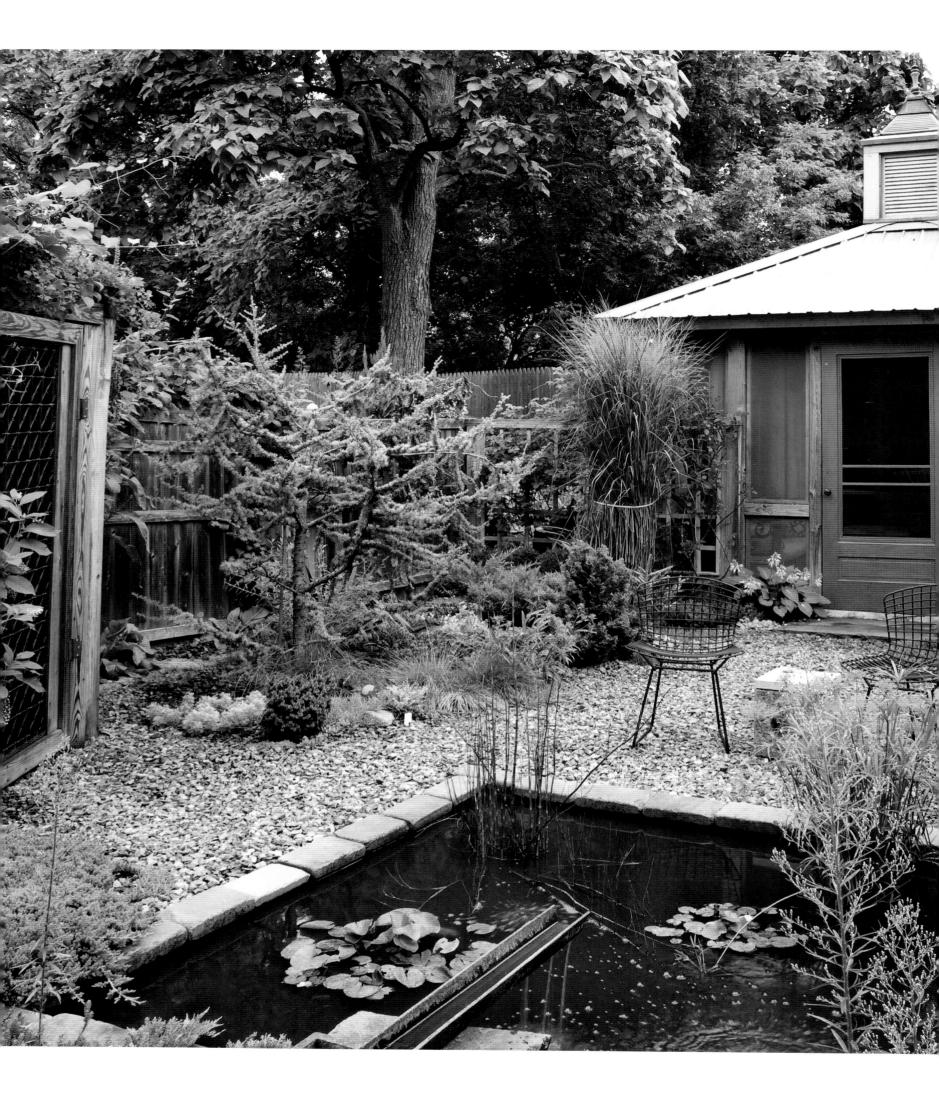

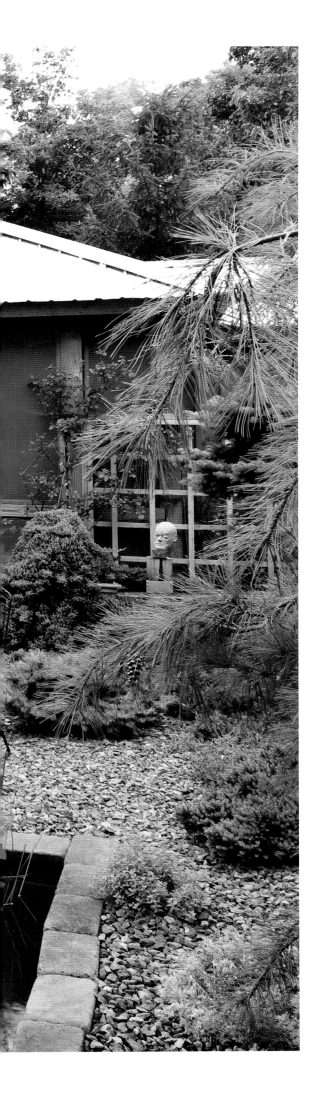

Hidden Charms

There is something infinitely mysterious about a back garden, what Mirabel Osler, an English garden writer, refers to as "a curious quality that lulls you into feeling secluded." She could have been writing about Richard Eagan's garden in Hudson.

Creating the illusion of space within the confines of an in-town garden is a challenging proposition, but it doesn't seem to have caused Eagan any problems. Having gardened for many years on the North Shore of Long Island before moving to Hudson a few years ago, he searched for a house with the biggest backyard he could find. What he got was, in his own words, "a big long dreary space" with nothing much in it but a huge tulip tree, part of an old grape trellis, and a straight stone-paved path that led to a dilapidated carriage house. Making the existing path his site line, he filled in the space with trees, shrubs, high perennials, lots of boxwood, and even yucca, dug up from the local cemetery. The carriage house had to be torn down, and Eagan decided to turn the space into an enclosed interior gravel garden. He was away the day that the gravel, twenty-two tons of it, was delivered by mistake to his neighbor's garden next door. "That was painful," he admits; the horror of moving the gravel, wheelbarrow load by wheelbarrow load, into his garden still vivid.

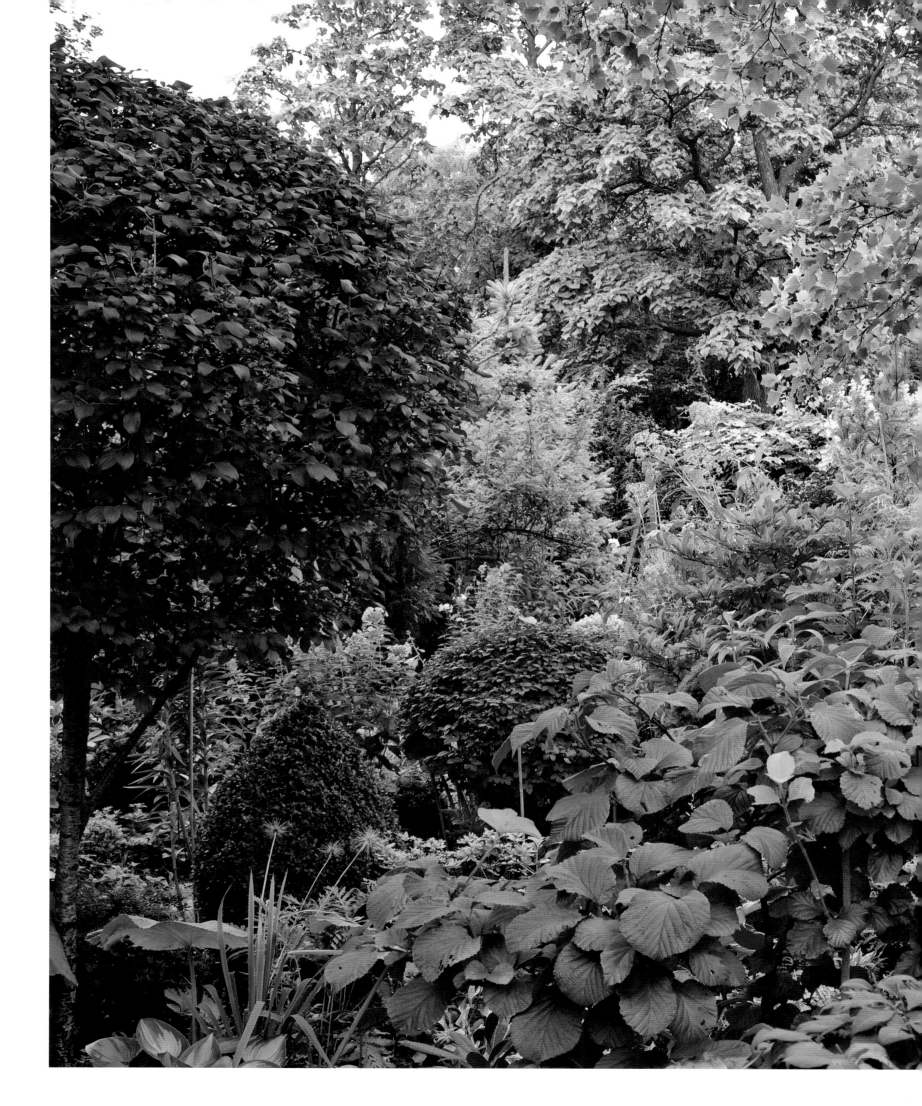

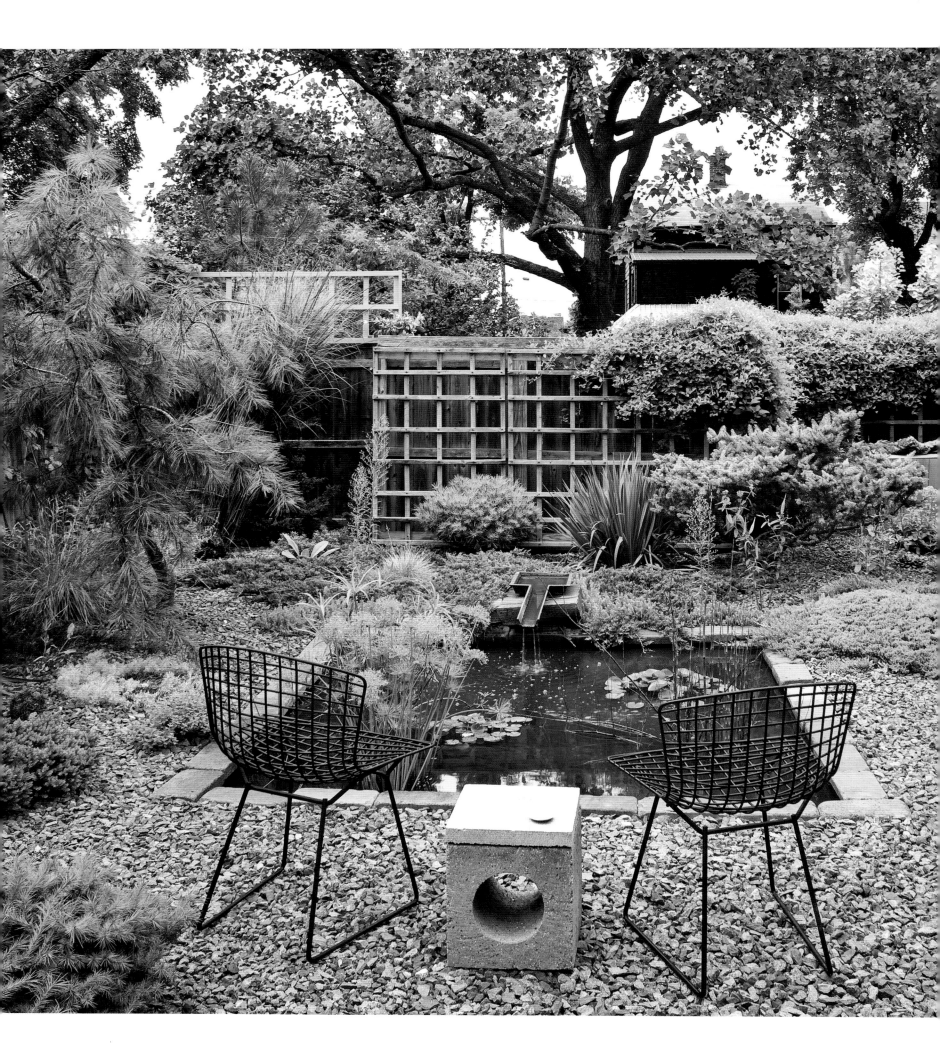

Originally, Eagan's intention had been to have nothing but a pond for fish and frogs and one or two silver blue pines in this interior garden. However, he was soon bored by this restraint and began to add more plants. The garden is so well protected that it turns out to have a microclimate of sorts, and an ice juniper, not supposed to survive in this part of the world, thrives happily. The entrance is through an arbor, where silver thorn, clematis, climbing grapes, and kiwi all fight for their place in the sun.

Eagan thinks of his garden as a plant lab. "Higgledy-piggledy" is his much too modest description of the verdurous density he has created. There's a sense of untrammeled wilderness about this unconventional urban garden. There is no grass, no hard edges, and its paths are so narrow that visitors must walk in single file with any conversation taking place over their shoulders. Different in every season, this garden is all about looking through, looking over, looking under, and all the other ways of looking. In spring there is a mass of alliums and daffodils, and by late summer, it is a jungle with thistles, verbascum, and milkweed, one of Eagan's favorite plants because, "it only grows where it wants and I love that it breaks up my notion of what a garden should be." He also loves pokeweed, a plant he likes to bonsai. "The birds love it and so do I as it brings me a bumper crop of Monarch butterflies." By the end of December, Eagan is off traveling and his garden is left to survive on its own. But, once April comes, he returns with the spring thaw. "Now it's mostly about editing and I'm out there a lot with my coffee and Ikebana garden shears," he says with a note of real pleasure in his voice.

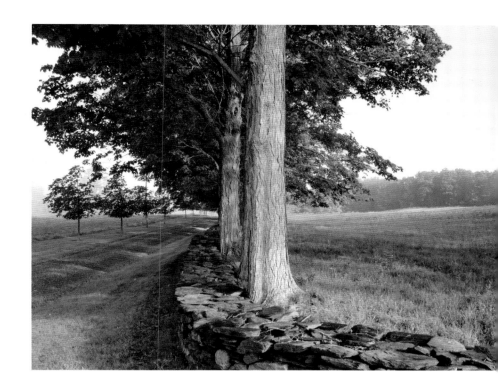

Subtly Understated

In 1980, Moisha Blechman and her husband, the illustrator and cartoonist R.O. Blechman, purchased a modest farmhouse on 125 acres of farmland in Ancram. From the start, Blechman's instinct was to make a garden that would reflect the spirit of her house and its wonderfully unspoilt terrain. Giving herself time to "feel out the land," she waited two years before asking the landscape designer Edwina von Gal, whose mother was a good friend and lived nearby, to give her some advice about how to create a long border down one side of the house. Once von Gal had selected a site, and the bed was dug, Blechman still has a vivid memory of her "pacing up and down and waving her hands like an orchestra conductor" as she worked out the exact placement of each perennial and shrub. Today, the border, a satisfying mixture of colors and textures, is the main feature of the garden around the house. Beyond it, there is a shade garden, enclosed by a low stone wall and planted with maidenhair and ostrich ferns, Solomon's seal, and hosta. There is also a vegetable garden.

These are the more formal features of Blechman's garden, but the magic of this property is the landscape itself, or what Blechman sees as a series of landscapes. Her everyday routine allows her to enjoy this larger garden, and determines her gardening priorities, be they pruning, clipping, making paths, planting, or mulching. One of her great pleasures is planting trees. She finds it impossible to plant only one of a species since she likes every tree to have an echo and this means planting another one in close proximity. Her rationale: "I want my eye to be taken from one to another. It feels more natural."

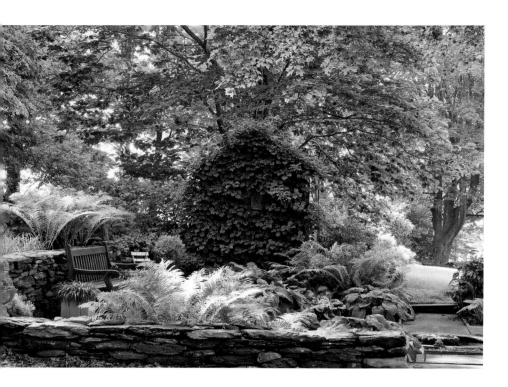

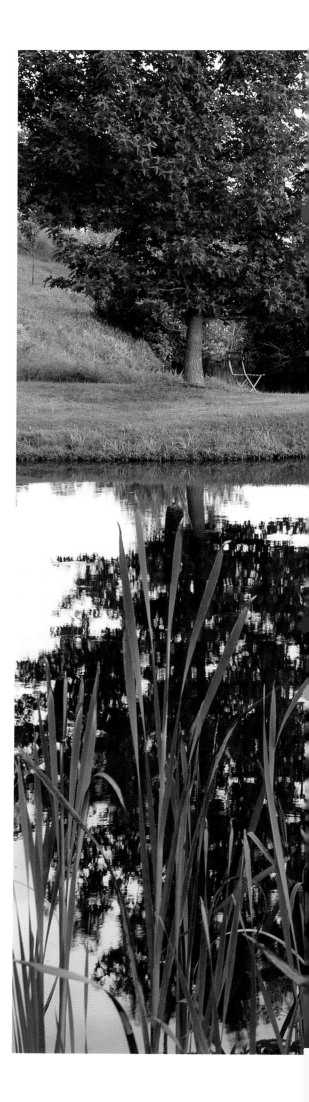

From May to October, each morning begins with a swim. There was a pond when the Blechmans purchased the land, but it was small and only four feet deep. The couple both love to swim and one of their first improvements was to dig out the pond and make it larger. Now sixteen-feet deep and fed by local springs, it never freezes. Blechman admits that on cold mornings, "I have to tell myself it's like swimming in the ocean in June." Part of her pleasure in swimming is that she is surrounded by Siberian spruces, sweet gum, sourwood, and poplar trees, and from the water, she has a different view of her meadowed farmland.

Breakfast is eaten on the terrace in front of the house, next to pots of creeping jenny and thyme. Looking past a maple tree there is a dramatic view across the meadow to the distant Taconic hills. Further in the distance at the very edge of the Blechmans' property there is a group of maples, oaks, and shade trees. Set on a hill that dips and rises, they give the illusion of being part of a graceful inverted arch.

Most days, the Blechmans like to walk. Their usual route takes them down the drive, which is bordered by a long line of red chestnut trees, and then up a hill, where they walk along a ridge overlooking a valley. Light and weather bring constant change to the view, which Blechman has greatly enhanced by removing truckloads of invasive Russian olive trees. Some afternoons, she walks through the woods at the back of the house and, sitting on a bench made of cedar branches, enjoys looking at the meadow flowers; or she may have tea in the shade garden. Everywhere there are splendid views. "Finally I think it's my trees which give me the most pleasure," she says.

Native Drama

Even as a teenager in high school, Duncan Brine knew he wanted to be a theater director. He moved to Los Angeles and, making his way up the ranks, became the art director for a television series. Then he met Julia Allard, now his wife and business partner. She was an artist and graphic designer living in Brooklyn, and her apartment had an empty backyard with nothing in it except for a few tomato bushes. Brine took one look at the space and decided he would make her a garden that he could film. "The art director in me was blown away by the possibility," he says. He had never made a garden and he planted it mostly with seeds, growing in concentric circles. Friends liked what they saw, started asking him for help, and soon the theater was forgotten and a new business got started.

Fast forward six years, and the Brines, now with clients both in and out of the city, decided to move to the country. "We wanted a bigger garden for ourselves and we were looking for somewhere within a two-hour radius of New York that we could afford," says Julia. In 1990, they found a 1920s house and a few acres of land in Pawling. The house, once part of a large dairy farm, sits on a long sliver of pasture-land. According to Duncan, it was "an awkward rectangle with some big trees and not much else," but he was not deterred and set out to make a naturalistic garden. "At the time," he explains, "we cared more about the look of a garden but over the years our style has slowly changed. We are now more environmentally conscious and our focus is about creating a natural landscape that takes its cues from the feel of the place." This means a strong commitment to native plants, but the Brines are not rigid purists. If they like a plant, it goes into the mix.

Nothing, in fact, is rigid about their garden. Loosely fenced-in, everything about it is intentionally curved. An intricate network of winding paths meanders through *Callicarpas*, and low massed plantings of catmint, viburnums, lacy elderberries, and a huge *Yoshino cryptomeria*. There are oak leaf hydrangeas, stephanandra, specimen trees, and an oversized hedge of *Miscanthus giganteus* that extends the full length of the garden. Plants rise up at every twist of the gravel paths. "We were into gravel well before the celebrated English gardener Beth Chatto, but please don't tell her," Duncan remarks conspiratorially. "There's none of the tyranny of a traditional garden with small plants in front and large ones at the back," he explains. For him, landscape is a narrative with one shape or color influencing and leading to the next. He wants people to be enveloped in texture. "I want the experience of my garden to

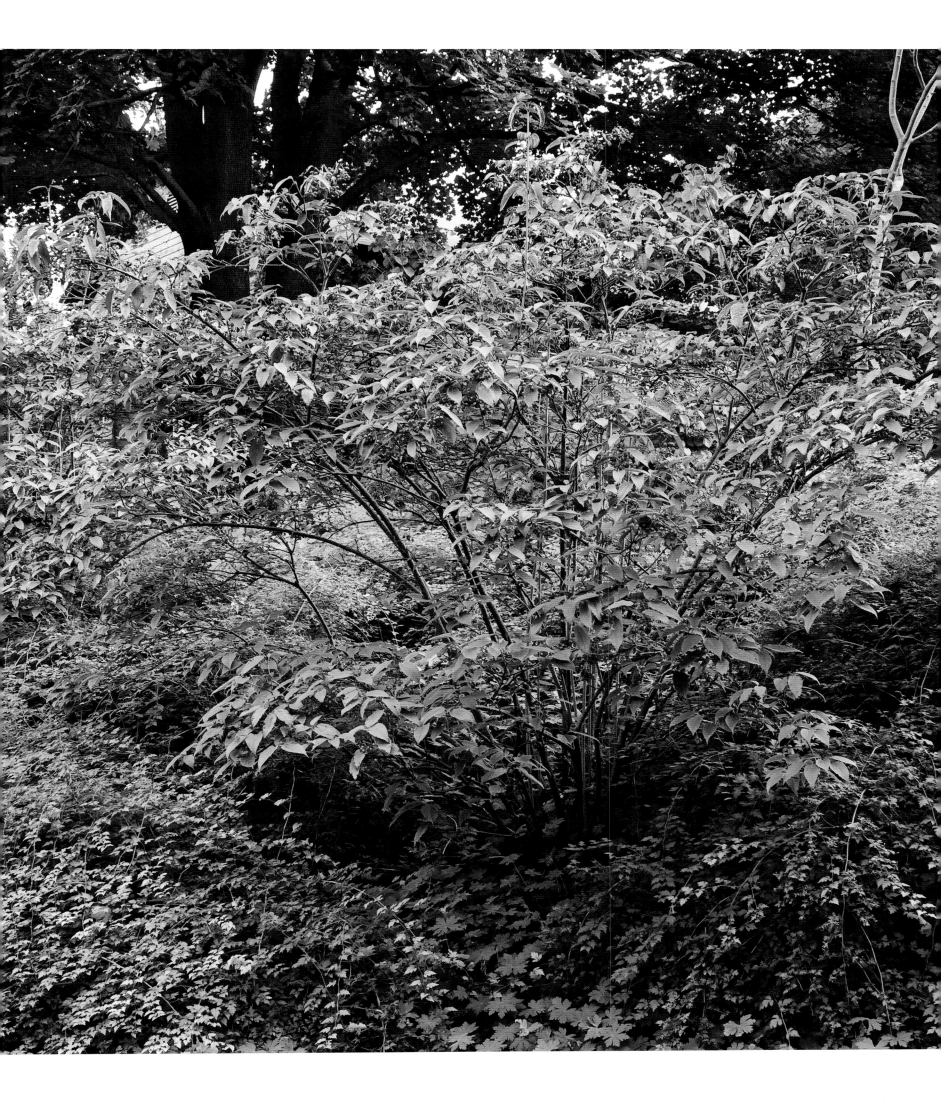

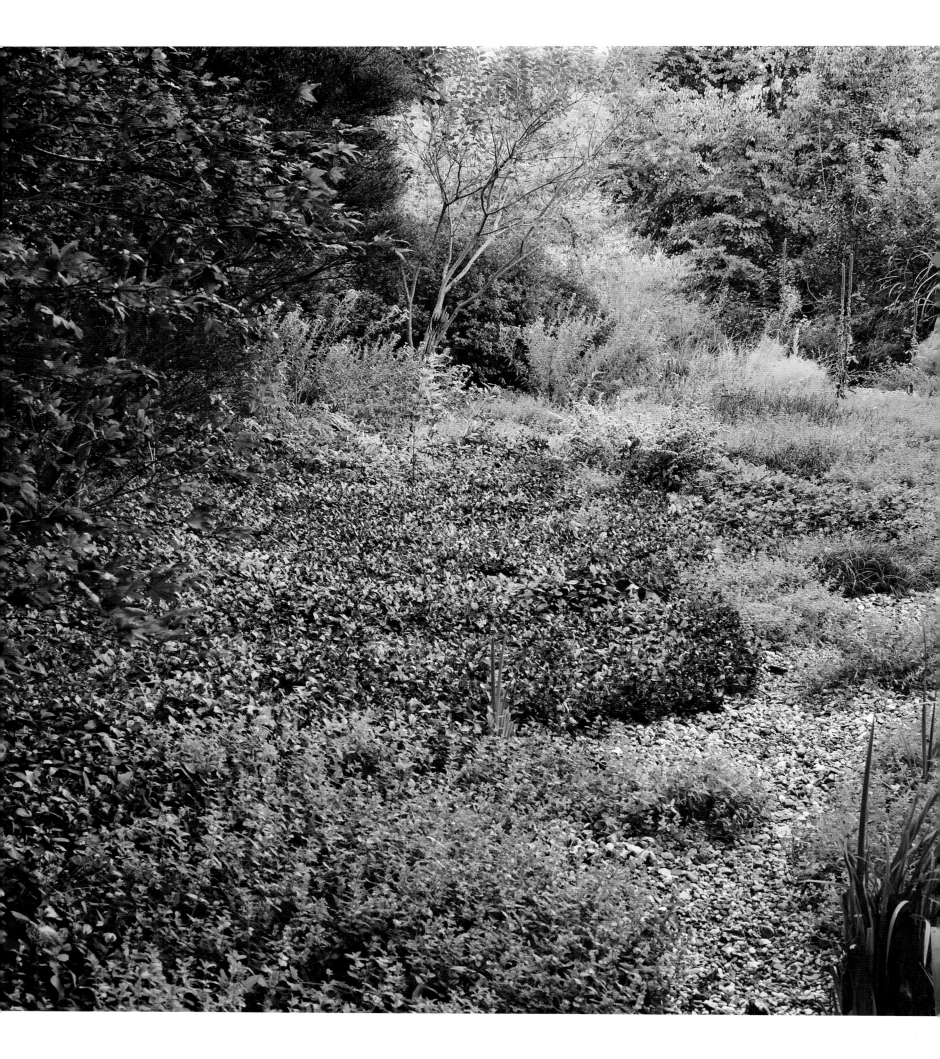

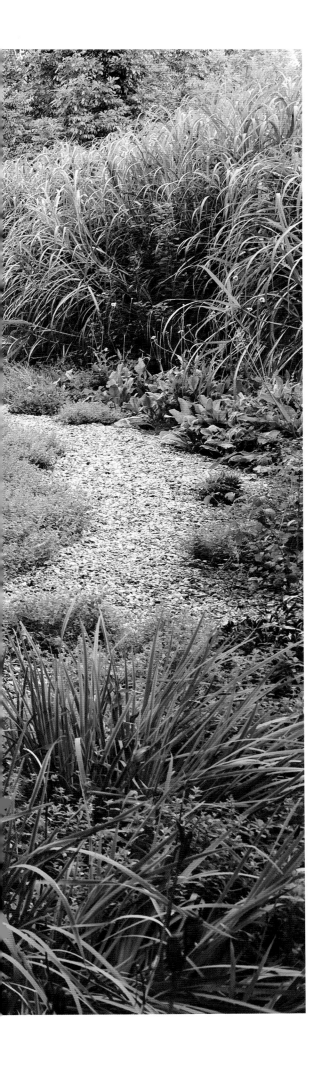

be like theater-in-the-round," he says. It's a curiously apt analogy for someone who came to gardening from the world of theater, and this idea takes hold as one moves deeper into this arsenal of plants and the level begins to drop and the terrain gets marshier, leading to what the Brines jokingly refer to as an allée of *Taxodium distichum*—not really an allée, only the fragment of one. It opens into a clearing with three weeping *Katsura* trees. At the end of the garden there is a fenced-in nursery area where the Brines grow plants for their landscape business. It has no roof or walls, and Duncan refers to it as his structureless greenhouse. In winter, the pots are laid on their side and covered with microform blankets. "Everything survives just fine," he says with pride.

A few years ago, the Brines were able to buy their neighbor's house, which has become their office, and to acquire considerably more land. The new part of their property drops steeply away from the other side of their house and is still a work in progress. They are making an intricate network of paths and a series of woodland groves, planting black locusts, more *Katsura* trees, oaks, a viburnum glade, and a ravishing group of river birches. At a first glance their transformation process might seem haphazard, but Duncan has a well-developed sense of drama and a sure-footed way of setting his stage. The scenery includes bridges crossing streams, benches for sitting, hidden rooms, a tiny island, and even a ravine. It is Act II in theatrical naturalism, with all the drama of Act III still to come!

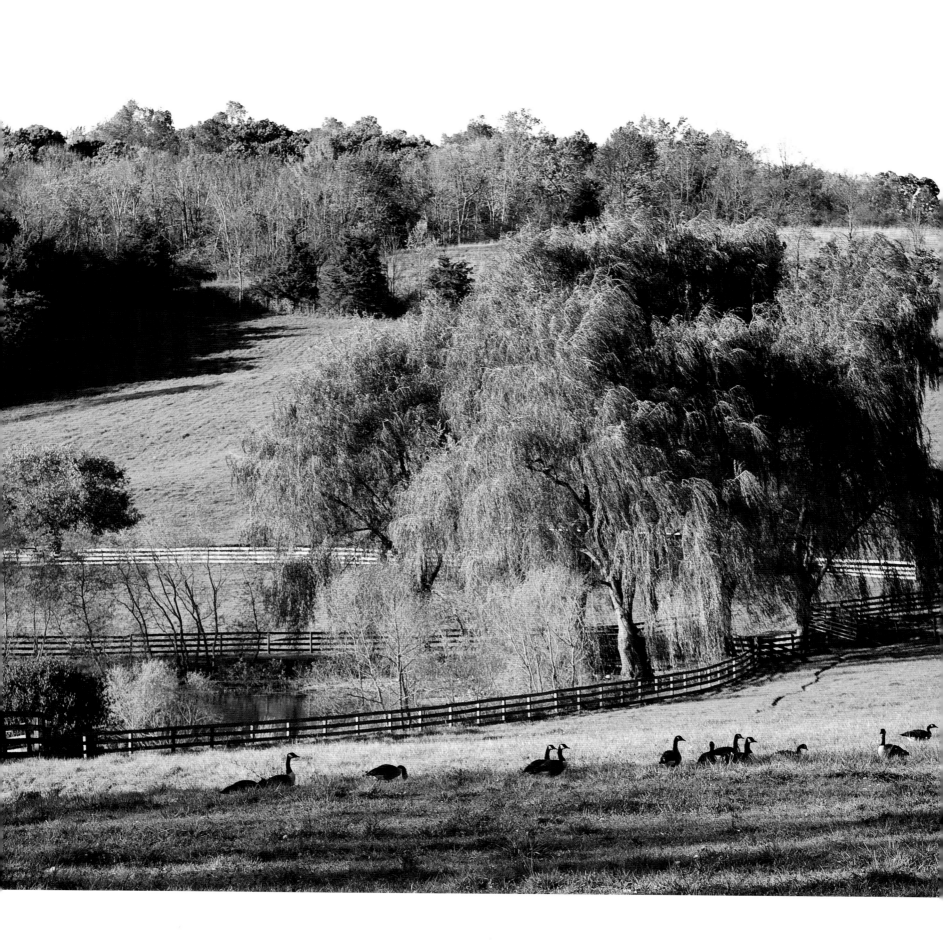

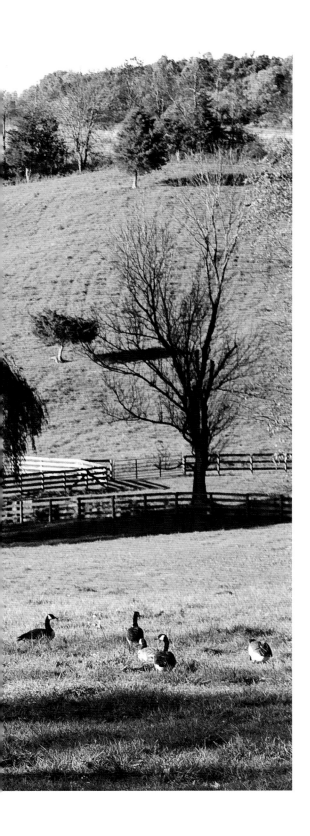

Transforming the Landscape

"I am not good at discipline," says Stephen Mazoh looking somewhat wistfully at his two large perennial borders. "I used to have all kinds of flowers here but the phlox, filipendula, and rudbeckia have pushed them out. It's all my fault as I've done nothing to stop it."

Perhaps he is not a disciplinarian, but Mazoh has an intuitive understanding of design, and the landscape he has created is unforgettable. When he purchased his house and 350 acres of land in 1974, he looked only in Dutchess County, his rationale being that anything further north was too far from New York and anything closer was too expensive. Although he had gardened since he was a child, Mazoh was intimidated by the size of the place, which had formerly been a large horse farm with its own racetrack. "I don't remember exactly when I got started but the first thing I did was to create the north perennial bed to hide the shed where we kept the farm machines. Then I did three beds near the house and three more to balance them," he recalls. "I asked Madison Cox to advise me, but he told me I didn't need any help, so I did the layout all myself."

Mazoh moved to the country full time in 1986. "The garden is essential to me because it satisfies my urge to tamper with the land and I don't think this is an urge that will ever leave me," he admits. Over the years, he has contoured the surrounding hills, planted many trees, including red leaf maple, oak, and magnolia, and created a succession of three linked ponds, all fed by one creek, from an existing pond near the house. He has also put in a large and quite formal kitchen garden, which he calls his vegetable patch. Having once seen a garden in East Hampton filled with hollyhocks, he planted some yellow ones that have self-seeded and multiplied to become the dominant floral feature of this garden. An English garden, where the owner grew her vegetables in straight lines, inspired him to plant his vegetables in the same fashion, and he has rows of sage, Swiss chard, dill, cilantro, arugula, *Nero di Toscana*, asparagus, Jerusalem artichokes, Egyptian onions, and tomatoes. "Far too many of them," he says with resignation. Behind the kitchen garden, he made an apple orchard and further off is a swimming pool, its interior originally painted by his friend David Hockney, but replaced.

A long winding drive, bordered by magnificent willow trees originally planted to prevent the gravel from the old racetrack blowing into the swimming pool, leads

to the property. It twists and curls with languid grace past farm buildings, skirting around the back of a large barn, now an artist's studio used by Mazoh's partner, Martin Kline, and ends in a simple courtyard in front of the main house.

Mazoh likes to complain about the state of his garden, is philosophical about saying goodbye to plants that don't work, and curiously modest about the ravishing landscape he has created. While the placement of the trees, the shape of the land, the flow of the ponds, and the winding of the drive look gloriously natural, they are, in fact, all invented by a man with impeccable taste.

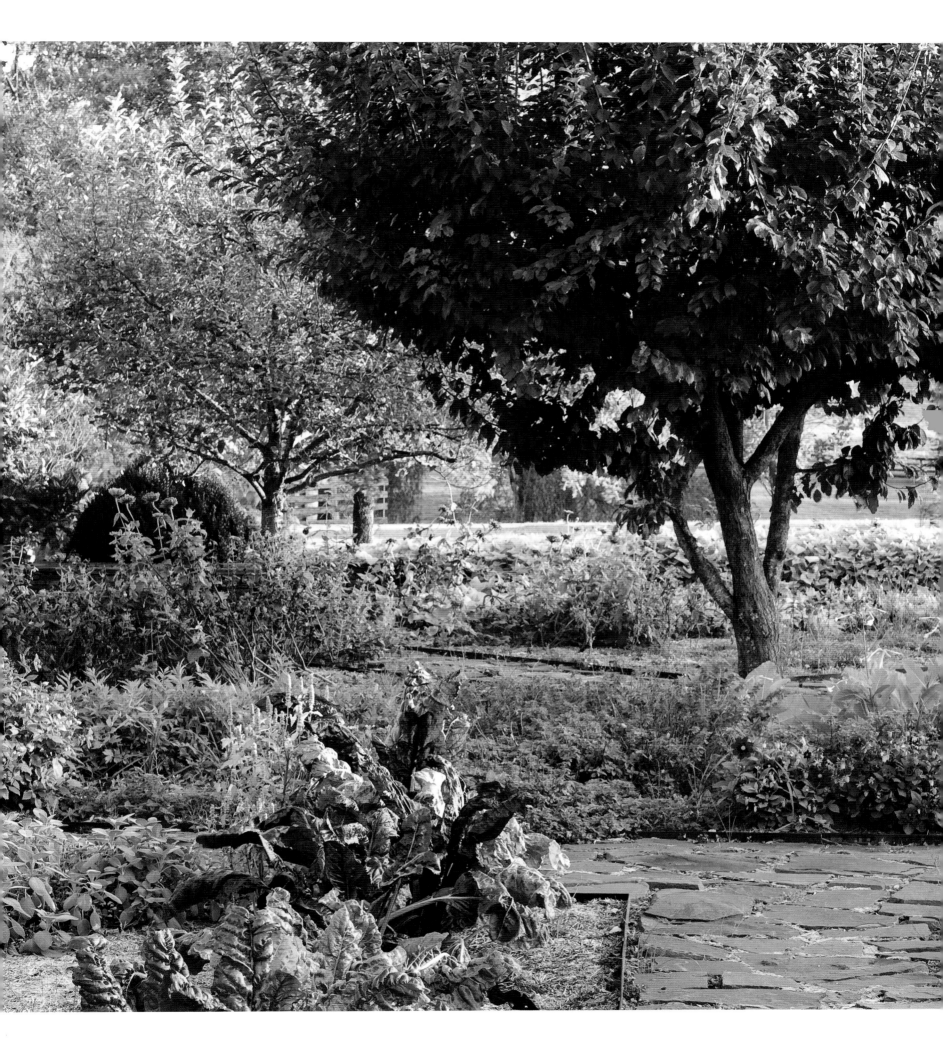

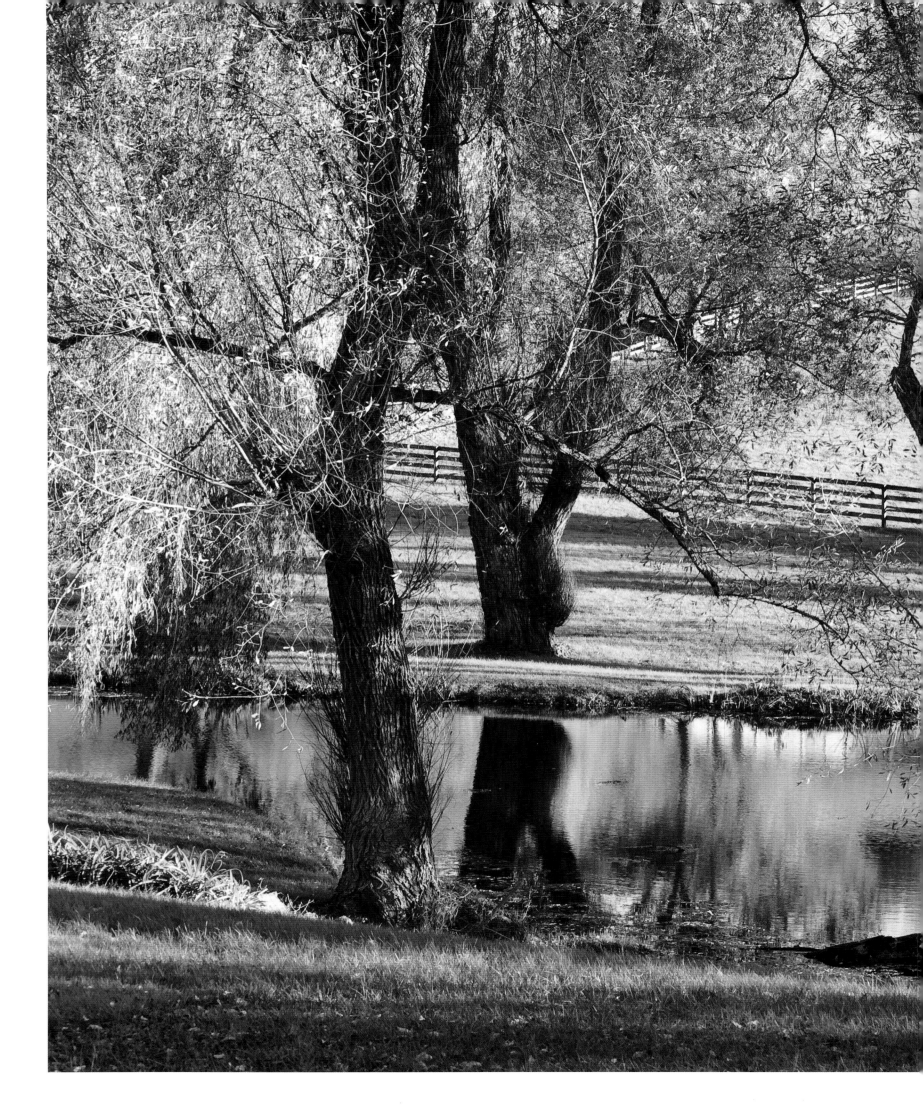

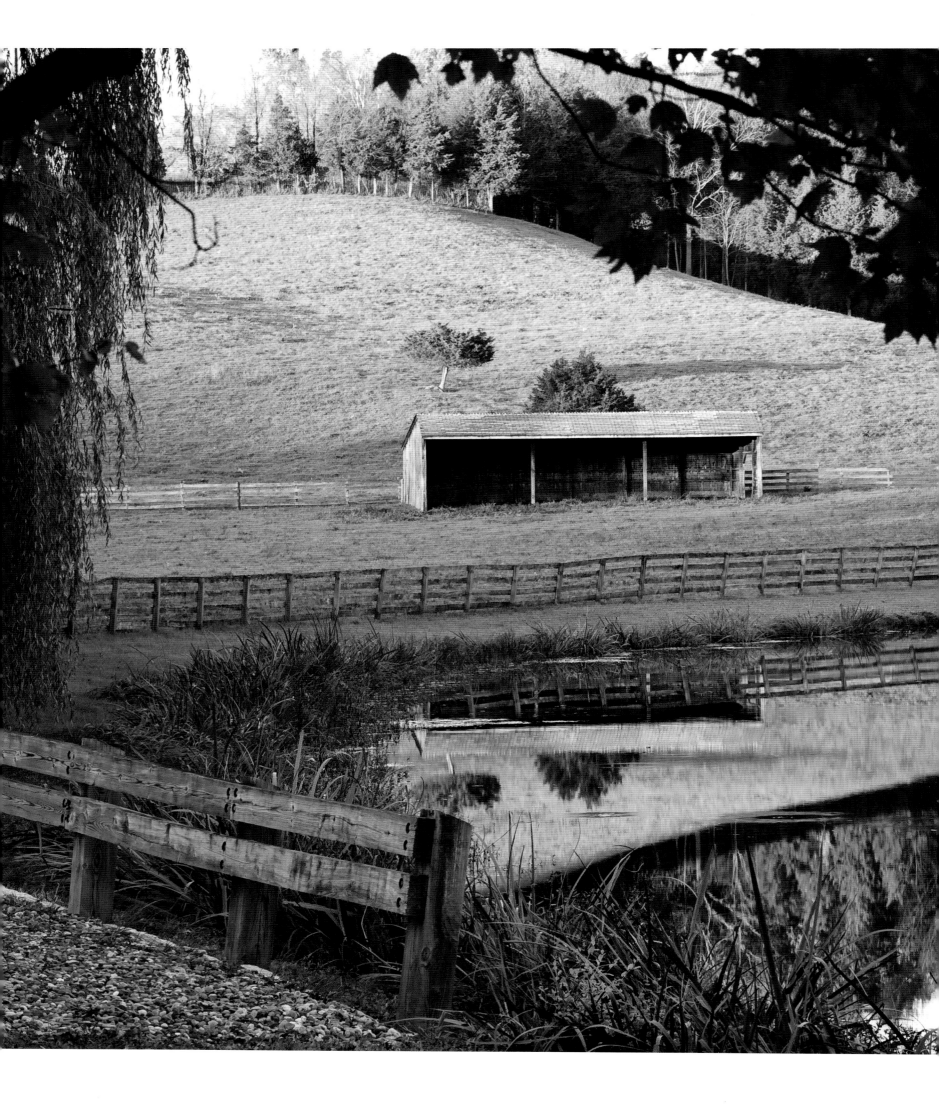

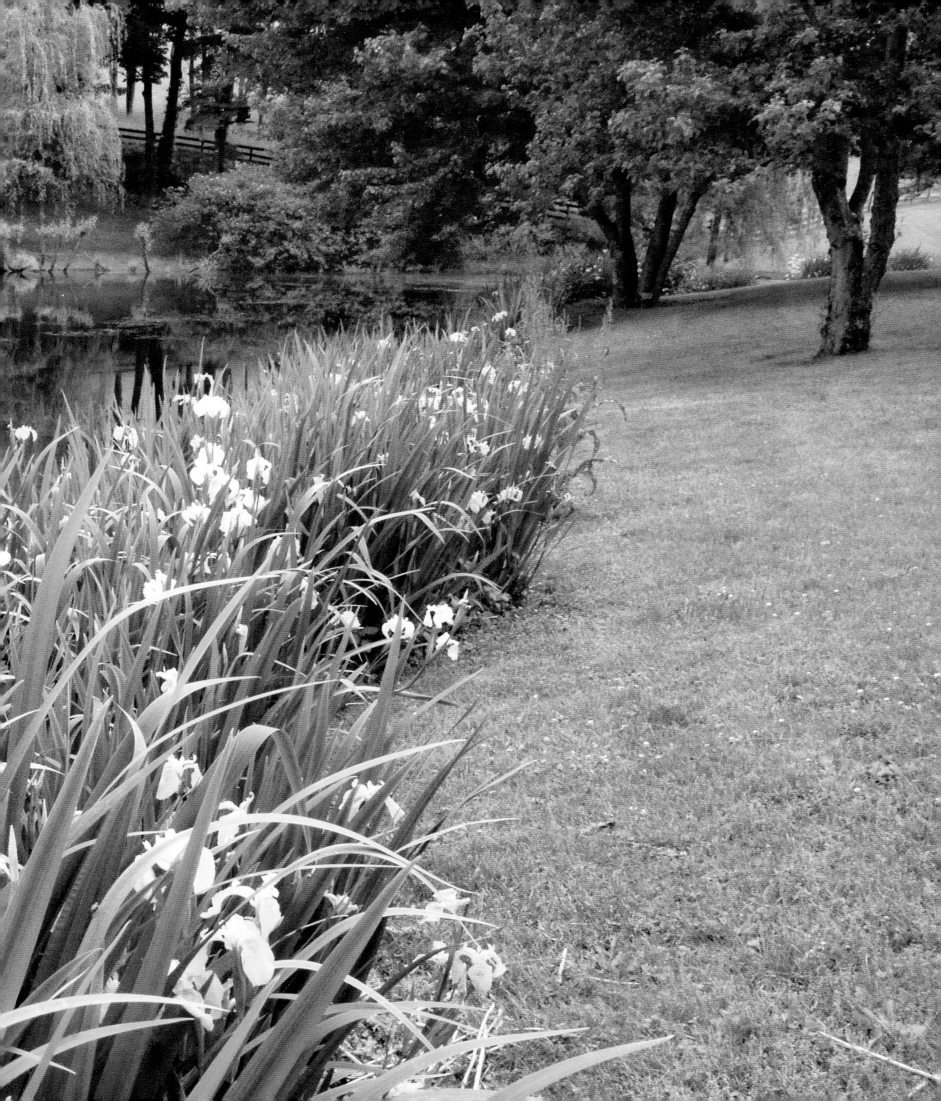

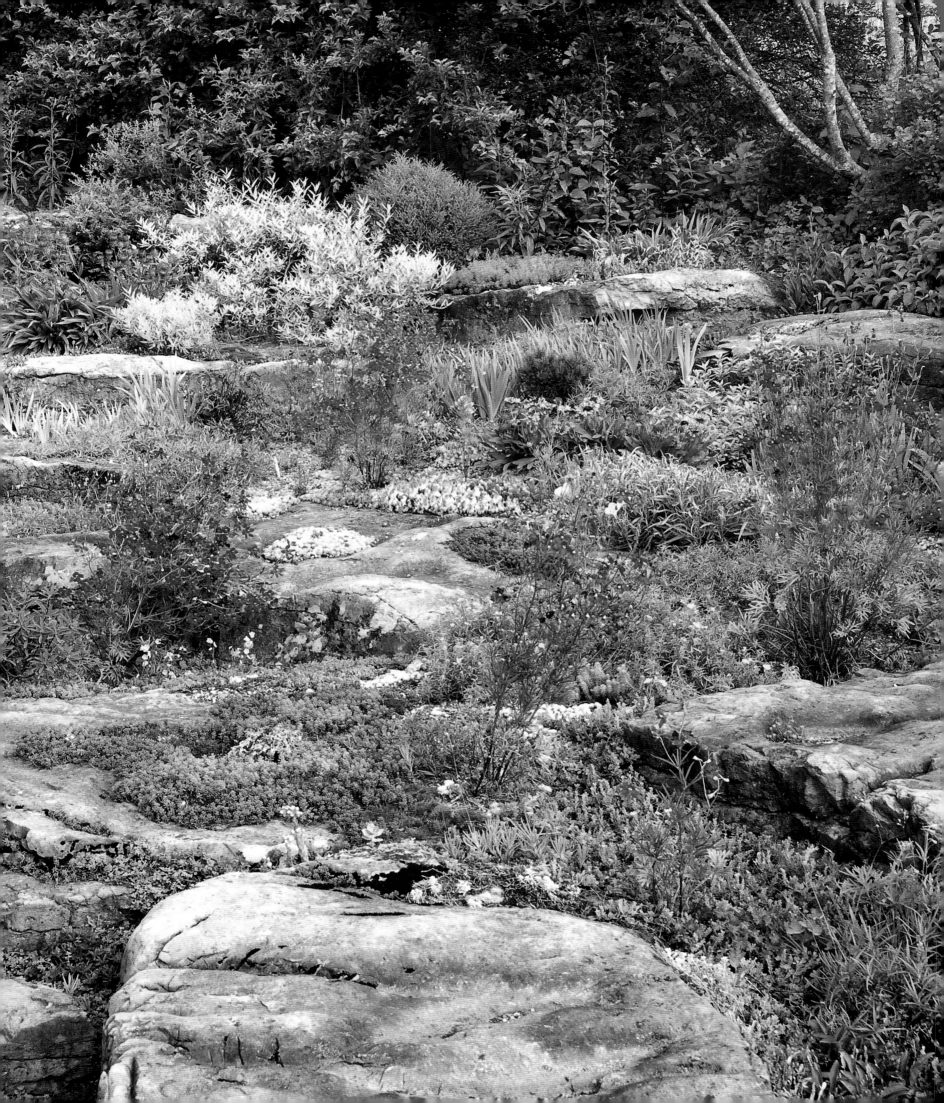

Style and Exuberance

"I have ideas all the time, but I know my limits," says Helen Bodian, whose garden exudes energy and imagination. Bodian and her husband, Roger Alcaly, bought a nineteenth-century farmhouse in 1985, to which they added a wing designed by architect Peter Gluck. At the time, Bodian had young children and, to begin with, she did little with the garden. But an interest in botany, dating back to college, led her to join the Rock Garden Society and she found she enjoyed reading their newsletter. "It seemed to give more advanced information than any garden magazine and I liked that it identified plants by their Latin names and made distinctions between species and varieties," she recalls. The newsletter piqued her interest in creating a rock garden around three large rocks that were close to the house. Wanting to buy stone, she found out about a bluestone quarry near Albany and enlisted the help of garden designers Wayne Winterrowd and Joe Eck to help her buy stone. Together, they went to the quarry, where they were asked how much stone they wanted. "Sixty tons," replied Eck without a moment's hesitation.

Eck and Winterrowd helped Bodian with the placement of the stones and with the initial layout and planting. The scale of the rock garden is massive as it runs the full length of the house; Bodian quickly realized that the rim plantings needed to be larger to be more in scale with the hills beyond. Also, finding the long horizontality a little tedious, she broke up the garden into compartments, allowing the shrubs at the rim to float down into the body of the garden. This enabled her to devise a more interesting planting scheme that placed wilder, bluer plants in the direction of the woods and more domesticated, pinker plants closer to the road. Gluck suggested that she follow the Japanese technique of repeating the same arrangement of colors and plants but on a different scale. This was helpful advice. "It was a design problem that needed to be solved, and I found I liked coming up with my own solutions," explains Bodian. Today, the rock garden, with Bodian's new planting scheme, is a rich tapestry of creeping thyme, euphorbia, many different sedums, miniature delphiniums, *Calochortus*, dianthus, gentium, dwarf iris, creeping veronica, penstemon, campanula, and globularia.

When Bodian started working on her rock garden in 1995, she was panicked by its size. Fearful that she wouldn't be able to handle it on her own, she hired Betty Grindrod to be her gardener. Ironically, Bodian then discovered that taking care

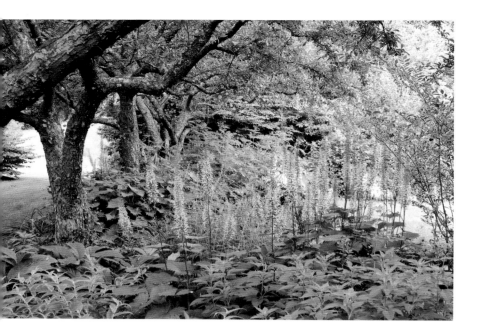

of the rock garden was not a problem. The rest of the garden, which is considerable, came about as a way to put Grindrod's time and energy to use.

Bodian had already planted a long row of hornbeams to hide a tennis court, and they became the backdrop for a large square perennial garden, made up of four beds, each one planted around a crab apple tree. Not wanting the garden to look too formal, Bodian and Grindrod have mixed in a lot of grasses and Joe Pye weed among the perennials and shrubs. Sun-loving plants include phlox, daylilies, delphiniums, poppies, species and hybrid peonies, cimicifuga, coneflowers, species roses, asters, pimpinella, and stachys. Shadier parts of the beds are filled with angelica, *Kirengeshoma palmata*, toad lilies, astilbe, aconites, thalictrum, tradescantia, heuchera, ligularia, and epimedium.

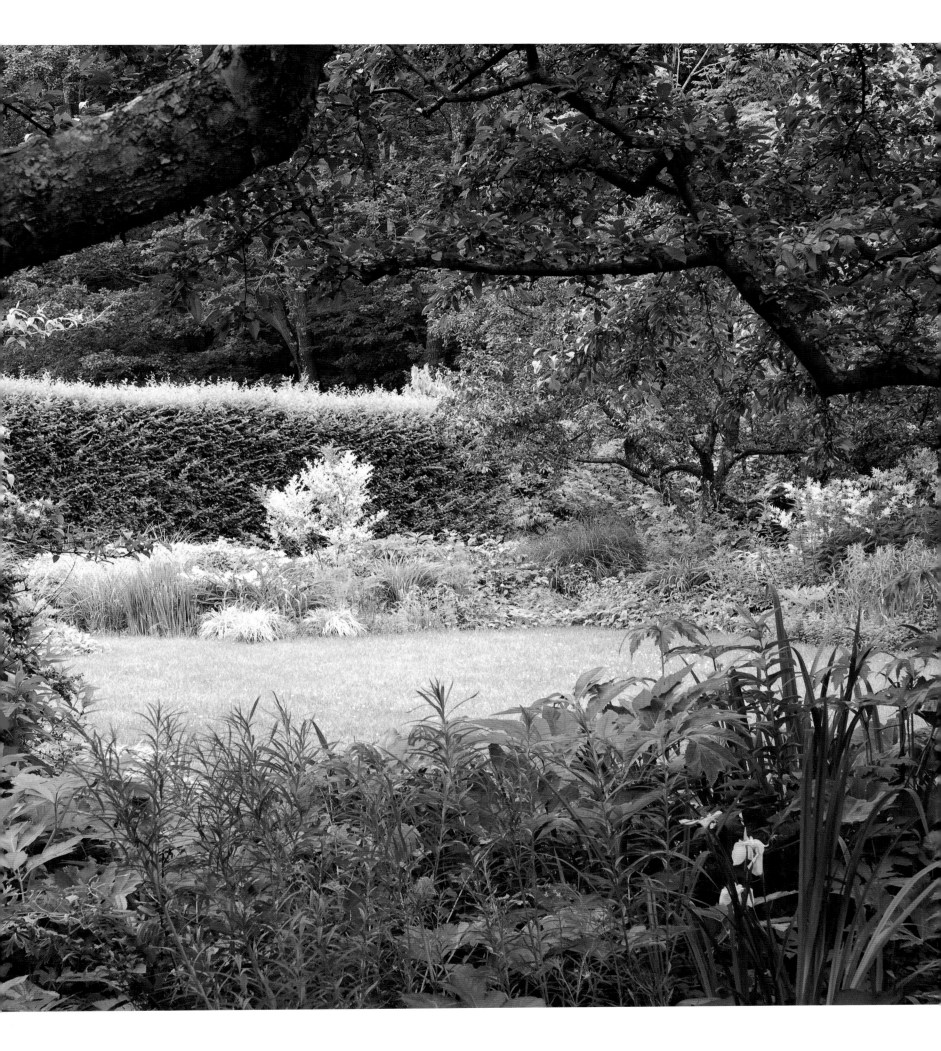

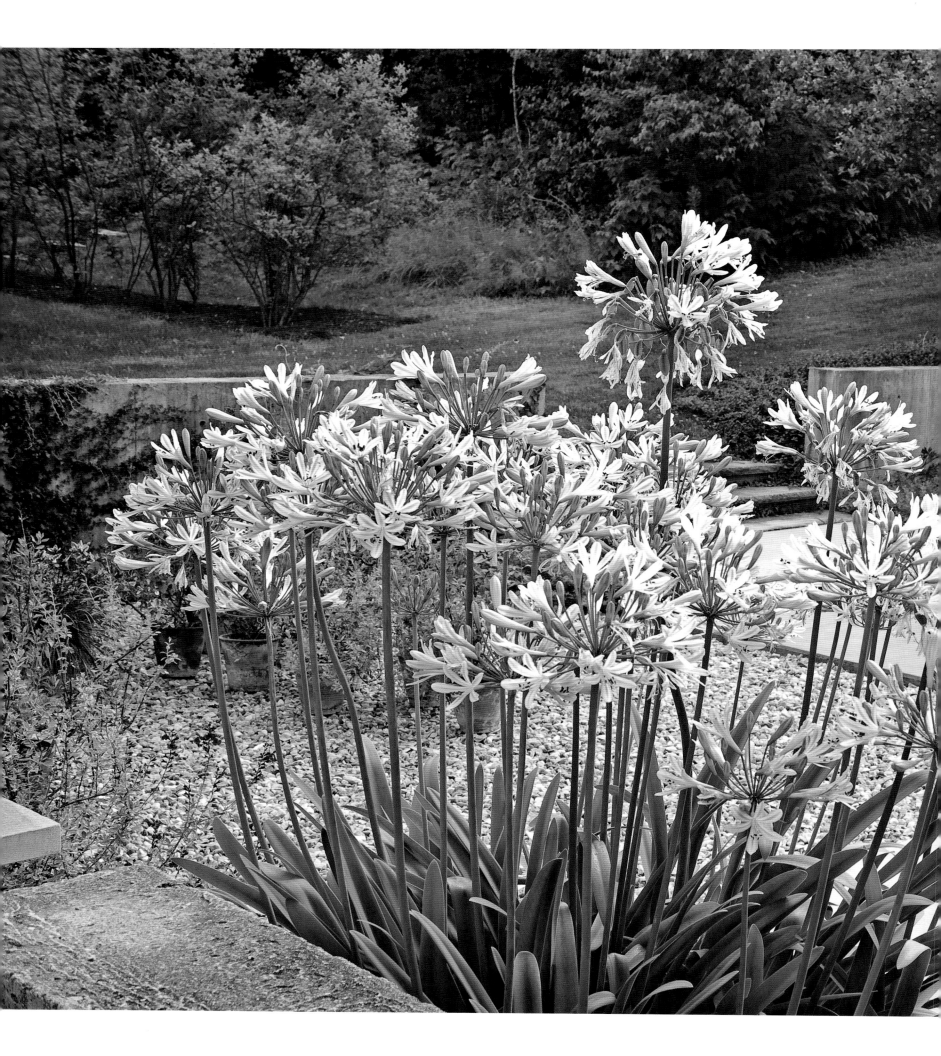

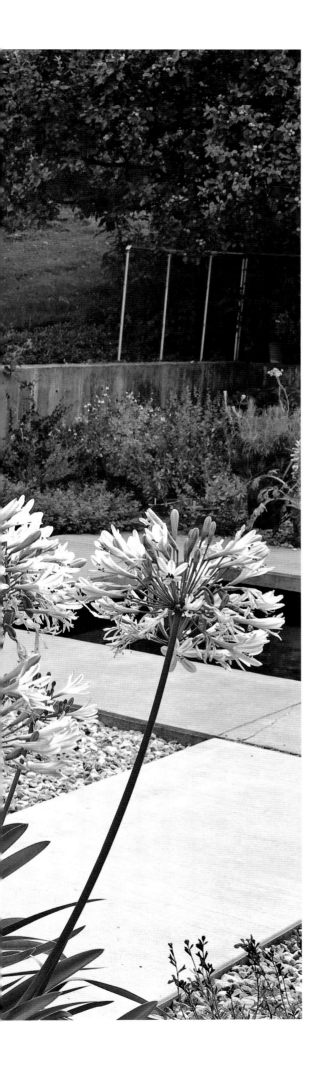

In 1998, Bodian built a freestanding greenhouse, extending one side of its low concrete foundation wall to make space for an enclosed garden of hot tropical plants. Having been to Christopher Lloyd's garden, Great Dixter, she was impressed at how he was able to create an entirely new visual experience by planting a combination of dahlias, cannas, and other colorful plants in place of his former rose garden. This led Bodian to choose an intense color scheme, designed to provide a complete contrast to the pastel hues of her perennial garden. However, replanting her walled garden each year proved so labor-intensive that three years ago Bodian replaced her tropicals with a simple pool garden, surrounded by gravel, that has a strong modern aesthetic. A dwarf version of Boston ivy climbs up the low concrete walls and a large collection of salvia, in simple clay pots, is lined up in a row on top.

In 1999, acceding to her husband's long-expressed wish for a vegetable garden, Bodian made this her next project. The garden is close to the house and reached by a mown grass path. It is enclosed by saplings of uneven length, placed closely together against a wire fence. "It's an idea I got from traveling in Asia," she explains, "but the saplings don't last that long, and I am now having to replace them with vertical wooden posts." This garden is home to amaranthus, cleome, nicotiana, and verbena, all of them vigorous self-seeders. There are bushes of variegated salvia with scarlet flowers, sweet potato vines, cabbages, peppers, asparagus, beets, carrots, tomatoes, and whatever else catches her fancy when she checks out seed catalogues in the depths of winter.

Now that she is a full-time photographer, Bodian spends less time in her garden, although she continues to take care of the rock garden. What she has not done, however, is cut back on time spent thinking and planning, and this marvelously rich and varied garden mirrors perfectly her taste and sensibility.

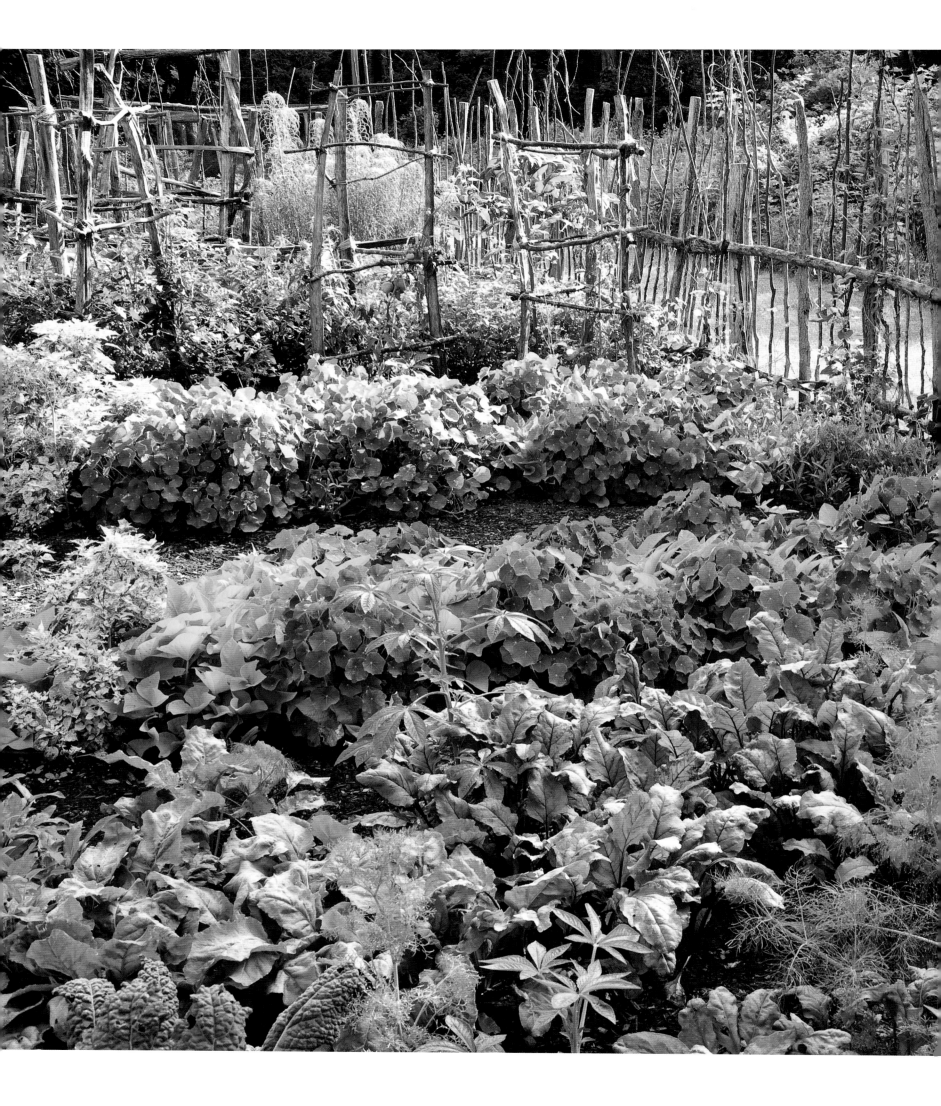

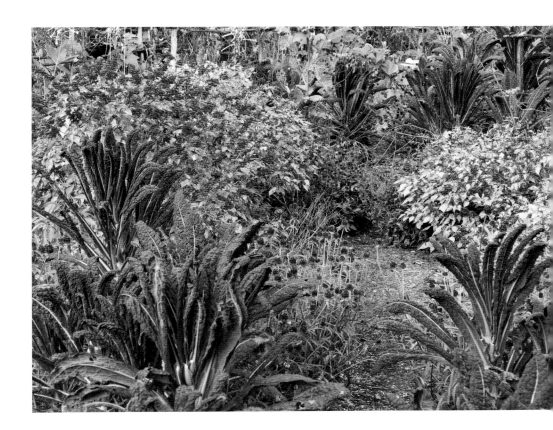

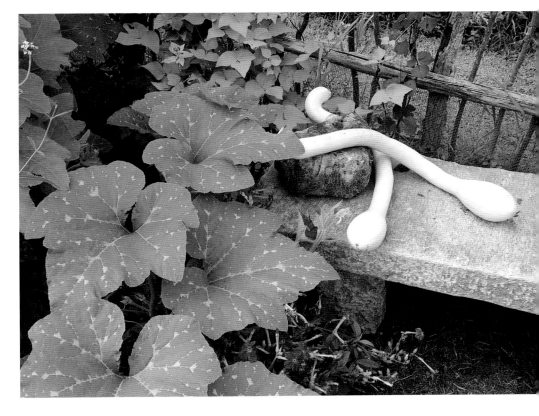

Masterfully Modern

Creating a garden around an imposing, very modern geometric house is not an easy assignment. If the house sits on a flat ridge on top of a very steep hill and has a glorious view of the surrounding countryside, it is even more of a challenge. The problem is not only to design a garden to soften the severity and scale of the architecture but also to effect a successful transition between the garden and the natural landscape.

In 1999, Steve Trevor and his wife, Ronnie Planalp, bought two hundred acres of steeply wooded land with no expectation that it would have much of a view. To their amazement and delight, once the woods were cleared, they found that they had a 360-degree view of fields and woods that stretched to the Shawangunk Ridge of the Catskills. After talking to several architects, the Trevors chose Thomas Phifer to design their house. The couple was living in London while the house was being built, and when the first phase was finished in 2001, Trevor recalls, "It felt like we had climbed Mount Everest. Everyone was short of breath and we decided to take a break."

The land had been severely compromised during construction; the vegetation was stripped and the top soil was gone. To make things worse, a freak winter storm took down two hundred trees, leaving the hillside looking even more bare and denuded. A solar irrigation system was installed that allows water to be brought 1,200 feet uphill without using electricity, and the landscape firm Oehme van Sweden was asked to come up with a master plan for the garden. They did much of the initial work, which included installing two formal allées of linden and plane trees, both sited close to the house, designing and planting a trellis garden and a rose border, and mass plantings of perennials and grasses along the drive and in the meadow.

In 2006, Trevor decided the garden needed a fresh eye and a change of direction. He asked Peter Meyer, a landscape architect who had worked with Dan Kiley, to come up with a plan to soften the area around the house, connect the separate parts of the garden, and better integrate them with the larger landscape. Meyer knew that the land needed more time to heal, and he began to plant trees immediately, putting in a hawthorn grove to the left of the drive and a orchard of crab apples on a bare slope leading to the tennis court. At the far end of the house, where the land juts out

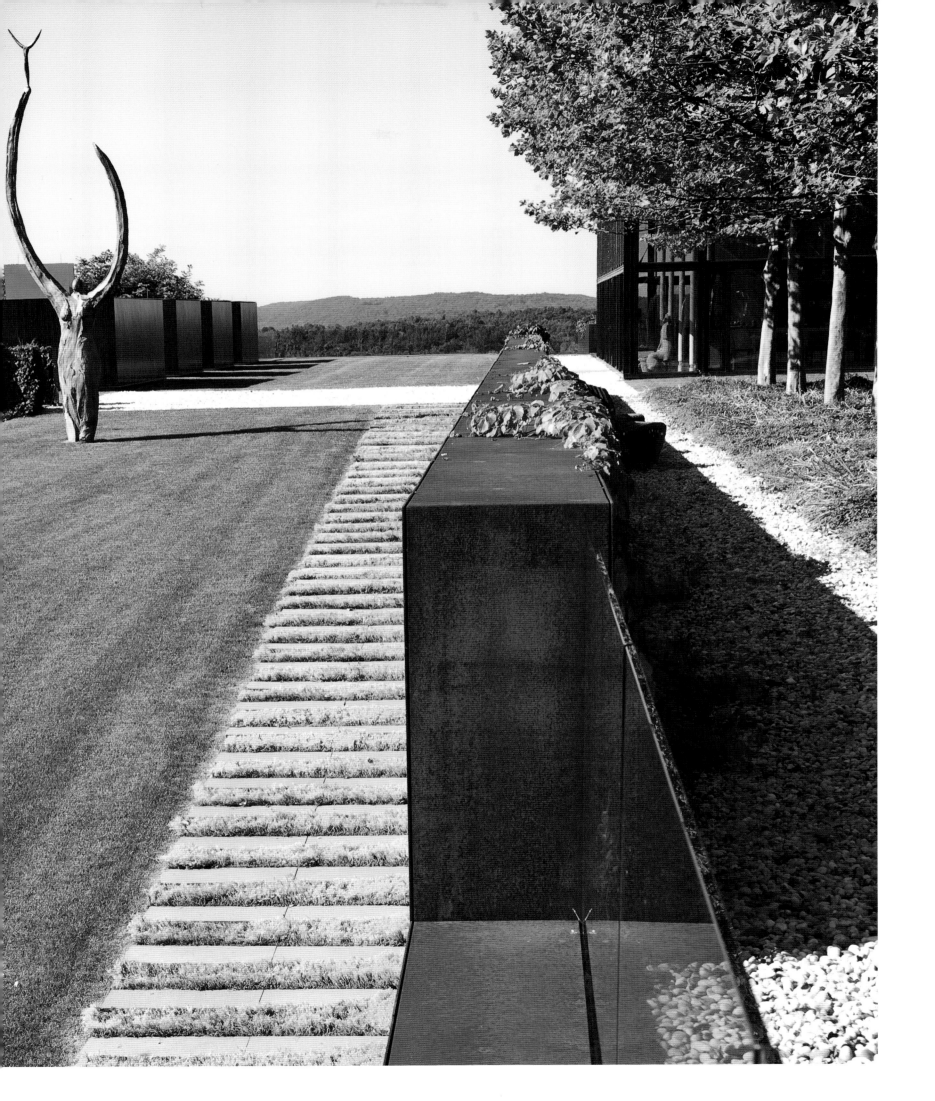

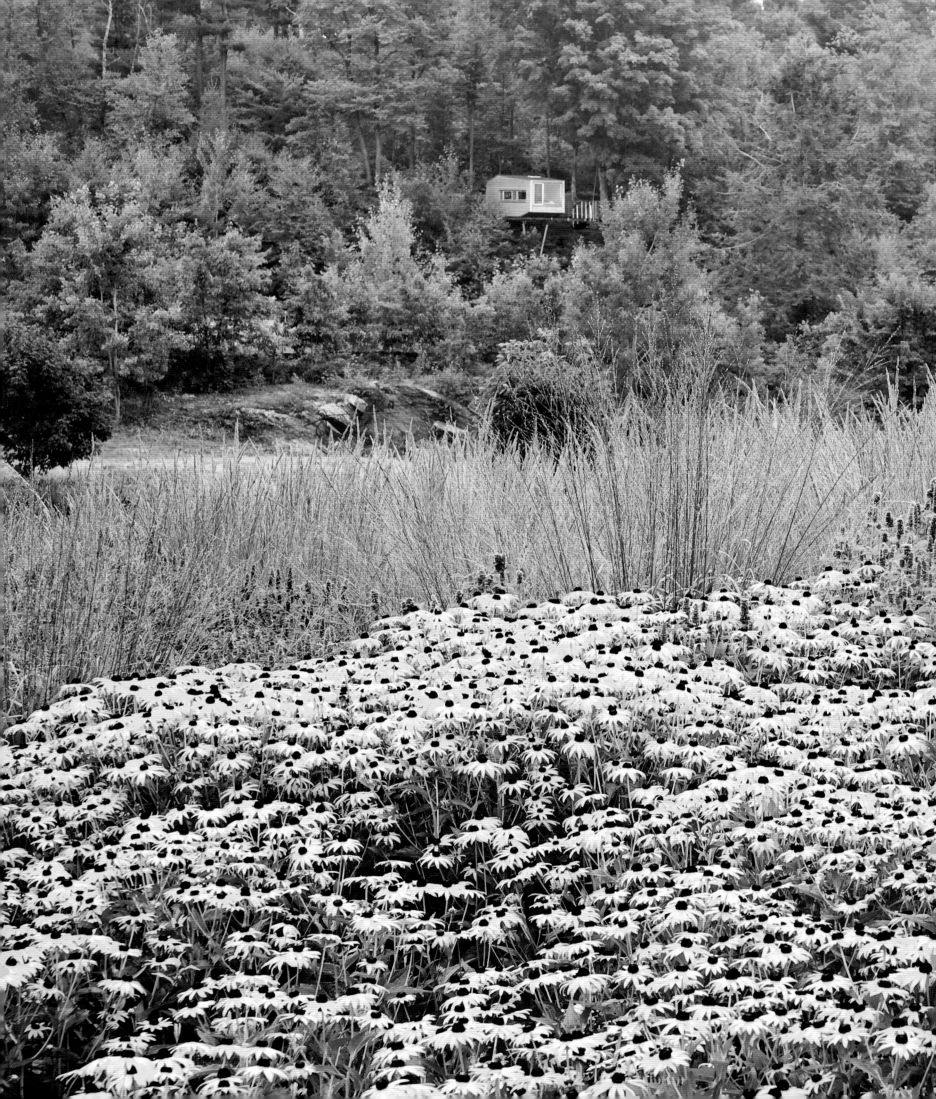

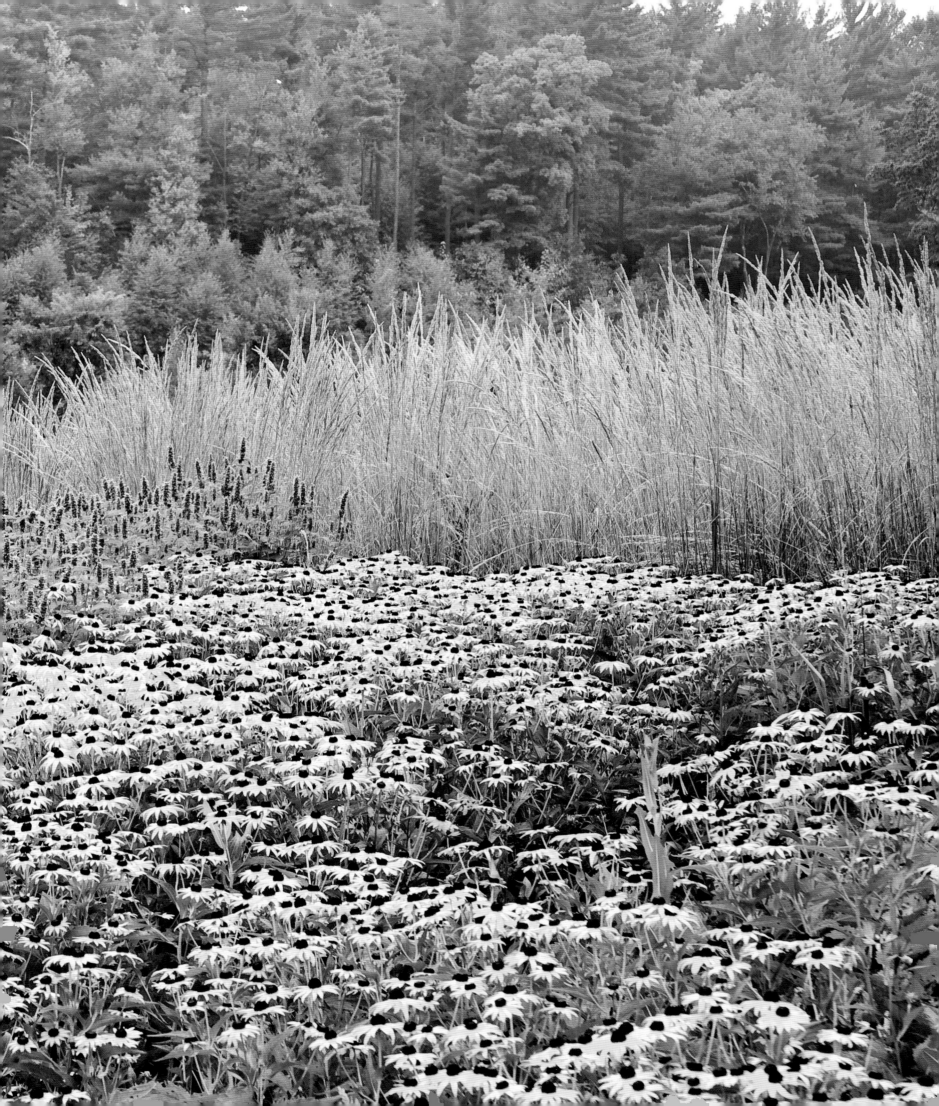

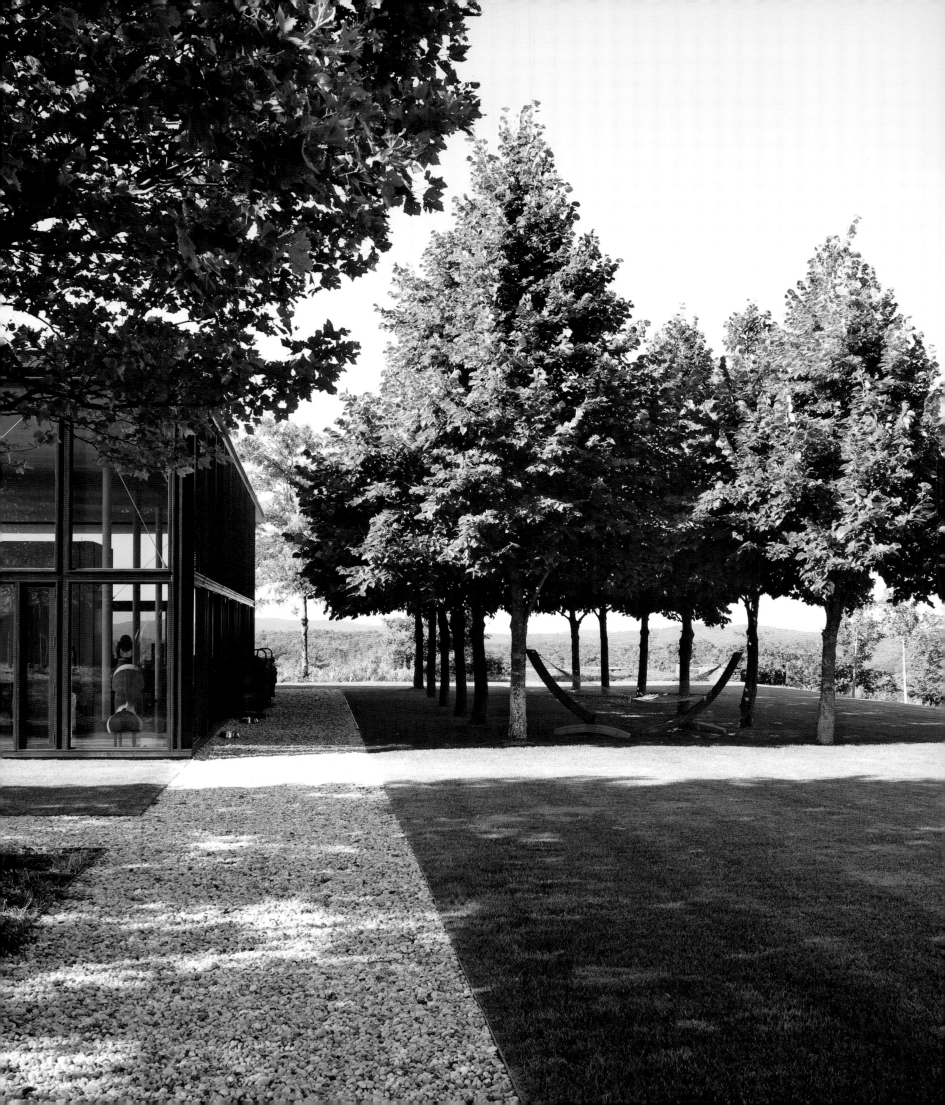

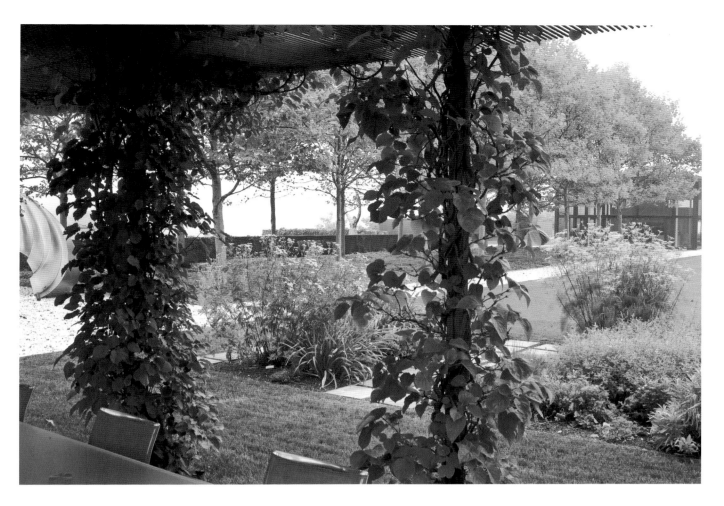

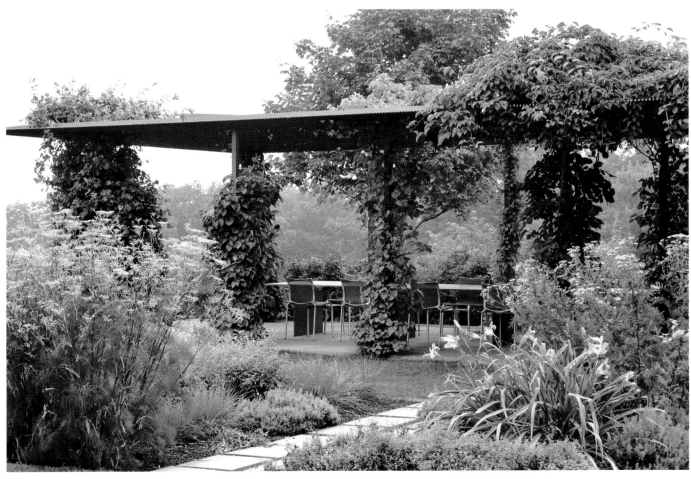

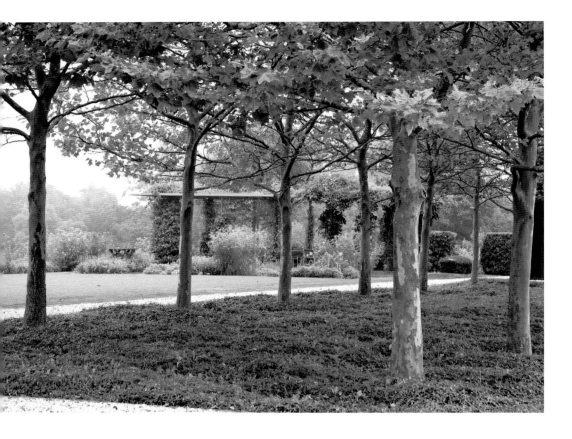

over the hillside like the prow of a ship, he designed an open circular fireplace with stone benches underplanted with cotoneaster. Overlooking it and closer to the house is a terraced garden, blanketed with euonymus and planted with bulbs and annuals for seasonal interest. There was a row of four bedroom cubes along the east side of the house, looking out to a long bed of roses. Each had its own terrace, but not much privacy. Meyer has framed these spaces with large stands of bamboo underplanted with echinacea and plumbago to create a miniature garden for each room.

The stone walls on the property have been rebuilt to delineate more clearly the boundary between the cultivated land and the wilderness of the hills beyond. They also serve as guideposts for walks around the property. A new pond, stocked with bass and trout, has become an important focal point in the landscape, and large numbers of lilac trees have been planted nearby. Trevor likes to be able to pick things to eat from the garden, and Meyer has planted nut trees and fig trees on the property. A bank behind the swimming pool is planted with rugosa roses and gooseberries, currants, and raspberries.

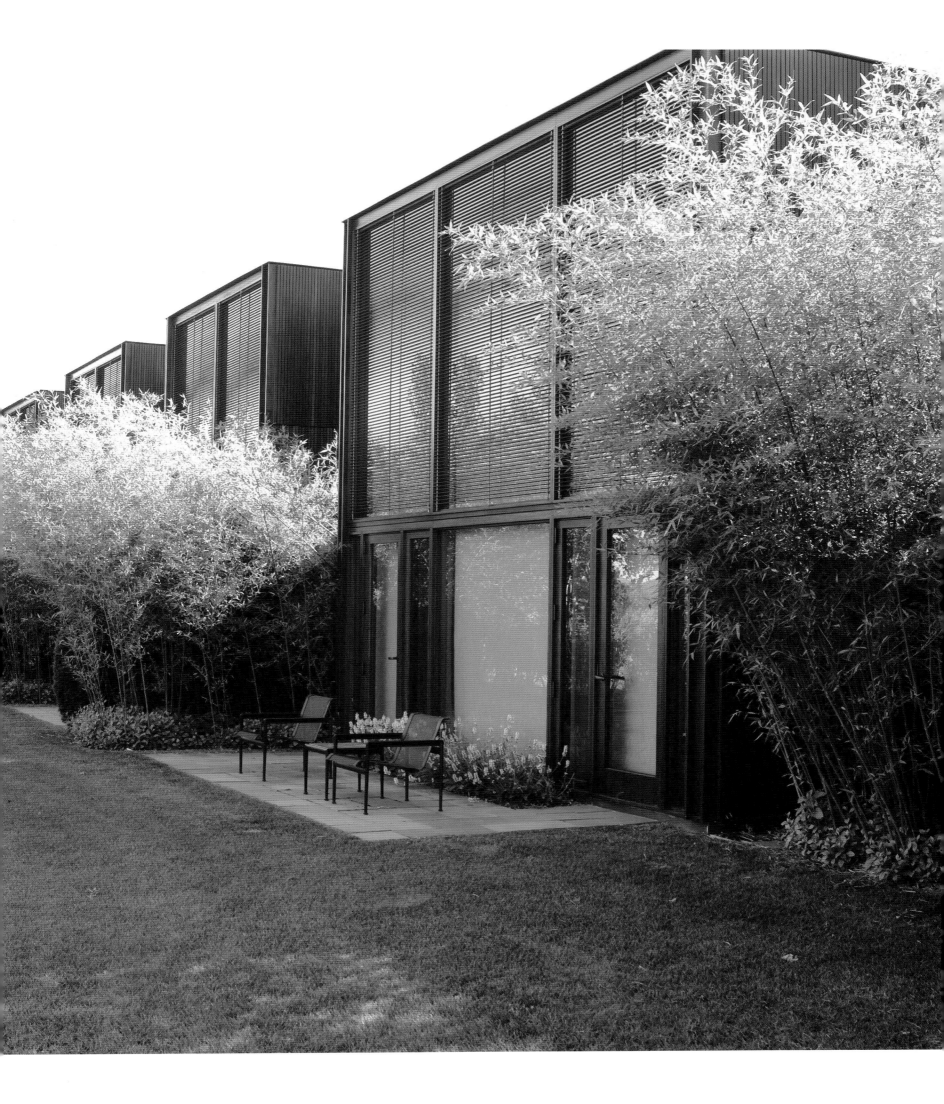

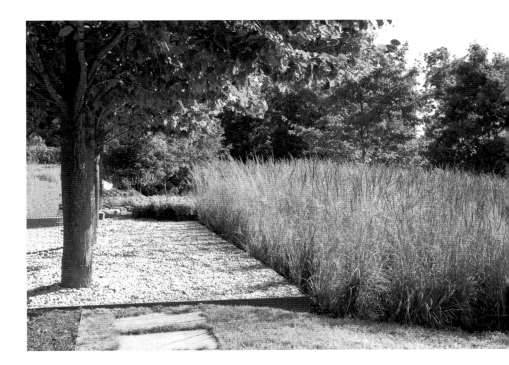

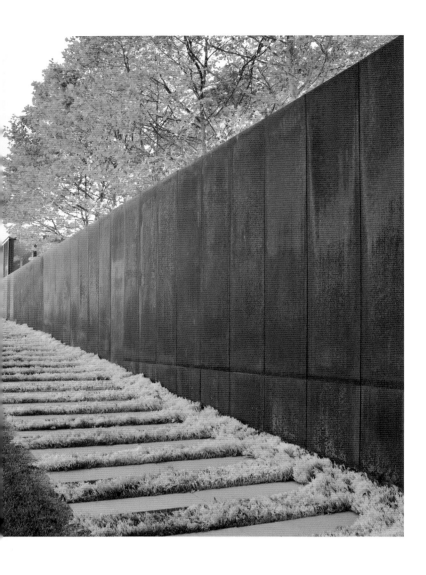

An important project was creating a maze garden outside a large family room. Meyer's green arborvitae hedging has humanized the space, and the walls play nicely off the lines of the metal walls of the house. Trevor and Planalp are interested in art and part of their vision for the garden is that it be a place to put their collection of sculpture. They bought their first piece by Ronald Rae while living in London and like to buy new work every year. There are now eight pieces of sculpture in the garden.

Trevor admits he's never met a plant he didn't like, and Meyer sees his role as helping to translate Trevor's ideas into a rational design process. Both of them want to make the land more self-sustaining, and they clearly have a productive partnership. Both men agree that a garden on this scale will always be evolving and there will always be more trees to plant, more views to enhance, and more sculpture to place. But in the meantime, the land has healed, the structure is there, and the different parts of the outdoor tapestry relate and connect to each other, creating a wonderfully eclectic garden perfectly in tune with the architecture of the house and with the greater landscape.

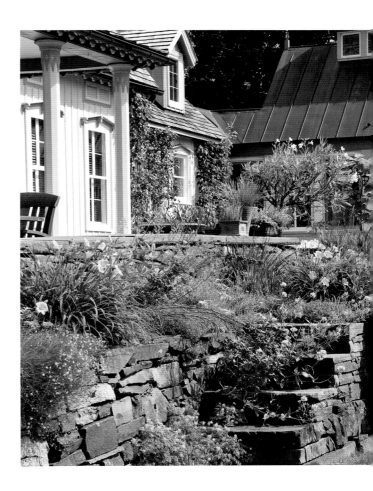

SCOTT CANNING AND JEFF RUZICH

GERMANTOWN

Attention to Detail

Other people check out views or inspect the heating system, but when Scott Canning was looking to buy a house in upstate New York, he carried a spade and trowel to check out soil samples. Canning is director of horticulture at Wave Hill, which explains his concern about finding the right soil for his future garden. He and his partner, Jeff Ruzich, began their search in 1995 but it wasn't until three years later that they settled on an 1840s Hudson Valley Carpenter Gothic house with three-and-a-half acres of rich sandy loamy soil.

There was an orchard of old pear trees on the property but not much else. Canning and Ruzich's first project was making a terrace at the back of the house to replace a steep slope from the house to the lawn. Today, there is a spacious raised stone terrace with two sets of steps leading to the garden proper. Its furnishings include large pots of agapanthus and figs, and the dry stone wall, capped with bluestone that borders it, is ideal for pots and container plants.

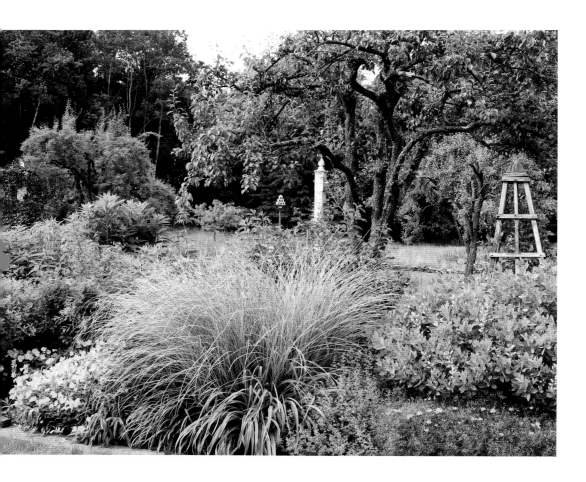

A recent addition to the house (constructed in Carpenter Gothic style by a craftsman in Detroit and shipped in pieces to Germantown) presented the opportunity to add a second terrace. A small stone fountain in the middle neatly edged with teucrium, to which Canning and Ruzich have added a handmade cast lead waterlily spout, sits on a plinth in a water basin. The terrace opens onto a pergola that has concrete pillars finished to look like stone. Growing up its trellis that will never rot are wisteria, trumpet vine, and a silver lace vine.

Canning decided to place a large double border between the terrace and the orchard. "I probably would not have made such a rectilinear garden, but the orchard determined the structure," he explains. "We started by making a Belgian espaliered fence at the back of both borders." Canning had assumed he would have to cover the area with netting, but the deer almost never come so the espaliered wall is now purely decorative. Nervous about having enough time to take care of two such large beds, Canning and Ruzich began by planting a lot of grasses, Joe Pye weed, and prairie plants. A new irrigation system has allowed them to add more perennials to the mix, and today the beds are massed high with ligularia, monarda, Siberian and German-bearded iris, daylilies, dianthus, and other water-loving plants.

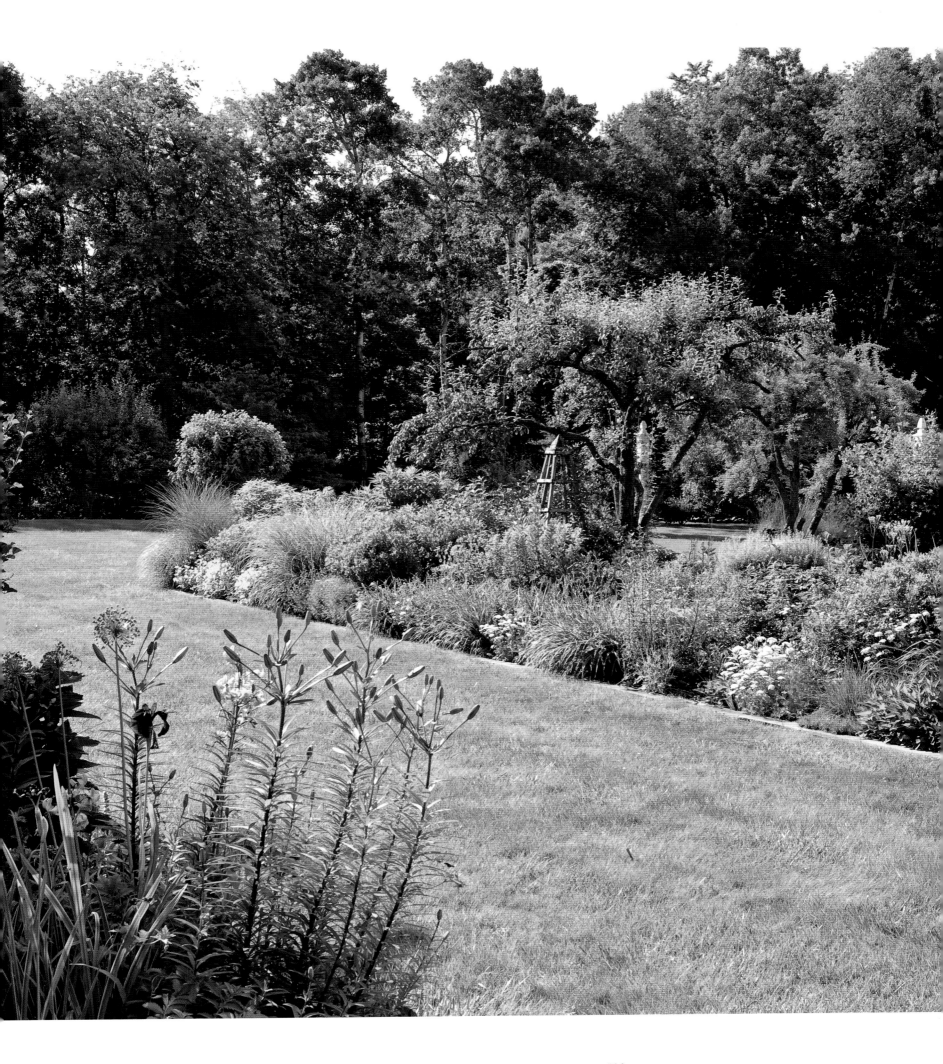

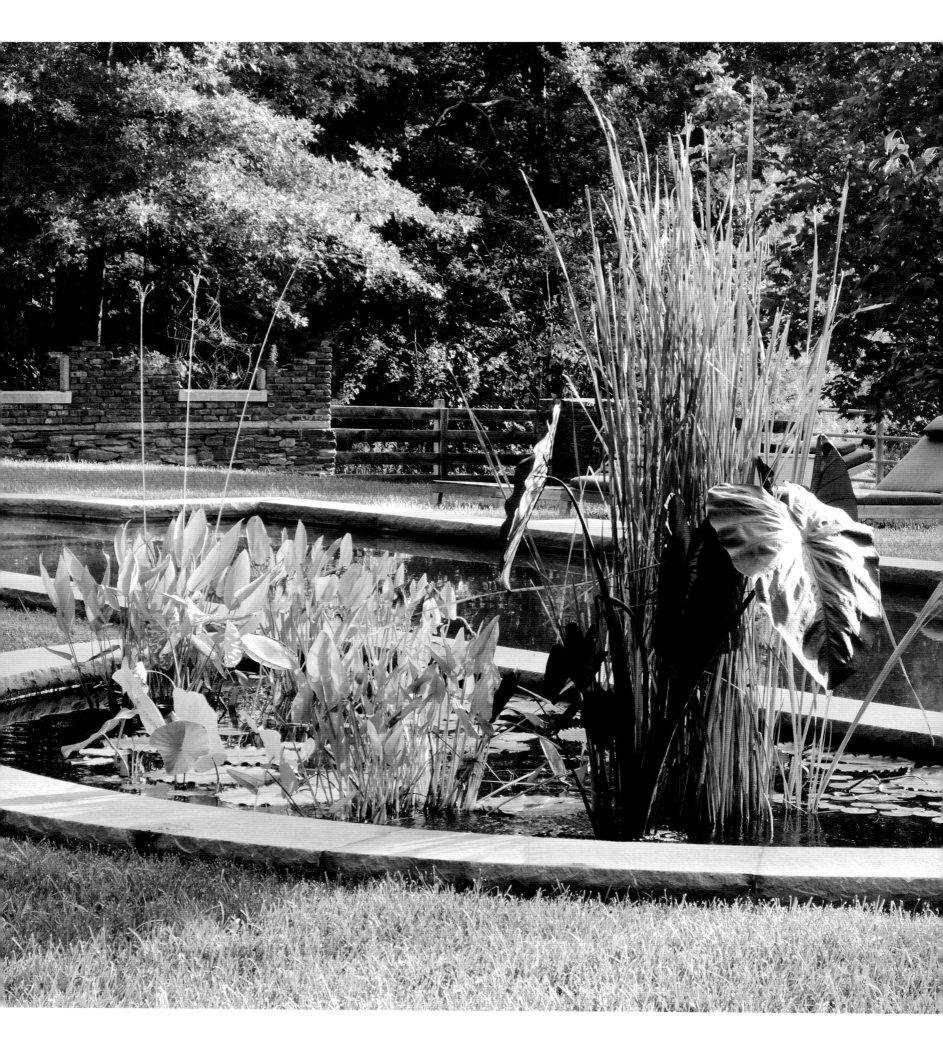

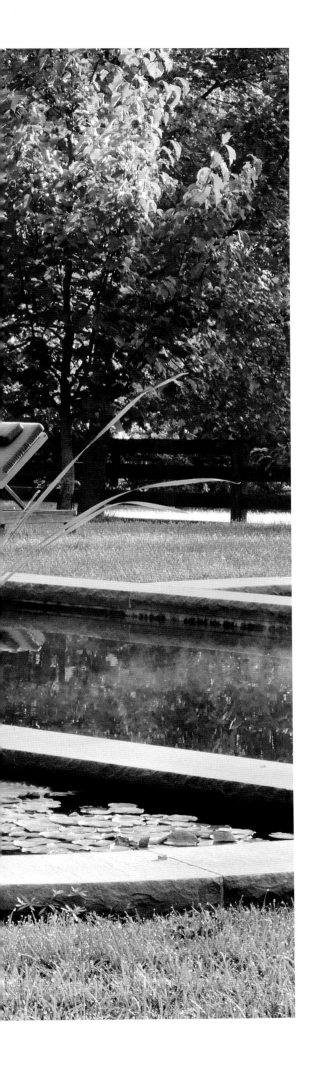

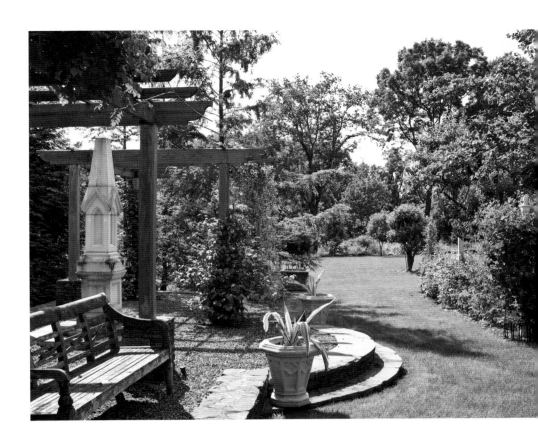

Other projects have included making a greenhouse, which Canning and Ruzich joined to an existing woodshed, and building a swimming pool with two water gardens integrated into the design. Asked how they came up with such an ingenious idea, Canning explains that wanting to make a connection between the look of the pool and the Gothic style of their house, he and Ruzich had played around with the idea of making a quatrefoil-shaped pool. Next, they thought to stretch out one axis, and this led to their decision to incorporate two semicircular water gardens into the structure of the pool. These are planted with hardy water lilies, hardy water lotus, and aquatic iris. "I thought the frogs would be a problem," admits Canning," but curiously enough they seem to know better than to jump in the pool."

Dogwoods and magnolias are planted in front of the woods beyond the pool, and Canning and Ruzich have replaced some of the more dilapidated pears in the orchard with cherry and plum trees. But their most recent and most whimsical project to date is creating a folly on top of the foundation of an old cistern at the edge of their property. Working with a local stone mason, they have collected old stone and antique lintels and created a masterfully convincing ruin that looks centuries old and carefully adheres to a floor plan designed by Andrew Jackson Downing in the nineteenth century. Ruzich and Canning's attention to detail and sense of play is evident not only in the construction of this fanciful folly but in every aspect of their delightful garden.

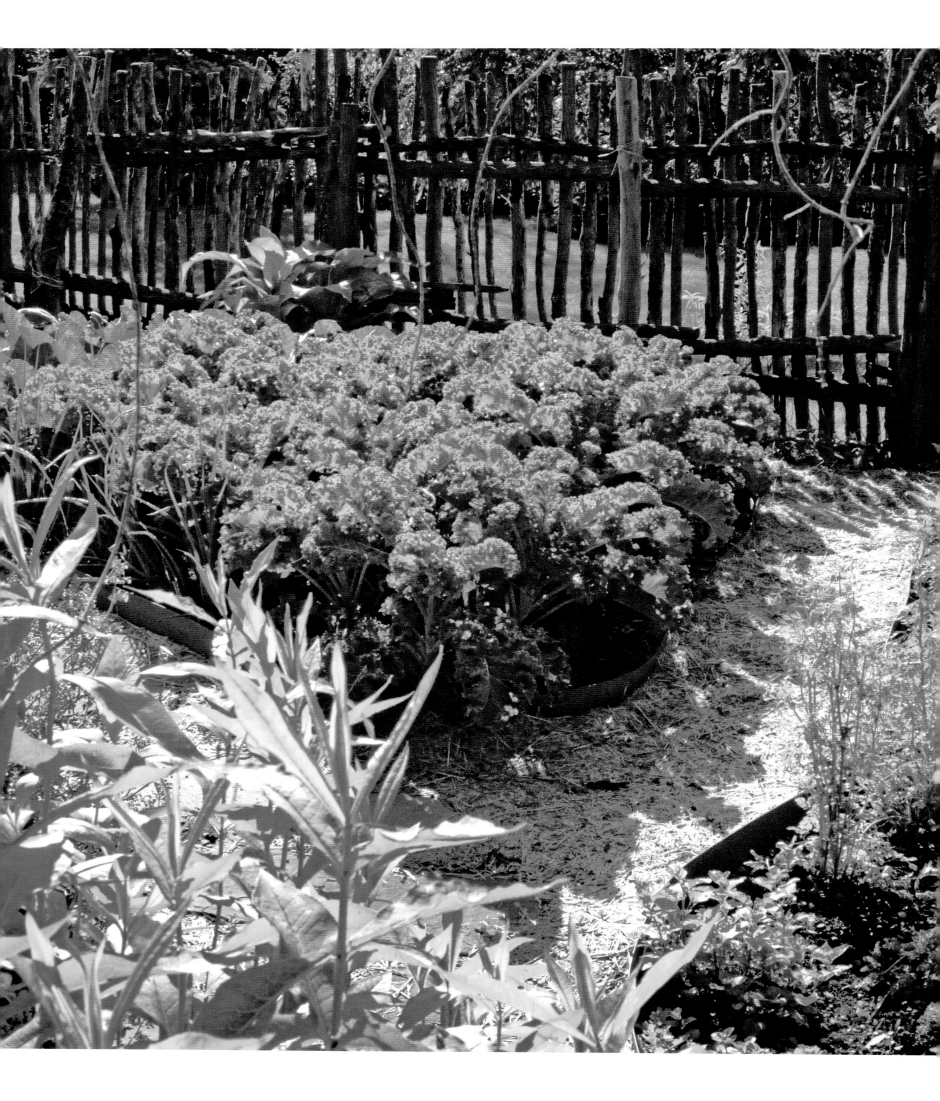

Small is Beautiful

"Nothing but an eyebrow colonial farmhouse sitting in an open field" is how Betzie Bendis describes the house that she and her husband bought twenty years ago. "All that flat land was a little scary," she confesses. However, as an artist and a self-taught gardener with her own garden design business, she was not daunted. Her first concern was that no trees meant no birds and no birds meant no birdsong. She created a small water garden outside the kitchen, dug up a lot of silver Buffalo berry, a native shrub that she found growing in the woods, and replanted it close to the water to make a thicket. Today, her garden is full of birds.

Bendis's next project was to make a vegetable garden, which she fenced in with locust saplings. The centerpiece of what she calls the big garden (and it is big) is a large decorative pyramid made of cedar. Wanting somewhere to sit that would feel open but at the same time be shaded from the sun, she came up with a design made entirely from wooden posts fastened together. By day, the pyramid-shaped structure is a good spot to sit and take in the view, while at night, Bendis hangs a candlelit chandelier from the rafters and it becomes a place for entertaining guests.

Kale is her favorite vegetable, and she grows it massed together in a large kidney-shaped plot. Other vegetables include purple cabbage, huge stands of basil, tomatoes, peppers, onions, beets, and carrots. Bendis has turned one side of her kitchen garden into a perennial garden, planted with shrub roses, phlox, coreopsis, nepeta, heliopsis, iris, plume poppy, lychnis, and acorus grass interspersed with viburnum, hydrangeas, clematis, and trumpet vine. An espaliered dwarf crab apple that "didn't work" adds verticality. "I love to change things and the fun of gardening is that I get new ideas all the time," she says.

Softening the landscape around the house was a priority. "I wanted a welcoming environment and I wanted the experience of walking to the house to be like a painting," she explains. To make this happen, she put in a path, "but it couldn't just be straight." A holding area near the house used for storing plants gave her the idea to begin planting close to the house and either side of the path. She couldn't stop and now there are plants and shrubs around the entire perimeter of the house. The final touch: a pair of matching urns filled with boxwood on either side of the front door.

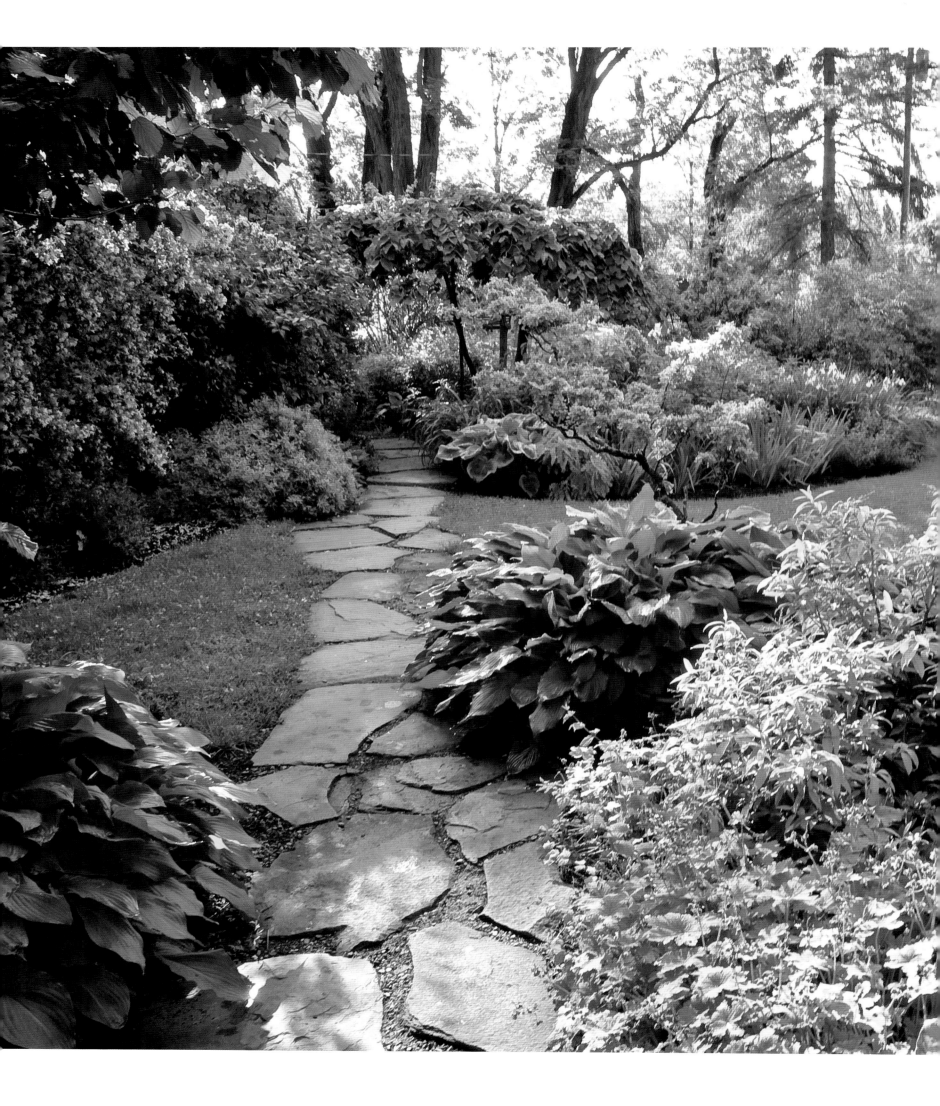

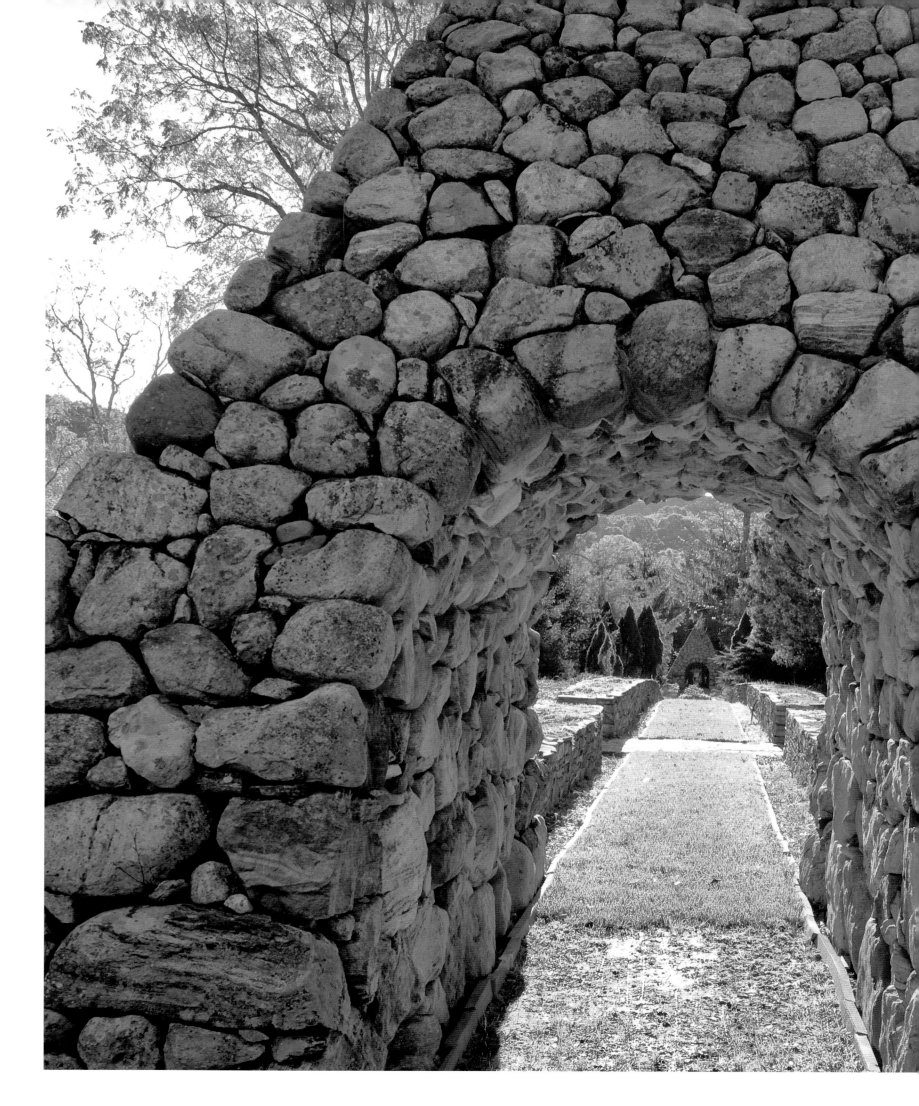

Artful Ruins

"Behemoth," is the word John Driscoll uses to describe the garden that he first saw in 2003, almost by chance. Driscoll, an art historian by training and owner of the Babcock Galleries, was smitten by its pyramids, belvedere, striped rocks, pavilions, obelisks, fountains, and grotto. He then got cold feet, but, after a few weeks, he couldn't resist going back to see the property. Wanting to own and preserve this astonishing garden, Driscoll was able to persuade his wife, the artist Marylyn Dintenfass, that this project would not submerge them, and a few months later, they became the new owners of one of the most fanciful gardens in America.

The garden is the creation of Paul Mayén, an architect and industrial designer, who once pronounced that "good taste and bad have no meaning for me," and also declared, "my garden is a monument to my pretentiousness." Born in Andalusia, Mayén came to the States in 1930 to study architecture and design. He later met and became the long-term companion of Edgar Kaufmann Jr., whose parents had commissioned the building of Falling Water, Frank Lloyd Wright's masterpiece. In the 1960s, Kaufmann and Mayén purchased fifteen acres of land and a cobblestone house in Garrison. Interestingly, they bought the property from a lawyer who had purchased it from Wright's daughter. Driscoll wonders if this was a coincidence. In 1979, Kaufmann and Mayén pulled down the house and Mayén designed an International Style house, where they spent most weekends. It wasn't until Kaufmann died in 1989 that Mayén began to work on a garden. Someone who knew them both thinks that this was probably because a garden this idiosyncratic would never have been to Kaufmann's taste.

Sadly, Driscoll has been able to find out very little about the history of the garden. No one seems to know if there was a master plan or whether it just kept expanding, and Mayén appears to have kept no notes or records. The garden radiates away from the house along various paths, which Mayén believed to be the "life force" of a garden. While it is undoubtedly the elaborate network of amazing shapes, walkways, and structures that leave a visitor gasping, Mayén must have been interested in and knowledgeable about horticulture. He planted twenty-four varieties of flowering thyme along the walk that runs between the two stone pyramids, and used a delightful combination of Spanish lavender and iris in a space that was intended for poetry recitations.

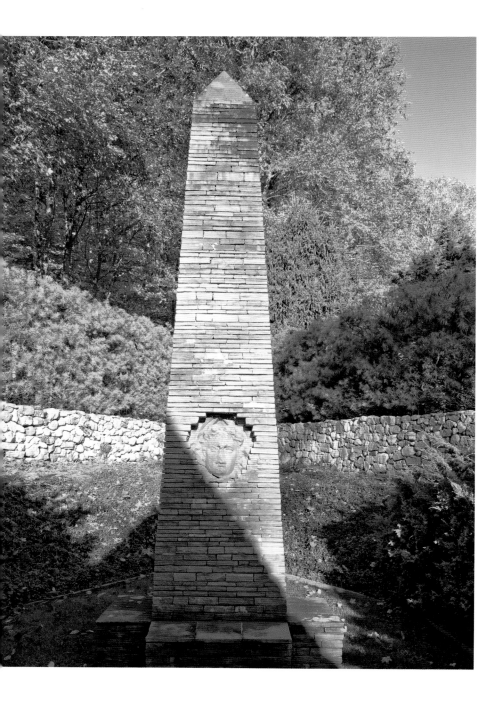

Mayén died in 2000, and it is amazing he was able to create a garden of such size and complexity in only eleven years. (The property was not put up for sale until three years later.) Driscoll takes his role as the garden's caretaker seriously. He would like to make it more of a garden for all seasons and do this by planting more trees, especially evergreens, and putting a stronger emphasis on a palette of blues and greens. He continues to be fascinated by the garden's combination of wildness and formality and its heady mix of cultural influences. "One part Tuscan, one part Los Angeles, and one part French or Spanish," is how he describes it. "Clearly, Mayén liked conundrums," he says. Driscoll's one regret is that his father, who loved gardens, never got to see this one before he died. From the time he was a child, Driscoll confesses that his dream was to own a painting by Monet. "And now I have one," he says with unconcealed satisfaction.

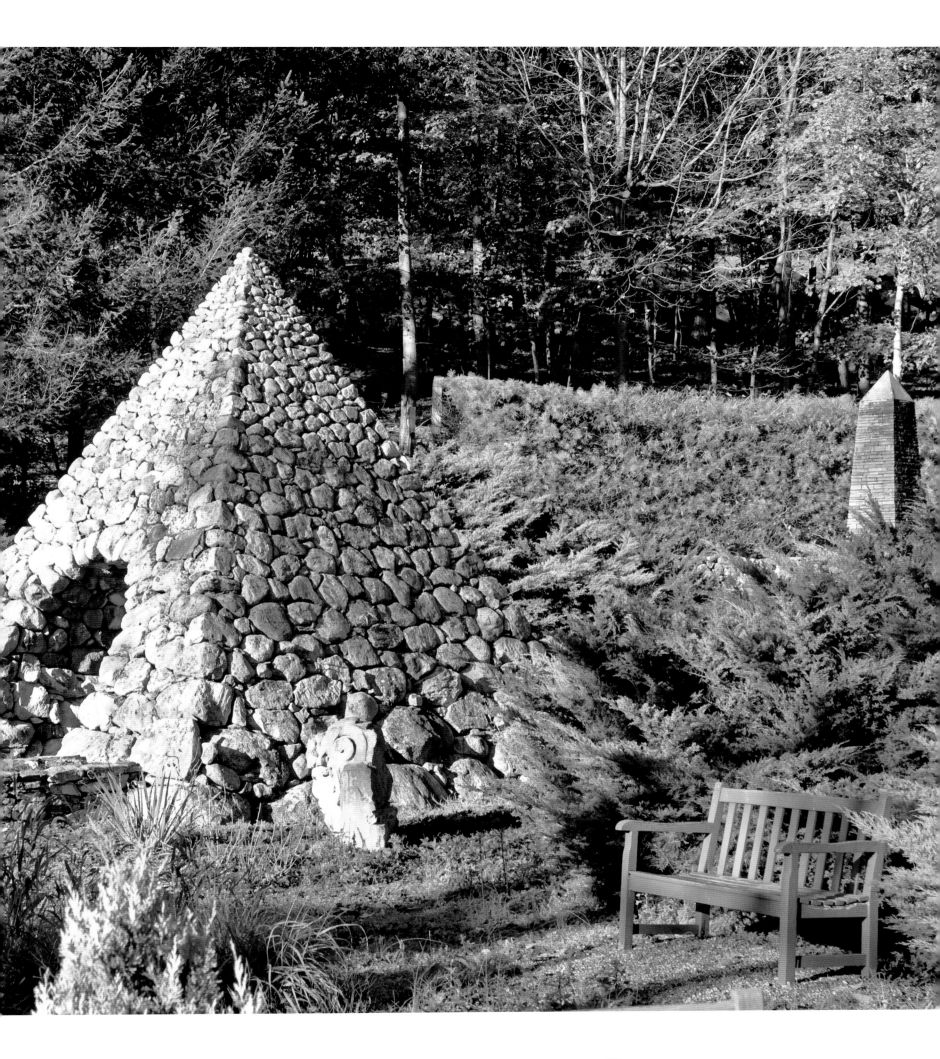

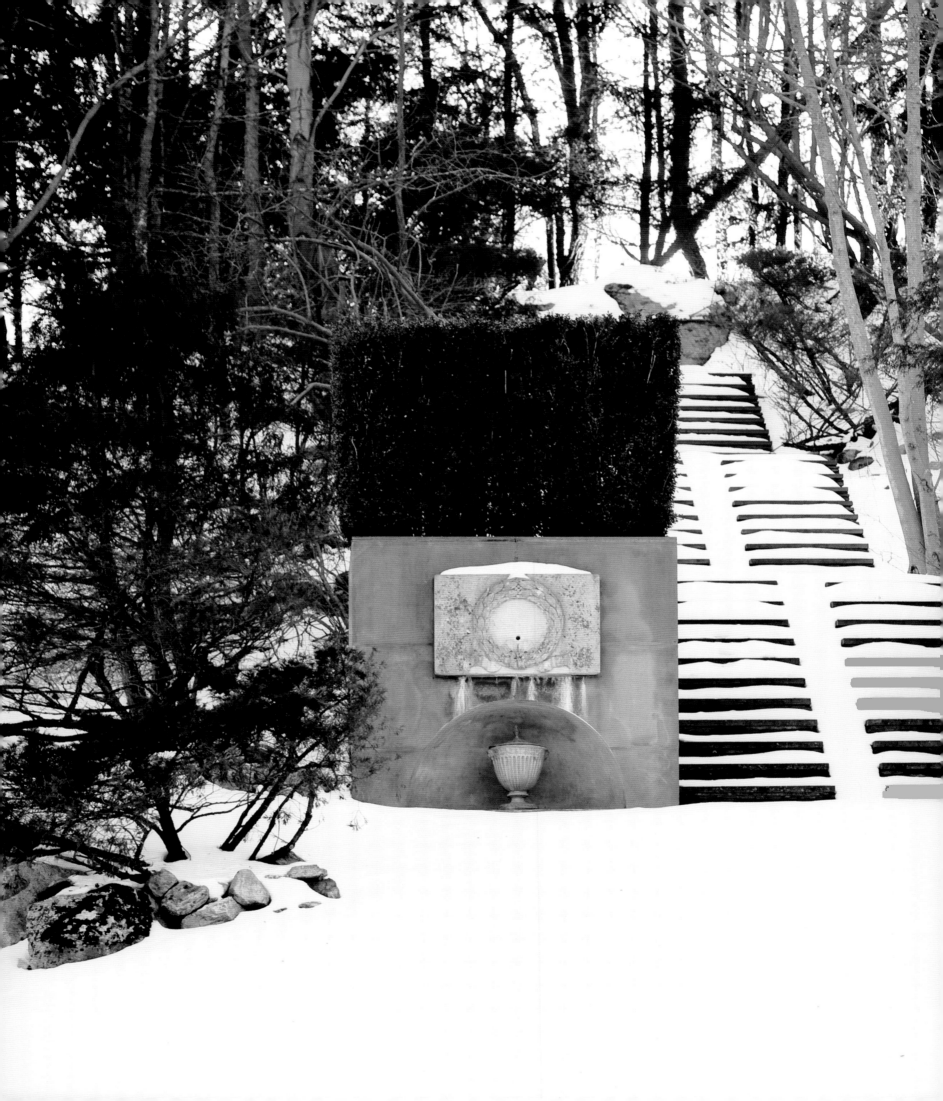

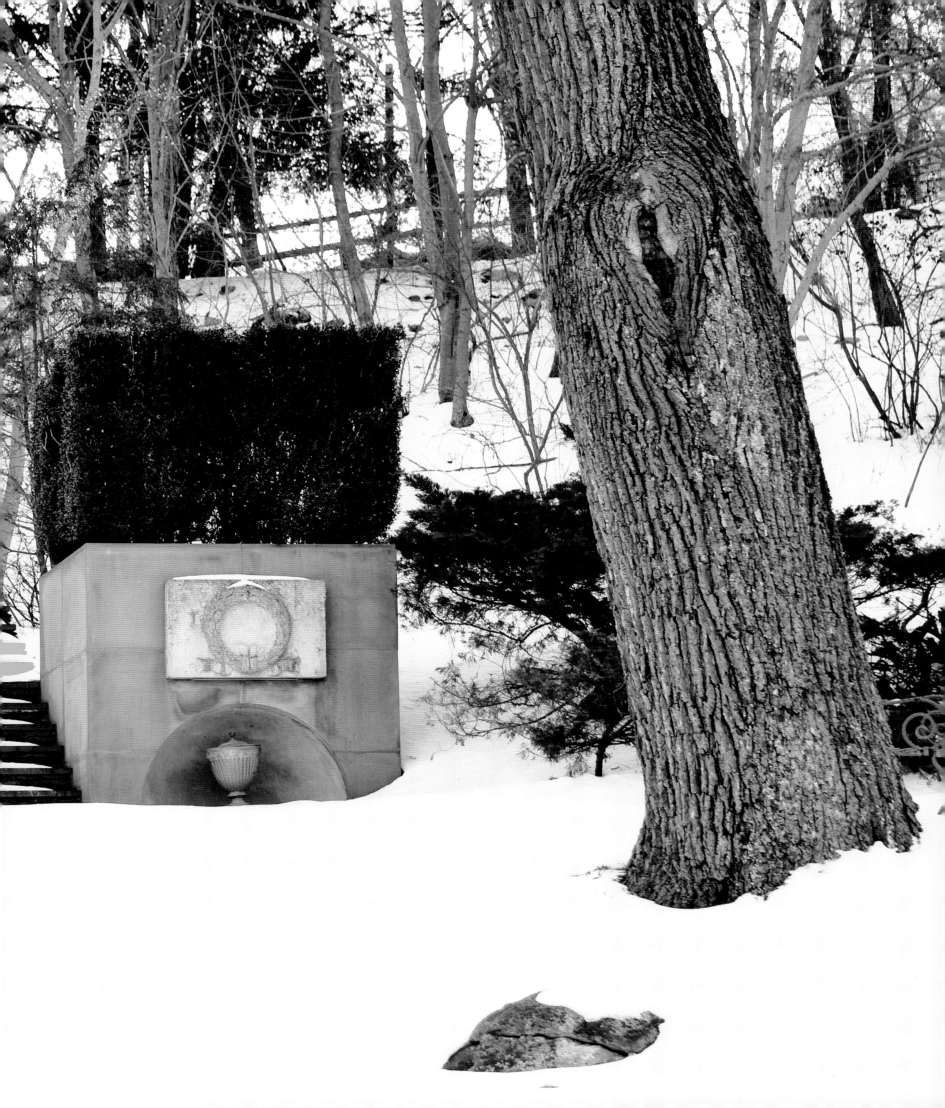

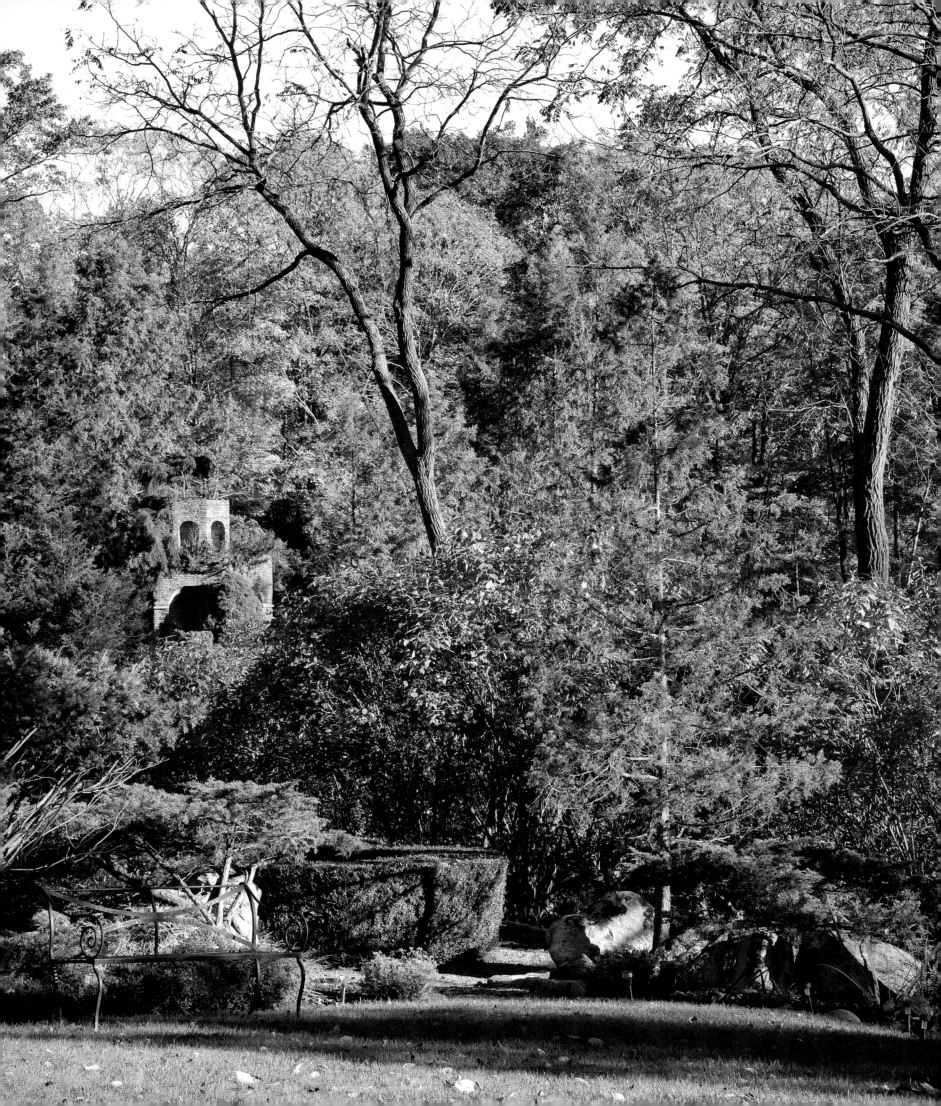

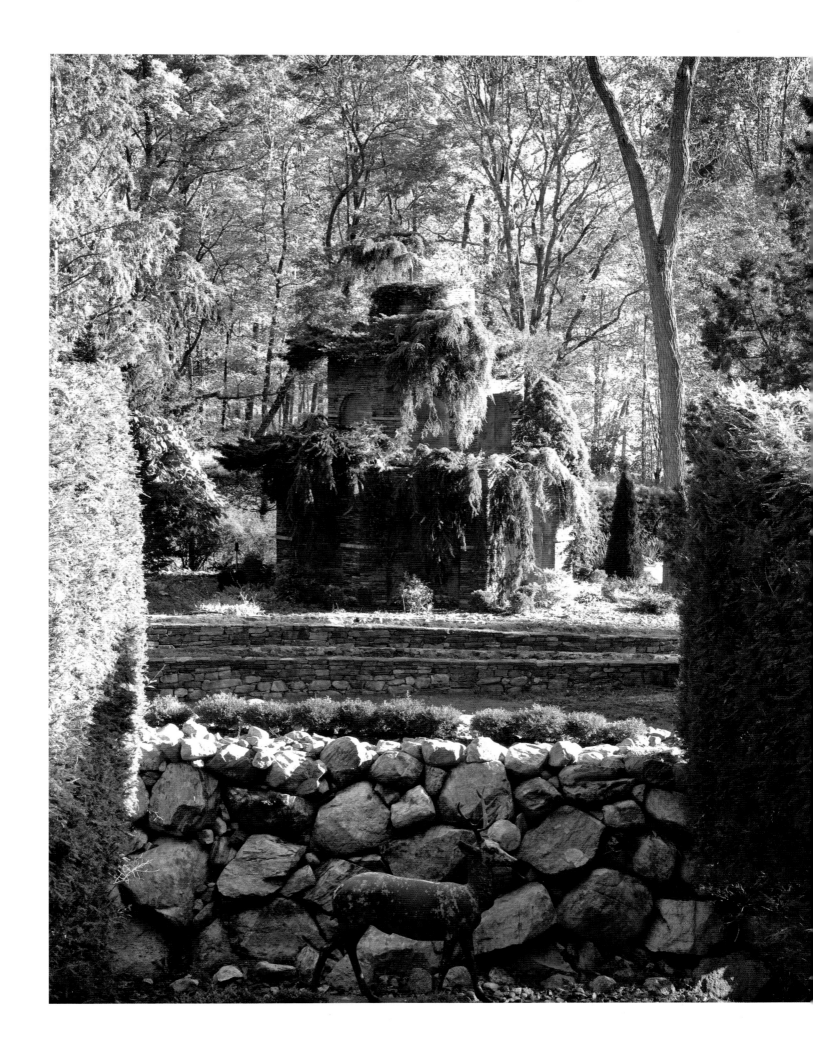

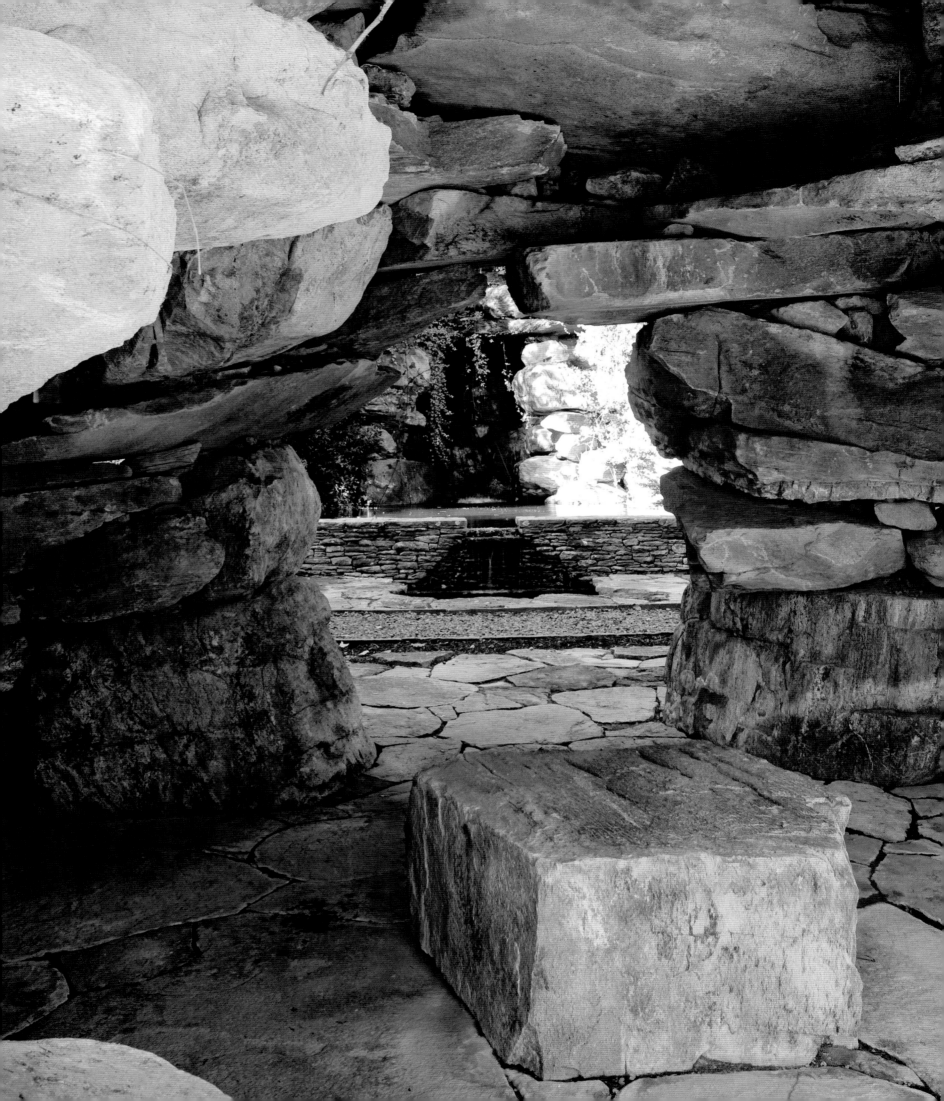

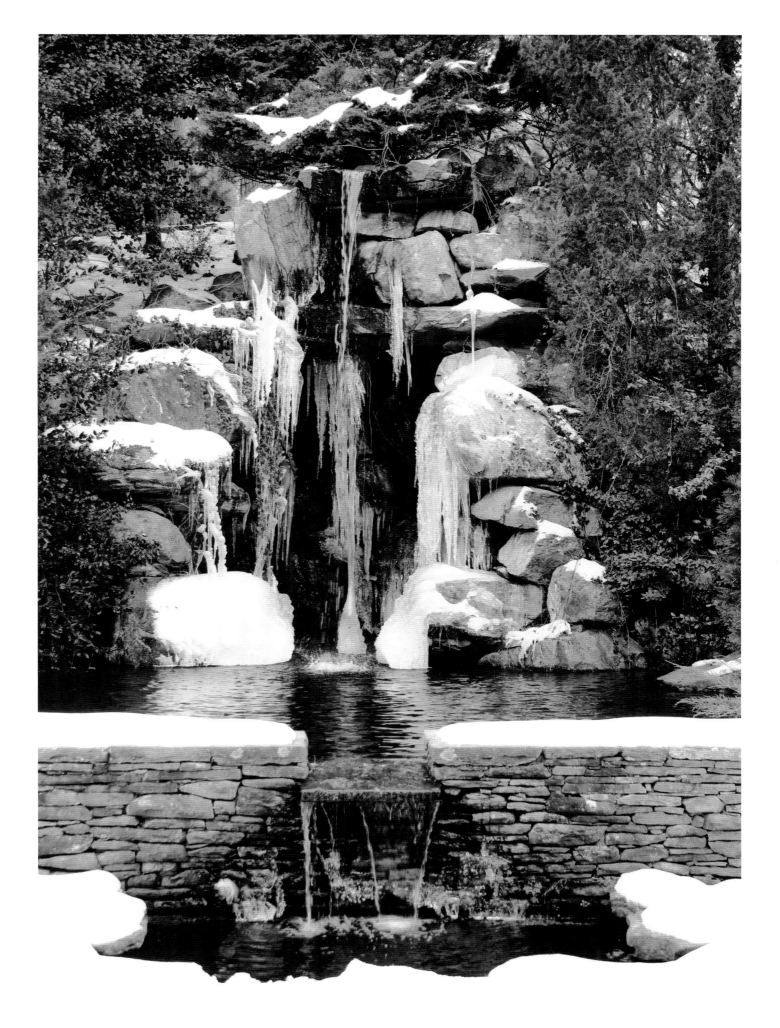

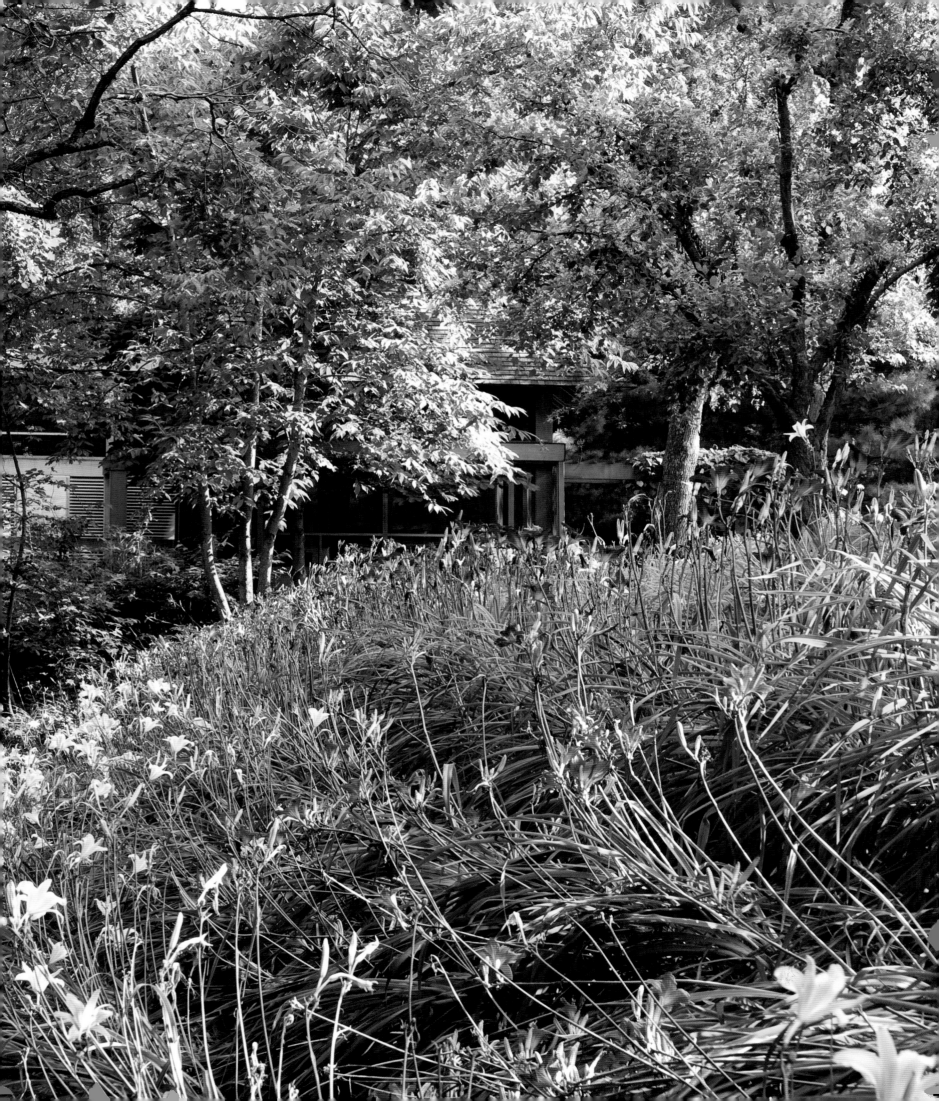

Making a Garden

Millie Wise lives in England for most of the year. However, she spends July and August in upstate New York, where she and her husband own a distinctive Arts and Crafts style house that had belonged to his parents. When the Wises inherited the house in the 1980s, they added plumbing and electricity, expanded the existing house, built a second similarly styled house, and put in a swimming pool and a contemporary screened-in pool house.

There was no garden to speak of, and Wise still remembers her husband's mandate: "You are in charge." The couple had recently purchased a house in the English Cotswolds, and Wise was flummoxed by the prospect of having to create two gardens in two different countries with two different climates and two different kinds of terrain. To better prepare herself, she enrolled in a year-long course in garden design at the English School of Gardening in London and then took additional classes in design at the Bagshot Agricultural College.

In England, her task was to plan a landscape around a house set in a flat field with no trees and in a temperate climate. In Red Hook, the challenge was quite different. Here, the land was steep and she had to contend with freezing temperatures in winter and intense summer heat. Since the house sits on a steep ledge and is surrounded by a seemingly impenetrable forest thick with deer, her first response was to cut back the encroaching trees and to clear an opening around the house. Next, she fenced in the property and installed an irrigation system. Before starting on the garden proper, she built a raised stone terrace at the back of the main house, high enough off the ground to jut out over the land below. Protected by three walls of the house, it makes a delightful outdoor room and its only floral embellishments are some shallow pots of red geraniums (Wise's favorite color) and four huge containers of hydrangea paniculata. (Amazingly, these survive the winter left in their pots on the terrace and protected only with a sheath of bubble wrap.) A mass of viburnum is planted in the drop-off below this wall, and for most of the summer the tips of their white flowers can be seen from the terrace.

To better define the boundary between the cultivated garden and the trees beyond, Wise planted a long curving hedge of barberry in front of a row of daylilies. A flower border, filled with filipendula, alchemilla, Japanese anemone, hosta, and hakone grass, leads to a luxuriant vegetable garden, whose entrance is flanked by two wild

cherry trees. On one side, it is bordered by a row of standard viburnum trees set behind ten espaliered apple trees. There are two fig trees in iron pots, and to the right of a garden house at the far end, two life-like straw figures, the work of artist Michael Melle, preside over the bounty of vegetables. Zucchini, herbs, kale, peppers, and cucumbers grow in eight triangular raised beds that were installed when Wise was not around, and which she admits were not quite what she "had in mind."

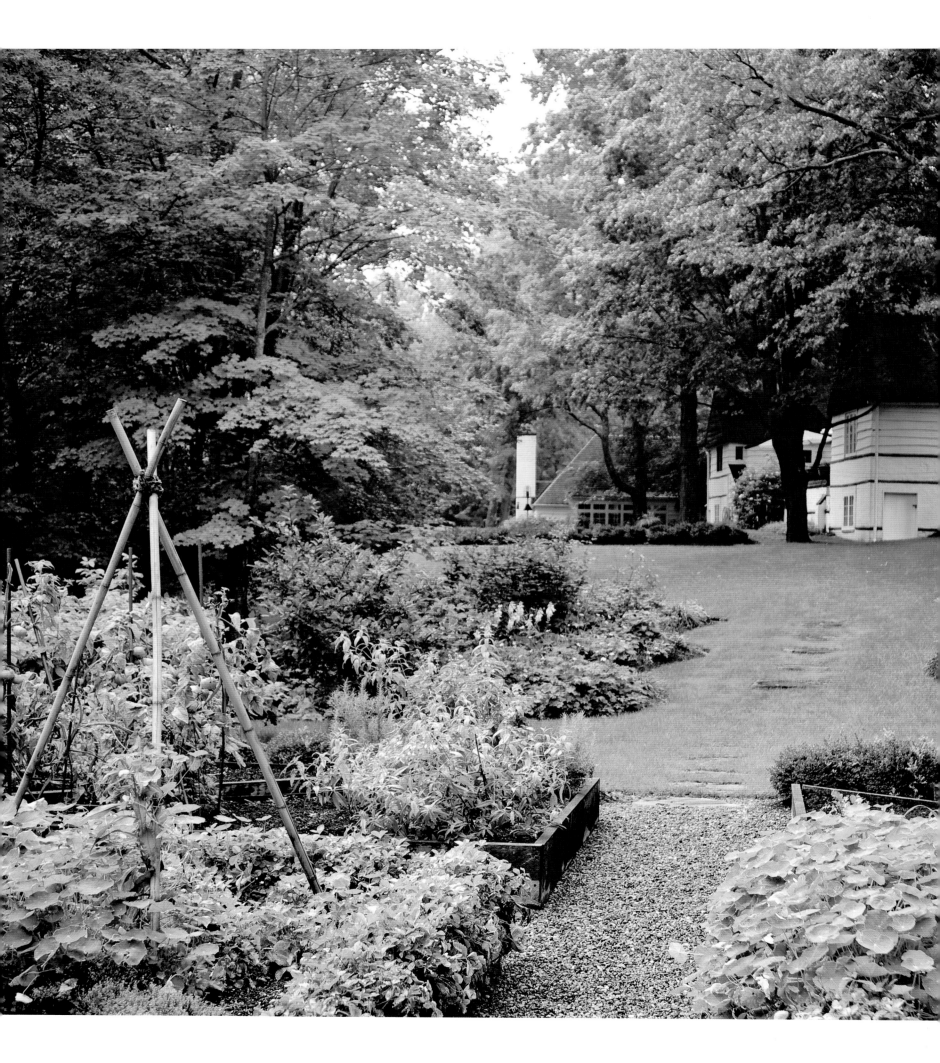

There is a large grouping of boxwood in front of the pool house. Wise's original thought was to make an undulating cloud garden, but the boxwood has been hard to train. "It doesn't grow as tight as English box and I'm getting resigned to ending up with bubbles not clouds," she says. Color is provided by a few judiciously chosen roses —"so hard to grow but I love them," she says wistfully. There are pots of plumbago and two containers of brugmansia, one pink and one yellow. "Another mistake—they were both supposed to be the same color," says Wise. "It's hard gardening when you are abroad. I now come twice in the spring to get the garden started." She gives high praise to her housekeeper, Diana Williams, who knew nothing about gardening when she started to help Wise, "but is now the one who makes it all work."

Long distance gardening isn't easy but over the years Wise has learned to take it all in stride. "I can't imagine a better hobby," she says firmly. "And there's nowhere I would rather be during the summer than in my American garden."

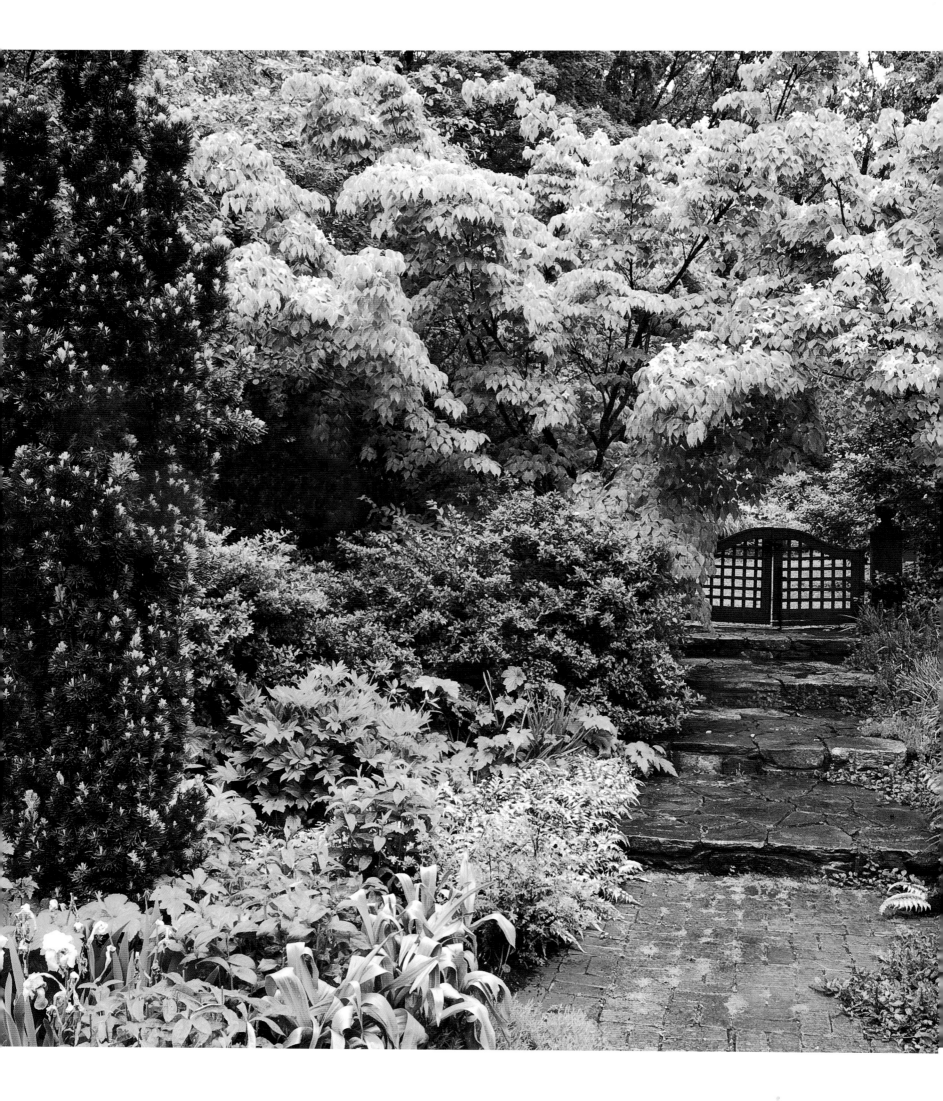

A Singular Vision

For most people, doing work on a house comes before making a garden, and often the latter is undertaken with some reluctance, and only because of a growing realization that something has to be done about a less-than-perfect habitat. But this is not how Frederic Rich thinks and, as it happens, this proved fortuitous. When twelve acres of land overlooking the Hudson came up for sale in 1989, it attracted a lot of interested buyers, who arrived with their architects and, to the seller's irritation, talked loudly about how they would pull down his split-level ranch house. Rich was the only prospective buyer able to assure the owner that he had no immediate plans to do anything with the house. "I couldn't afford to," he says, "and besides a garden takes far longer to make, so I needed to get going on it first."

When Rich was a boy, his parents bought a house in New Jersey with a garden designed by the legendary designer Beatrix Farrand. It was in terrible shape, but Rich remembers that "little by little, I discovered paths, parterres, terraces, and even uncovered a mural. Poppies, phlox, and peonies, all the plants that Farrand loved so much, grew back. Even as a child, I absorbed a certain kind of aesthetic." The experience led him to take a course at Princeton with the American garden historian David Coffin, and although he became a lawyer, Rich has never lost his fascination with gardens and garden history.

The riverfront property that he purchased was almost all on ledge rock. It was overgrown and neglected —a damaged landscape that needed to be remade. Rich's first and hardest task was to get rid of the mass of invasive plants that had choked out everything else. Working on his own, he began the long tedious process of reclamation, starting at the outer edge of his land and working inward. Bit by bit, the high bush blueberries, wild cherry, phenomenal mosses, and red pine were given room to breathe and grow.

"The key to understanding my garden is that I didn't have a master plan," he explains. "It was not possible to put on paper what I wanted to do as I was on a journey of discovery." Today, the garden covers about nine acres. Mostly wooded, it has a large pond and is planted naturalistically. Its acidic conditions have dictated Rich's choice of plants. "I have a lot of very interesting ones, but I don't consider this to be a plantsman's garden," he says. Being so close to the water gives him a microclimate and he admits that he pays little attention to instructions given in plant catalogues. "I'm quite

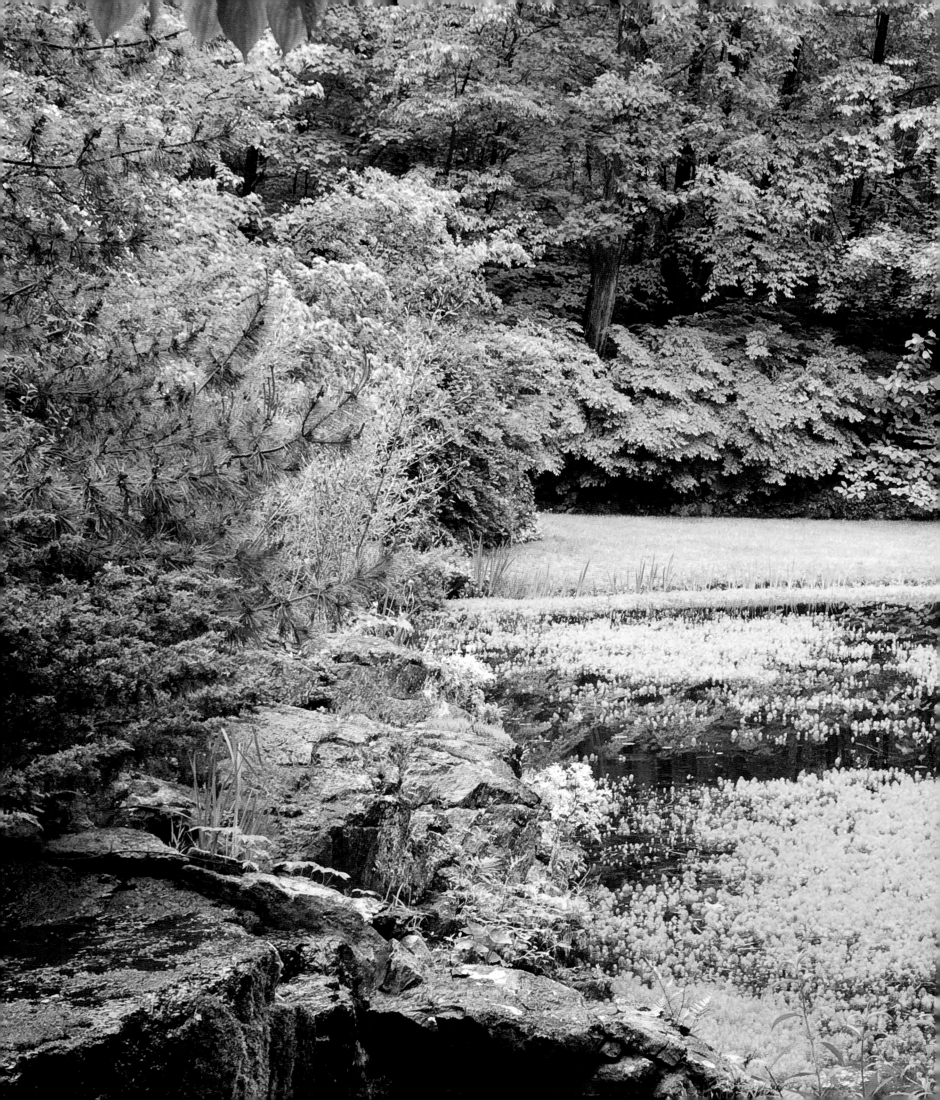

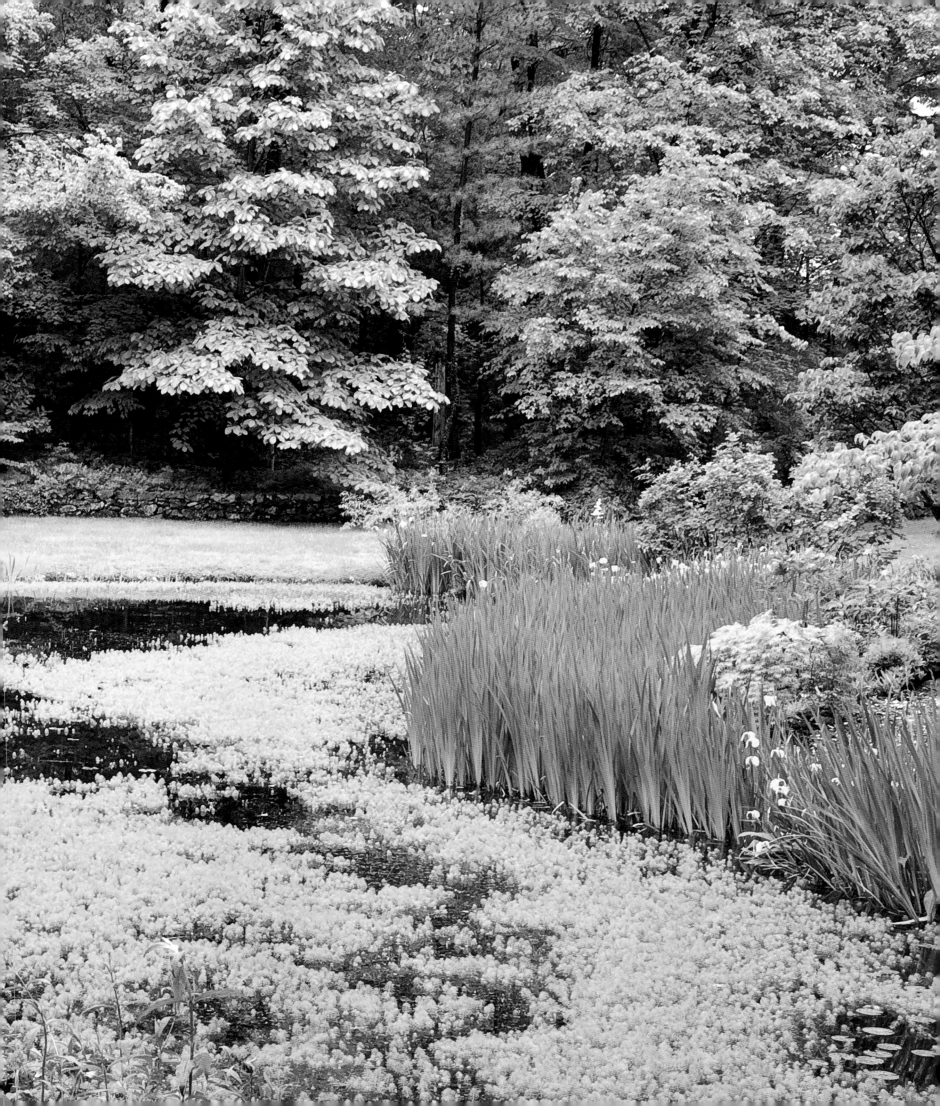

Darwinian in that respect, and if a plant survives I love to repeat it over and over."
Rich now has help with his garden, but still does all the planting himself, entering
every plant into a database that runs to more than 3,000 entries. He relishes having
a mixture of cultivated and natural plants, and takes great delight in growing large
plants from seeds or tiny cuttings. Two of his largest magnolia trees started out in
paper bags. In 1998, he renovated and greatly expanded the house. Ranch has given
way to American shingle style, and the house, which has astonishing views of the
Hudson, is very much in keeping with the spirit of the garden.

Rich follows his own design rules. A classical temple, reminiscent of Stourhead,
frames a distant view. Contrast this with a functional outdoor conference room over-
looking his pond that is furnished with twelve rustic ergonomic chairs and boasts
Internet access. A bed of ferns and lilies is planted exactly according to the style
of Gertrude Jekyll, but this bed is within walking distance of a swimming pool,
where state-of-the-art speakers are disguised as rocks.

Walking through his garden at dawn and dusk is one of Rich's great pleasures. On
the far side of the house, set apart from the rest of the garden, his walk takes him
through a wooden gate where he has created his own version of the Path of Hercules,
a common image in Renaissance art and an allegory often found in classical Italian
gardens. The path, which forks to the left and the right, depicts Hercules's choice
between virtue and vice. In Rich's garden, the left fork of the path leads to the vale
of indolence, represented by a statue of a bare-breasted maiden. The right fork
climbs up a steep narrow path, where a solitary Chinese scholar's bench depicts the
life of virtue.

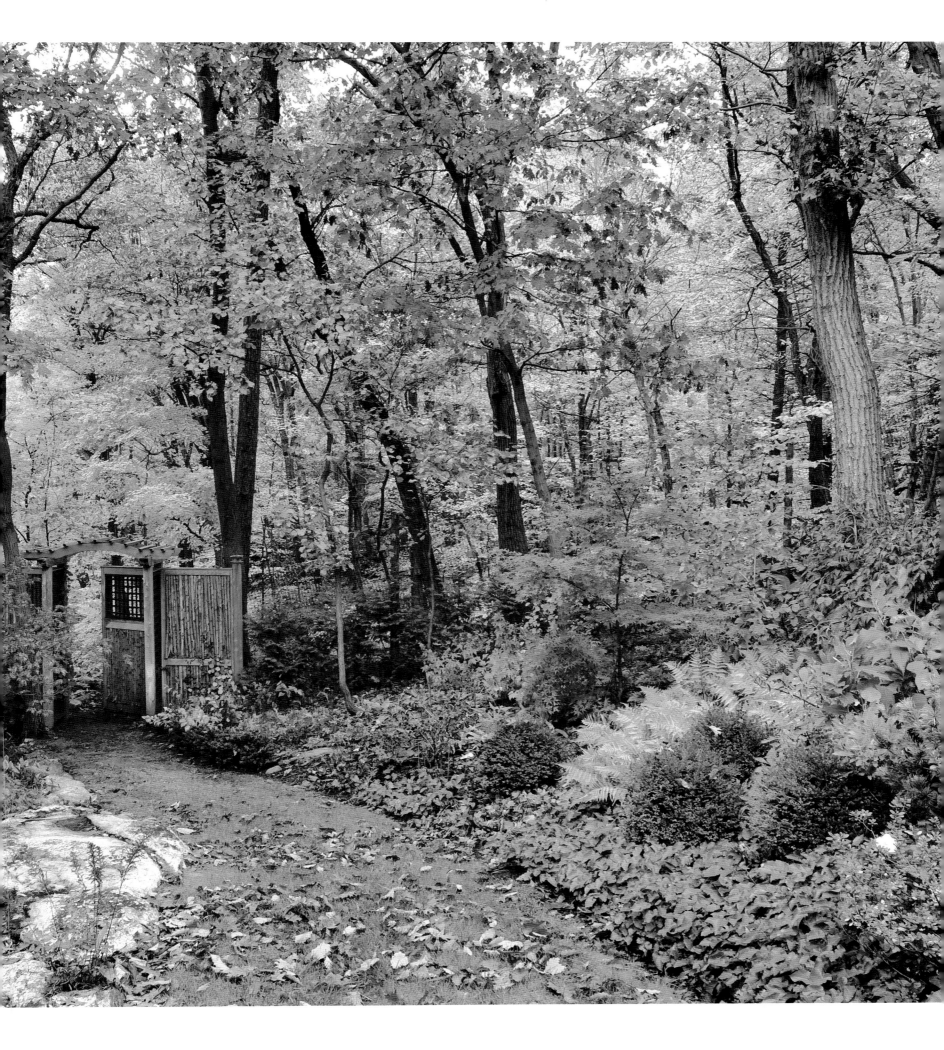

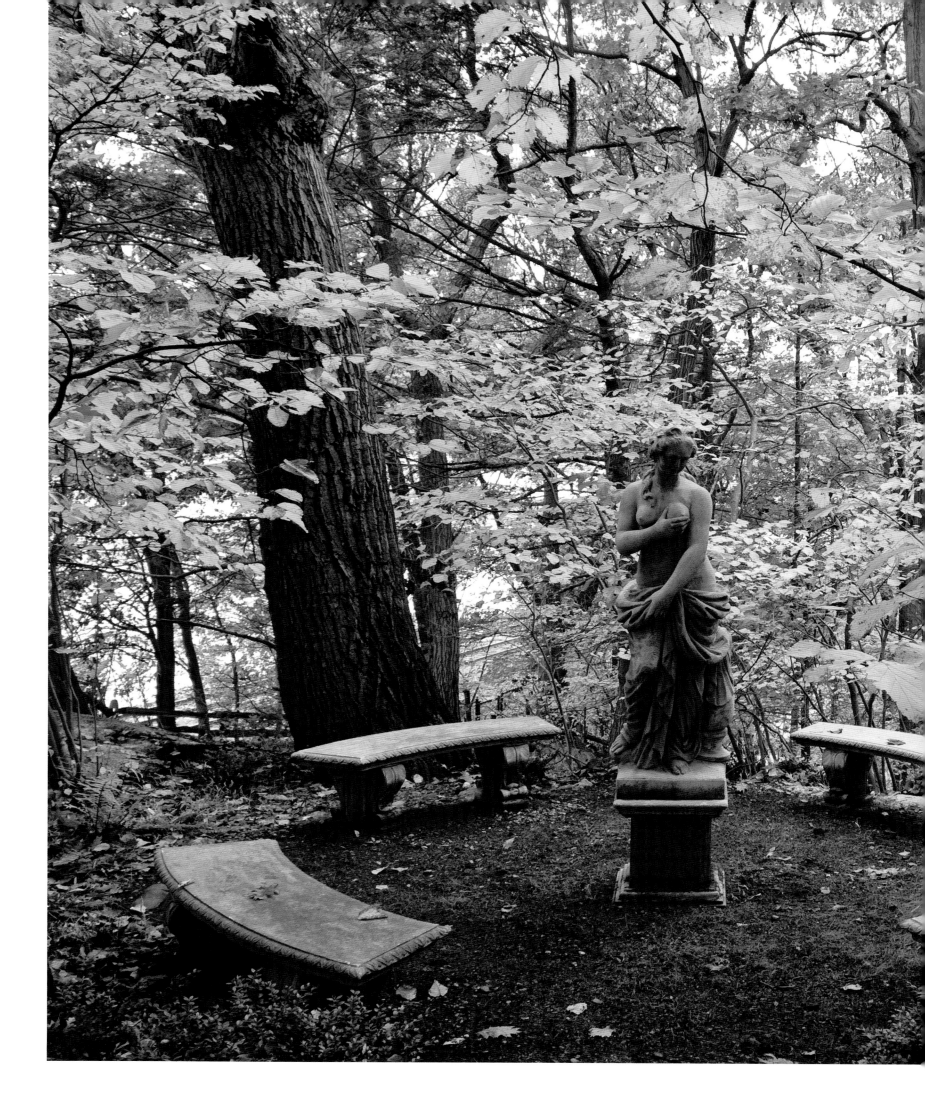

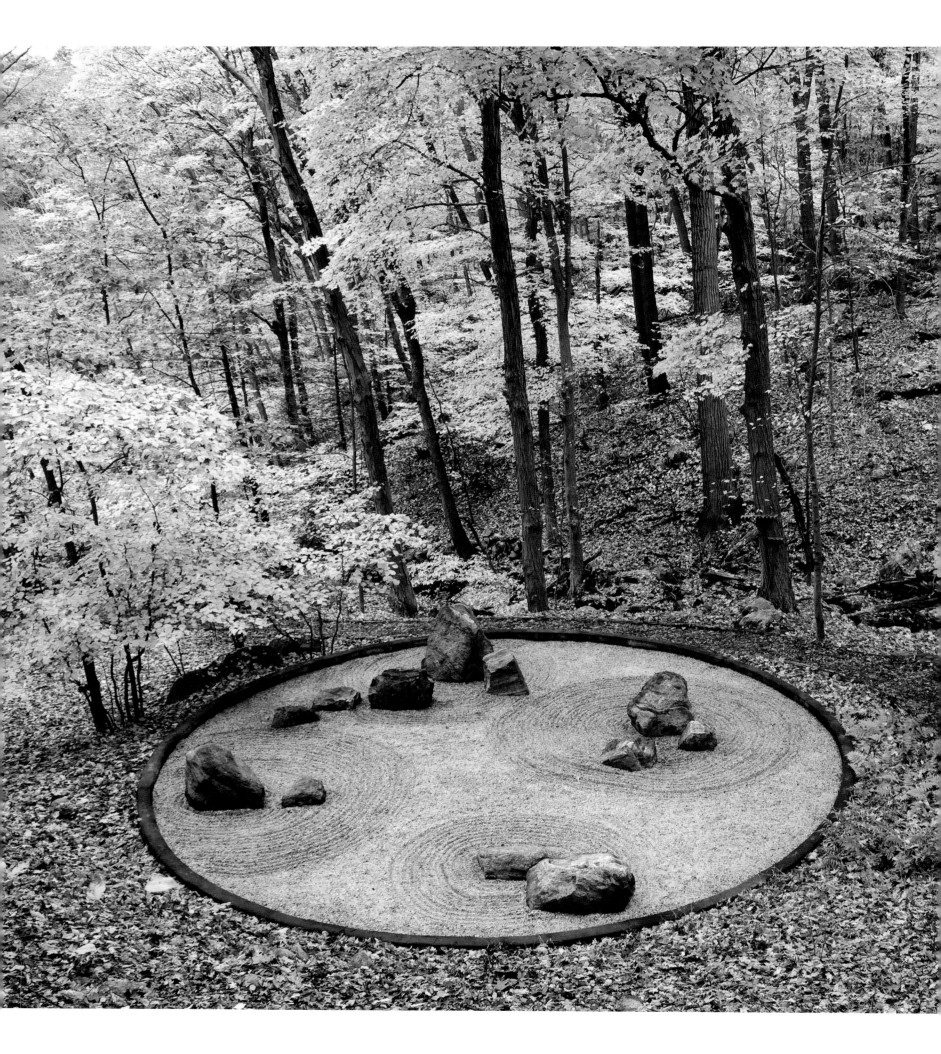

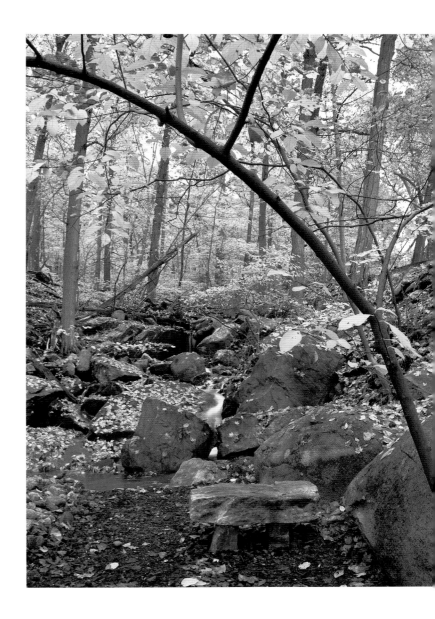

Having traveled in Japan, Rich has been deeply influenced by the Japanese garden aesthetic and, after going to Ryoanji, one of the most famous gardens in Kyoto, he was determined to create his own abstraction of nature in a wild setting. Moving from one civilization to another, he has boldly sited a Zen garden in the woods beyond the Path of Hercules. Before making this garden, he studied *Secret Teachings in the Art of Japanese Gardens* by David Slawson, which, he says, explains all the principles involved. The placement of the rocks and gravel in this garden appear completely natural but, in fact, nothing is left to chance. Each rock in the tableau sits on part of a grid and even the direction in which the rocks are leaning has been carefully worked out.

Placing a classical tableau within view of a Japanese Zen garden is just one example of why Rich's garden is so personal and so original. Against the dramatic backdrop of the Hudson River, he has created an outdoor Eden that is intelligent, unexpected, and compelling.

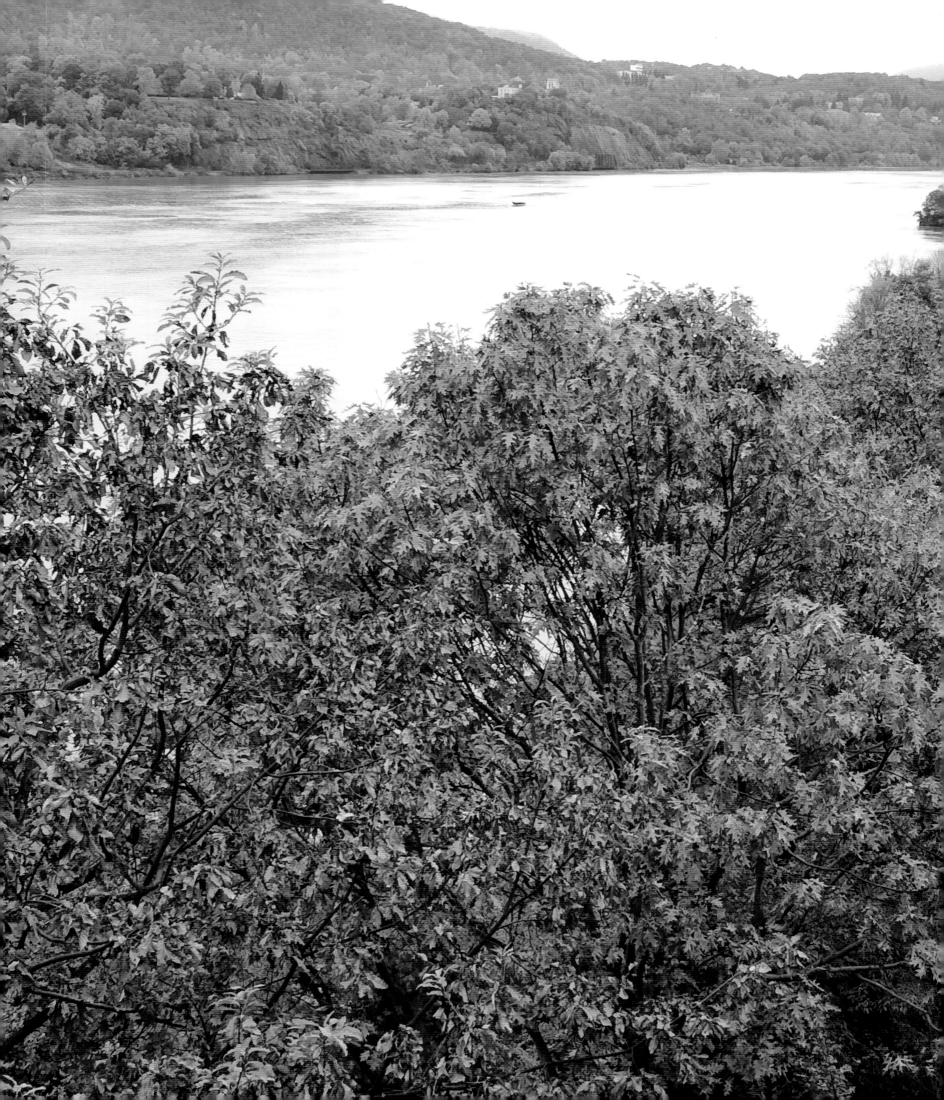

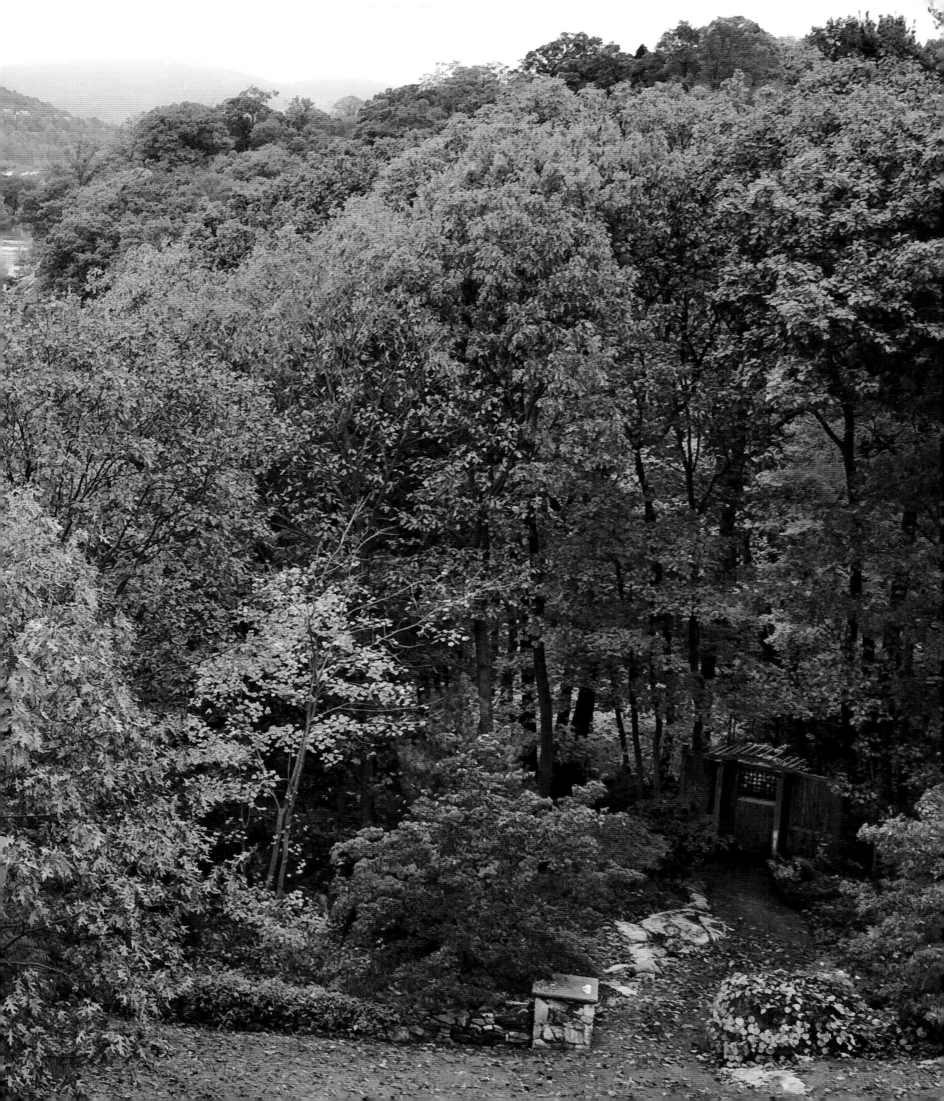

The Wow Factor

Given the right kind of care, gardens age marvelously well, and Eliot and Susie Clarke's garden, in the making for more than forty-five years, is a perfect example of this phenomenon. Their garden is an exuberant tour de force that pays homage to gardens Eliot has visited in America, Europe, and Asia. Every allée and border makes reference to moments and ideas that have captivated and charmed him on his travels. There's the temple set on a distant hill, a nineteenth-century folly, and even a long sinuous red bridge that spans one of Eliot's man-made ponds and leads to a tiny island. "The Chinese love red so when I decided to make a bridge, why would I not paint it red?" he asks. It's a rhetorical question but speaks to the pleasure he feels in welcoming other traditions and influences into his garden.

Eliot credits his interest in gardening to a leg injury he received during the Korean War that kept him in rehabilitation in Kyoto for six months. During this time, he became fascinated with Japanese gardens and limping around them on crutches opened up a whole new world. "I knew nothing about Japanese gardens. At first, I didn't understand them at all, but gradually I began to see what was going on." Later, he visited gardens in Italy and England and they also made a strong impression. In 1967, he purchased a 1758 Federal farmhouse that had originally belonged to David Jamison, chief justice of New York State, who came to America from Lithgow in Scotland. When Eliot began to work seriously on making a garden, he was not daunted in any way by its strong American provenance, choosing to create a garden filled with references to his extensive travels. When he married Susie thirty-seven years ago, she knew nothing about gardening and happily accepted her role as "weeder-in-chief."

Today, a walk around the garden leads through a rose garden, modeled after one that Eliot had seen in Williamsburg. "It's much easier to grow roses there, although the best roses I have ever seen grow in the Argentine," he observes. After a lot of trouble, he finally settled on red maybeline shrub roses underplanted with agapotum and variegated grasses. From here, one proceeds down a linden allée leading to an imposing William Kent–style urn, and across a dramatic axis that directs the eye to a temple on the far-off hill. A high white-pine hedge bisects the garden and, hidden behind it, a waterfall doubles as a swimming pool. Further off, a magnificent spirea walk, more than 300 feet long, leads to the folly—a belvedere made of limestone that was purchased on a trip to England. ("Something of a maintenance nightmare," admits its owner.)

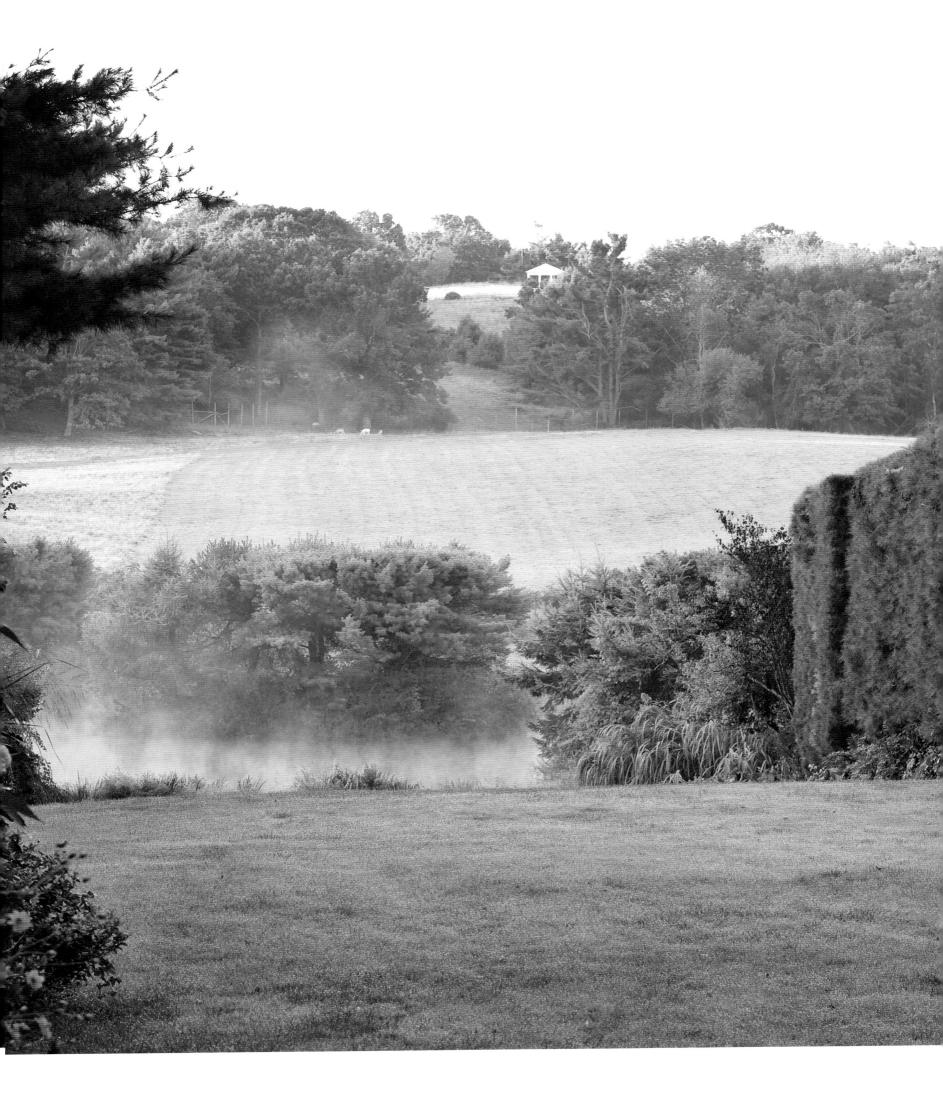

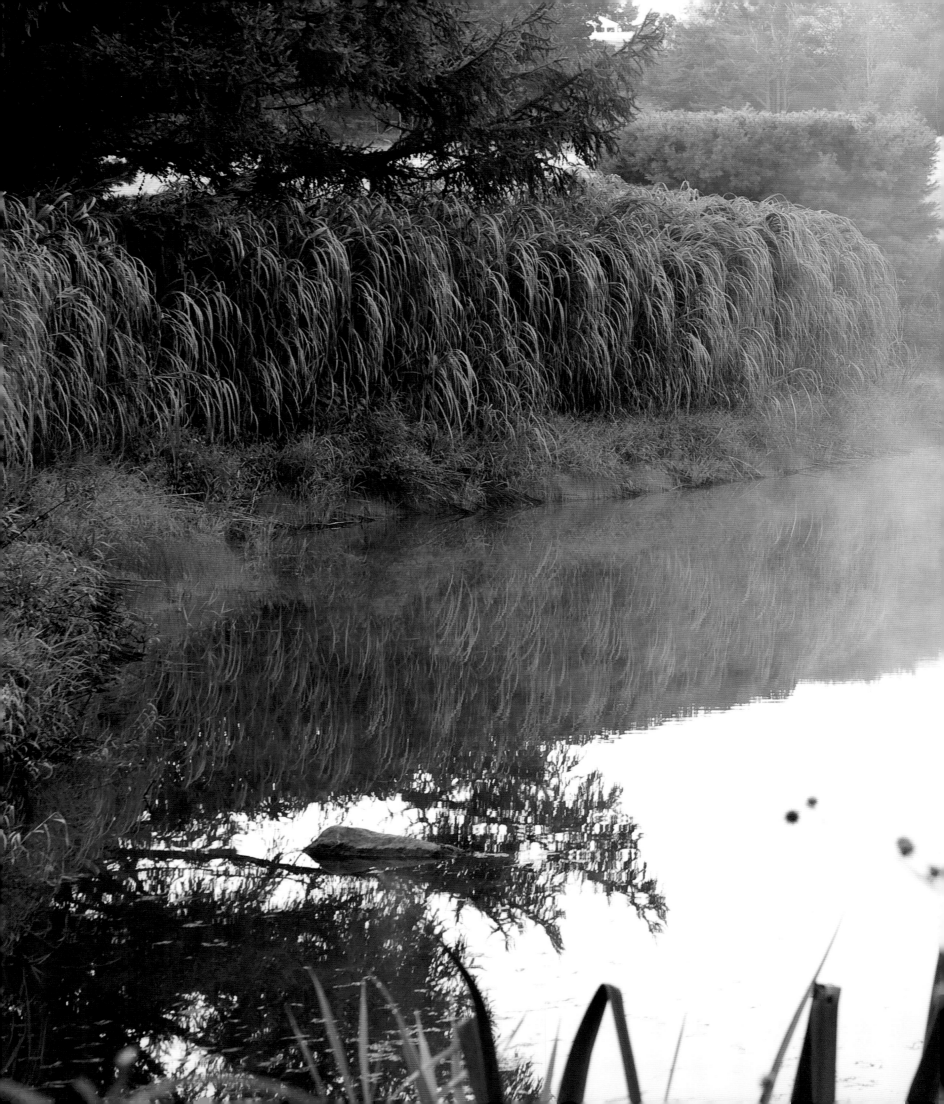

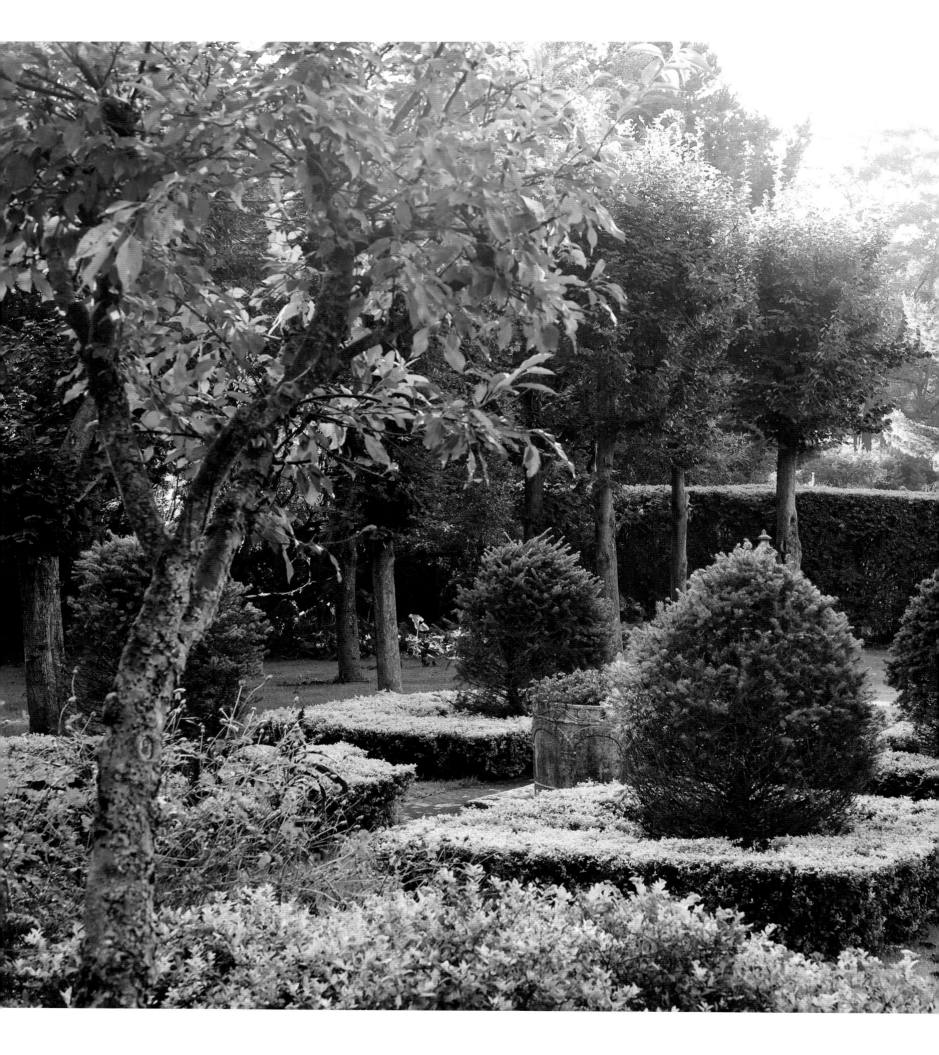

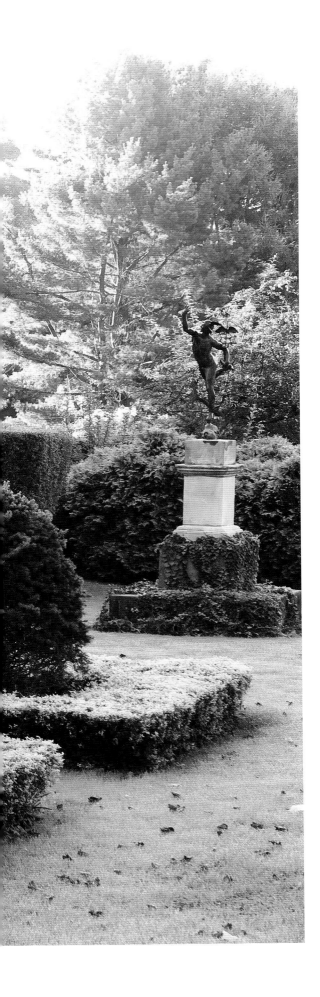

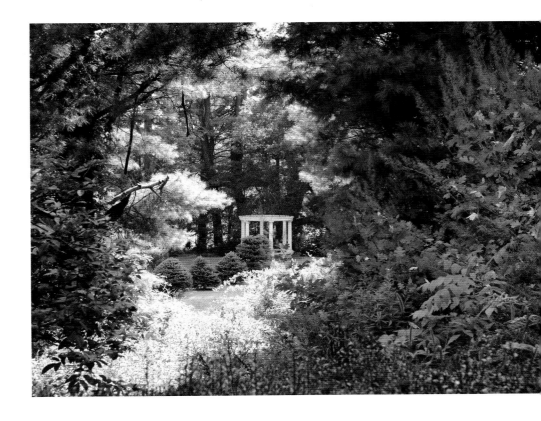

Susie's role as chief weeder ended abruptly ten years ago when her husband, running backwards to chase a deer, fell into a hole and pulled an Achilles tendon. For months, he could barely move and she stepped gallantly into the breach. They are now very much co-equals in the garden with Susie trying hard to make their garden less maintenance intensive. She has persuaded Eliot to plant shrubs rather than perennials but admits that cutting back is a Herculean task when married to someone who looks at a space and wants to fill it. Restraint is not a concept that holds much appeal for Eliot. Poppies, lilies, castor beans, hibiscus, echinacea, rudbeckia, scaevola, and phlox rub shoulders and thrive in near proximity. He is fearless in his choice of plants and although heracleum and petasites are invasive, he responds to their drama and they are always welcome in his garden.

This twenty-acre garden, where peacocks wander at large, is a remarkable endeavor. While its structure is formal, the planting is not. Eclectic, sometimes unorthodox, and always vibrant, the Clarkes' garden, with its strong European underpinnings and Yankee exuberance, has a pizzazz that is hard to match.

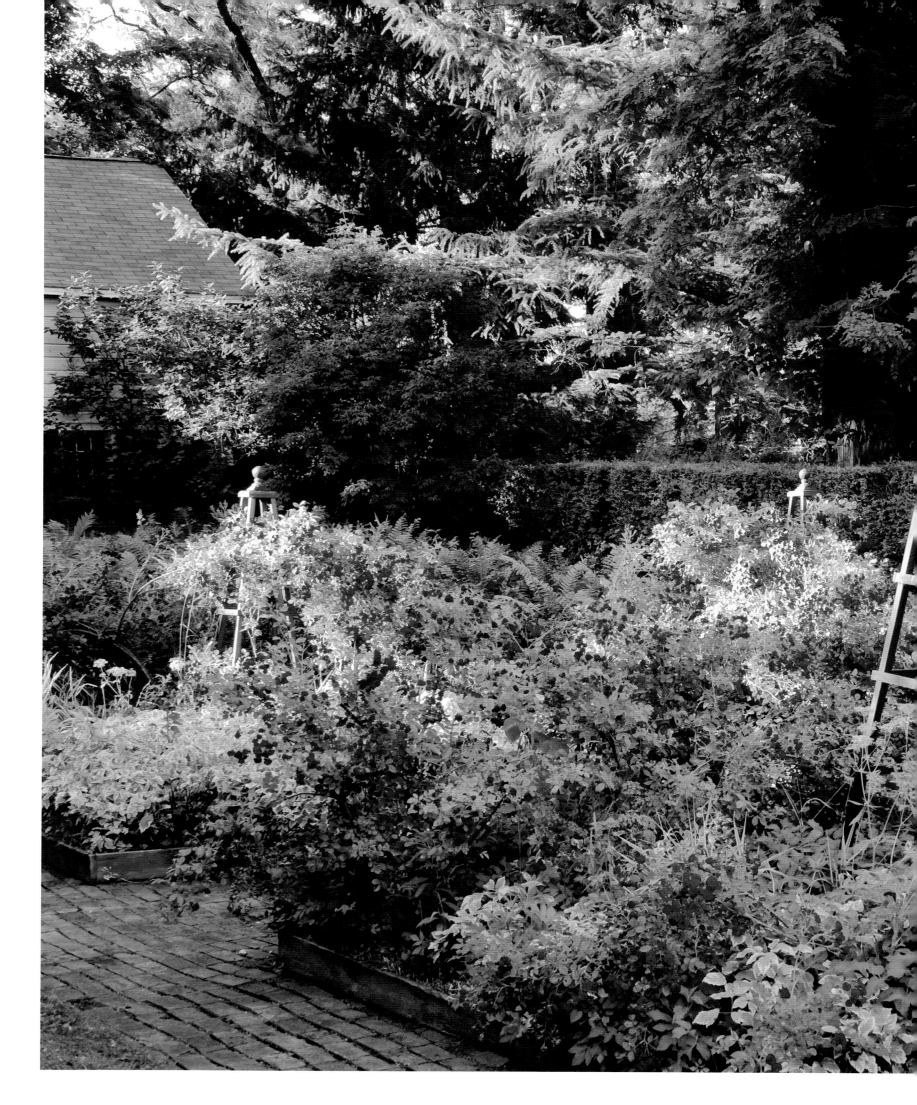

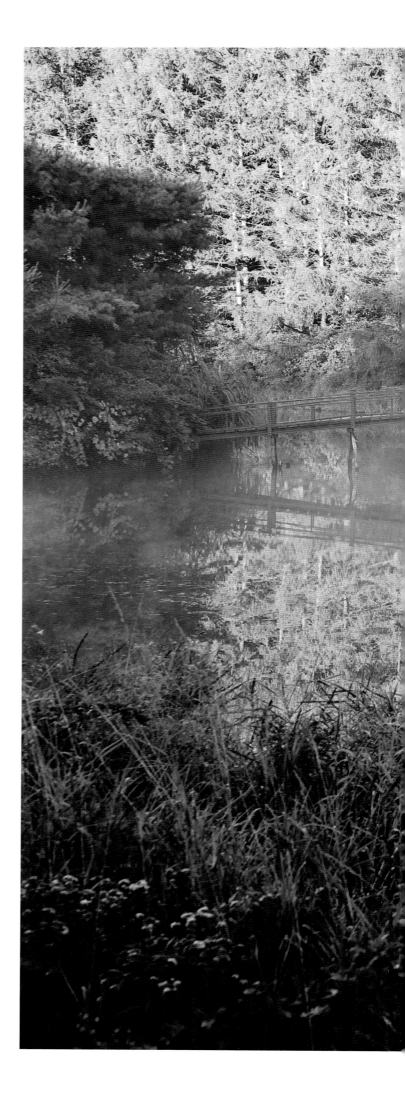

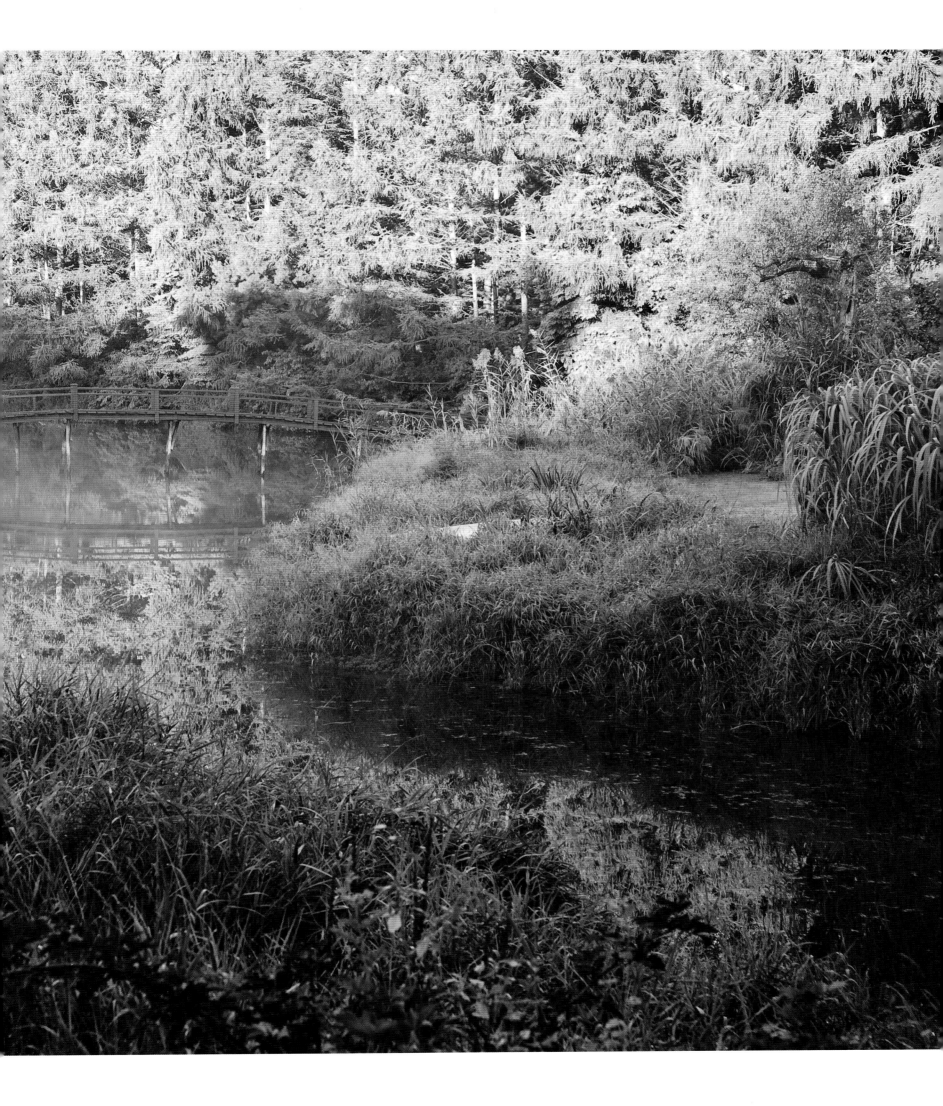

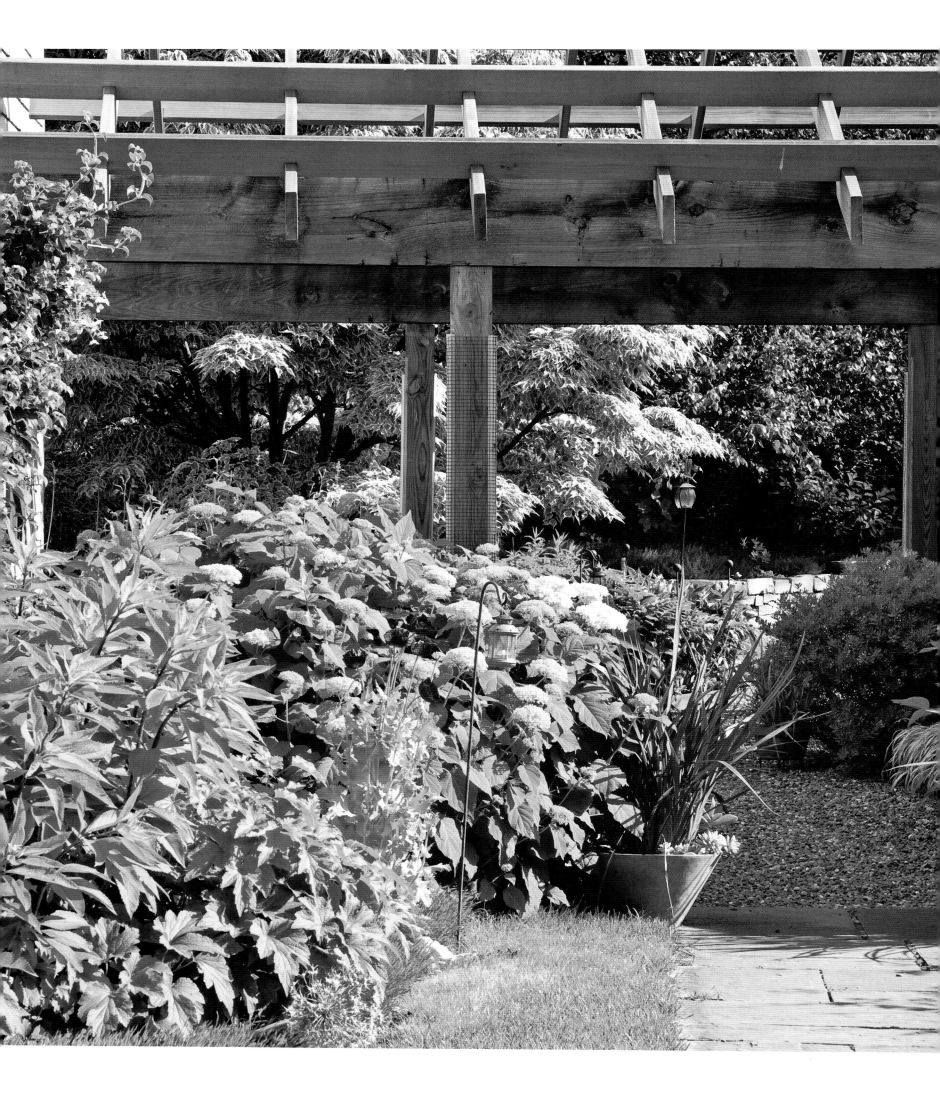

ELLEN PETERSEN ✿ STANFORDVILLE

A Plantswoman's Garden

"My aesthetic is on the messy side," says Ellen Petersen, but this is certainly not apparent to anyone visiting her garden. What is immediately evident is that Petersen is a passionate gardener. She is euphoric about plants that thrive and frets over those that languish. A walk around her garden, which doesn't seem that large until she leads you around, requires eyes that are alert, observant, and attentive. Petersen knows what's in every square inch of soil, and she takes real pleasure in talking about the foibles and rewards of each and every one of her plants. "I've always loved enormous plants like castor beans and cimicifuga," she confides. "They create atmosphere. I try to be pure about planting natives, but I am unable to resist having plants that I love, particularly peegee hydrangeas and daylilies."

Petersen always wanted to garden. "My mother was a gardener and I had read a lot of gardening books," she explains. In 1981, when she and her husband, Eric, bought their house on top of a steep hill in Stanfordville, her first venture was a vegetable garden, now long since gone. "I was a nursery school teacher at the time and for many years was only able to work on my garden on weekends and in the summer," she explains. The Petersens moved to Stanfordville full time in 2000, but before that his work took them to Pennsylvania for a few years. This gave her the opportunity to study horticulture at Longwood Gardens, where she learned about native plants and acquired much of her gardening expertise.

The main approach to the garden is through an arbor, underplanted on either side with hosta, ferns, and hydrangeas. For many years, it was covered with wisteria that, sadly, rotted out the wood and had to be removed. Now the posts and slats have been rebuilt, and the arbor is about to start on its second incarnation. It is framed on the left by a copper beech and to the right is a *Cornus kousa*, given to Petersen in 1995 by a friend from Alabama, who made her promise never to propagate it. And for Petersen, when it blooms in June, it is the star of the whole show.

"Two clematis, one hosta, and one peony were here when we arrived and they are still here. I started at the front door and planted a white lilac—my first surprise as it turned out to be purple," says Petersen. Today, the borders in her garden are filled with vigorous native shrubs and tall showy perennials such as bottlebrush, Joe Pye weed, and butterfly weed. They help blend the beds into their naturalistic surroundings. In summer, Petersen, who spends about three to four hours every day in the garden, tends to her poppies, feverfew, dill, chamomile, anise hyssop, native bleeding heart, bluebells, and columbine. In spring, visitors turning into

her drive are greeted with the intense blue of a carpet of grape hyacinth planted beneath an old apple tree, and to the right of the house, a small path leads to a glorious display of hellebores, daffodils, trillium, and tulips.

Peterson is that rare creature—a true gardener. It's a full-time commitment but one that she loves. When she isn't tending her beloved plants, her life, now that she is retired from teaching, revolves around horticulture. She reads extensively and is presently working on making a plant list. "It's a daunting undertaking, but I am inspired by my friend in Alabama, so I keep doing it." She serves on the boards of the Brooklyn Botanic Garden and Bartram's Garden, loves unusual plants, and tries never to miss the rare plant sales held at the University of Delaware twice a year. She particularly loves a nursery in Charlestown, Rhode Island, with the charmingly improbable name of Fantastic Umbrella Factory Gardens. "All my 'What's that?' plants come from them, and they have wonderfully interesting perennials," she says. "I hate to say it but the garden is still getting bigger," she confides, sounding none too guilty. No matter, she would not have it any other way.

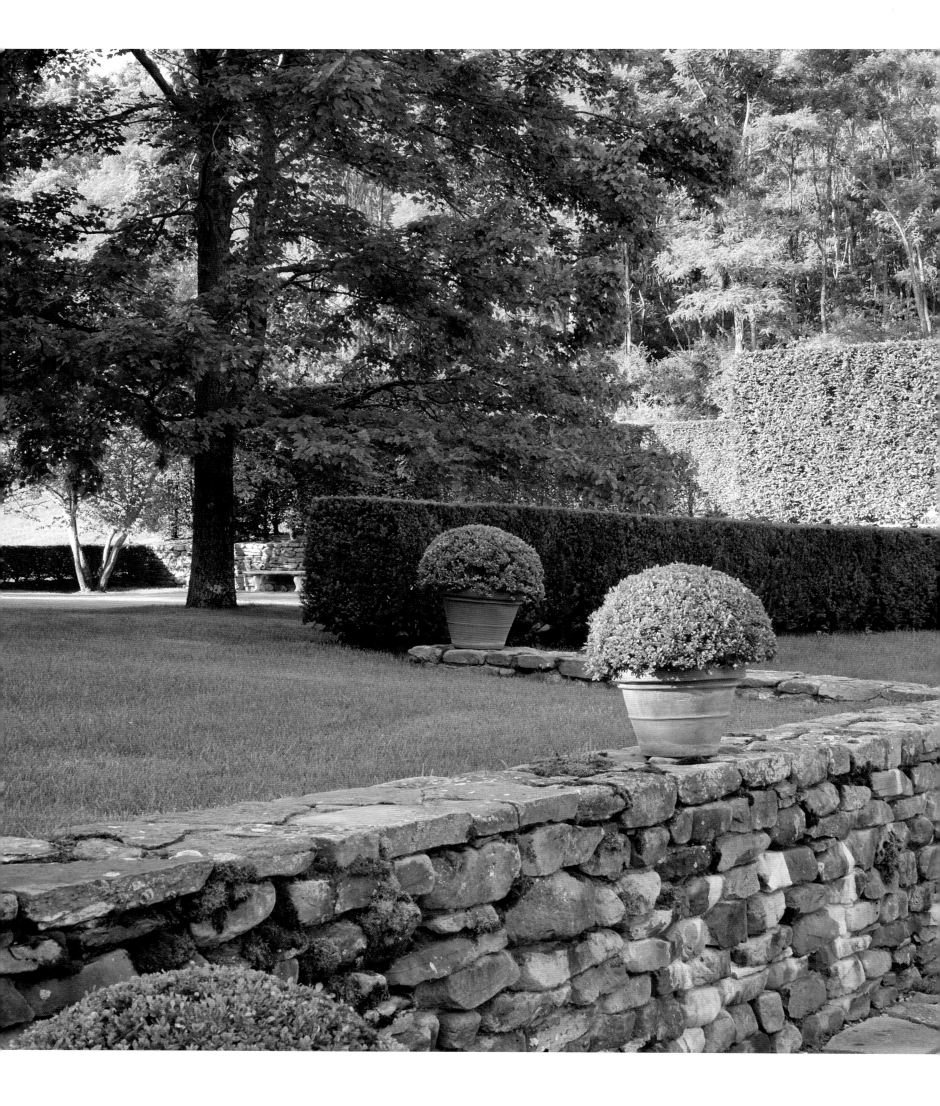

Structure and Style

Gil Schafer is a traditional architect whose expertise is building new old houses and renovating or updating historic ones. In the mid 1990s, he began a search in Dutchess County to find an old nineteenth-century Greek Revival house. But, after three years, unable to find anything that satisfied his aesthetic or fit his budget, he decided instead to buy a parcel of pristine meadowland. This is where he has built an imposing Greek Revival farmhouse. Fronted by four huge double-story Doric columns and anchored to its landscape by a network of terraced stone walls and high hedges, Middlewood feels historical to its core.

From the road, a long winding drive climbs a gentle incline, traverses the woods, and offers a few brief glimpses of Middlewood before reaching a simple gravel fore-court facing the house. Four fig trees in planters, drystone walls, a white bench, and large pots of boxwood are the only decorative features of this courtyard space, apart from a set of shallow stone-edged grass steps leading to the portico.

The house was finished in 1999 but even before construction got underway, Schafer worked with noted garden designer Deborah Nevins to create what he calls a "precinct" around the house. Their plan was to design a series of enclosed garden rooms, and to do this, Schafer and Nevins cut into the meadow to deline-ate where to place the stone walls, hedging, trees, lawn, and terraces needed to mediate between the architecture of the house and the topography of the land. Managing the tension that exists between a formal landscape garden and the sur-rounding countryside demands what Schafer calls "celebrating the juxtaposition and defining its edges." He and Nevins relocated a group of shale trees to the end of the valley and planted hawthorn and red maple trees in the meadow against a ravishing backdrop of existing locust trees. "I bought the biggest trees I could afford so it would look like a place as soon as possible," says Schafer.

The most dramatic part of the garden is the hornbeam room, set on axis with a screened porch and entered by a flight of seven shallow grass steps that to the eye appear equal, but Schafer, who understands the illusionary tricks used by classical architects, has adroitly made their treads unequal—the bottom one being deeper than the top. The rigid angles of the twelve-foot hornbeam walls have the abstract look of a piece of contemporary sculpture and the only decorative element in this garden room is a white bench, carefully placed in austere splendor at the far end.

Large terracotta pots of boxwood and hydrangeas are placed throughout the garden and three lichen-covered steamer chairs grace the lawn at the back of the house, where wisteria covers a classic pergola, inspired by the one at architect Charles Adams Platt's house in Cornish, New Hampshire. To one side of the house, there is a miniature kitchen garden enclosed by a whitewashed fence and furnished with a steeple from a church in Maine, an oversized urn, and some espaliered apple trees. Designed by Michael Trapp, this garden, planted with white roses, has a pergola thickly swathed with autumn clematis.

Despite touches of color, Schafer's garden is essentially, and quite intentionally, a green garden. He says that when he built the house he knew very little about flowers and didn't think he would be able to take care of them. Having read an article by Anne Raver extolling the virtue and practicality of hornbeam hedges, he decided that hedges were what he wanted and this is, he explains, "what my garden is all about." As carefully choreographed as Schafer's house, this dramatically restrained garden is all about craftsmanship and style.

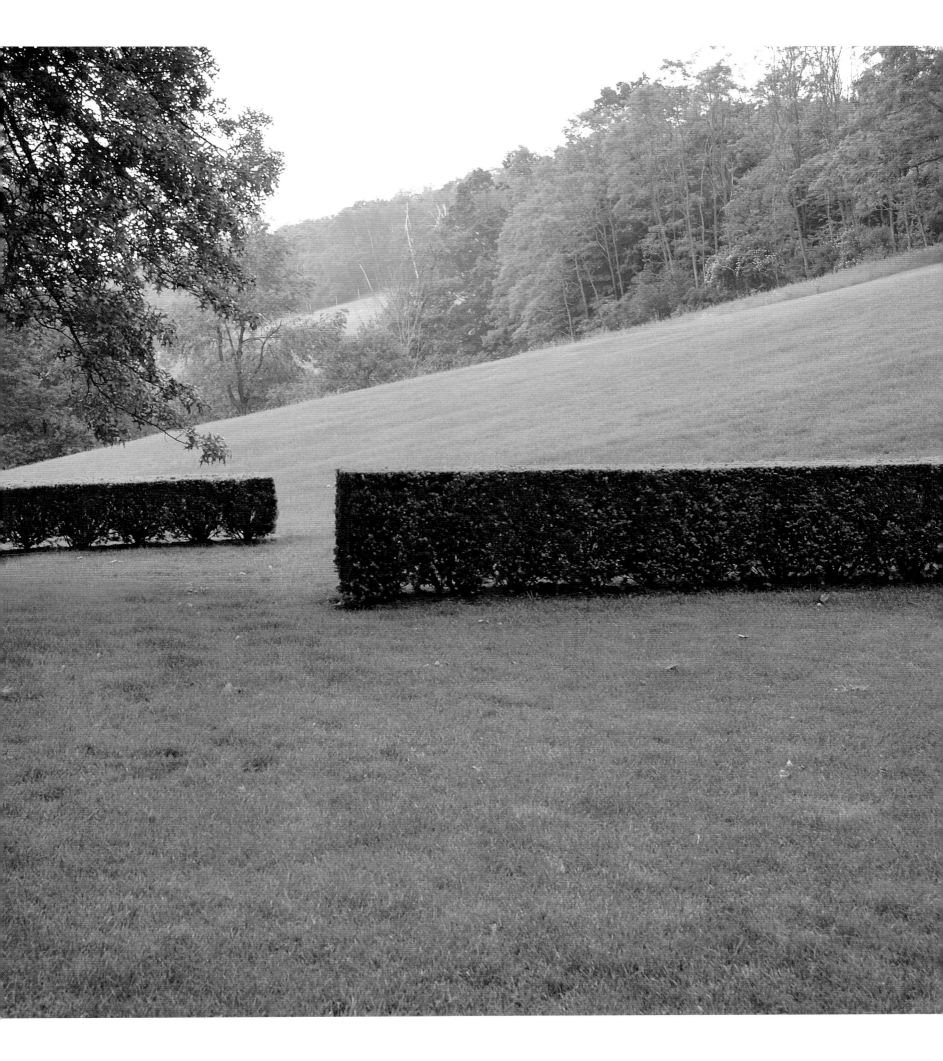

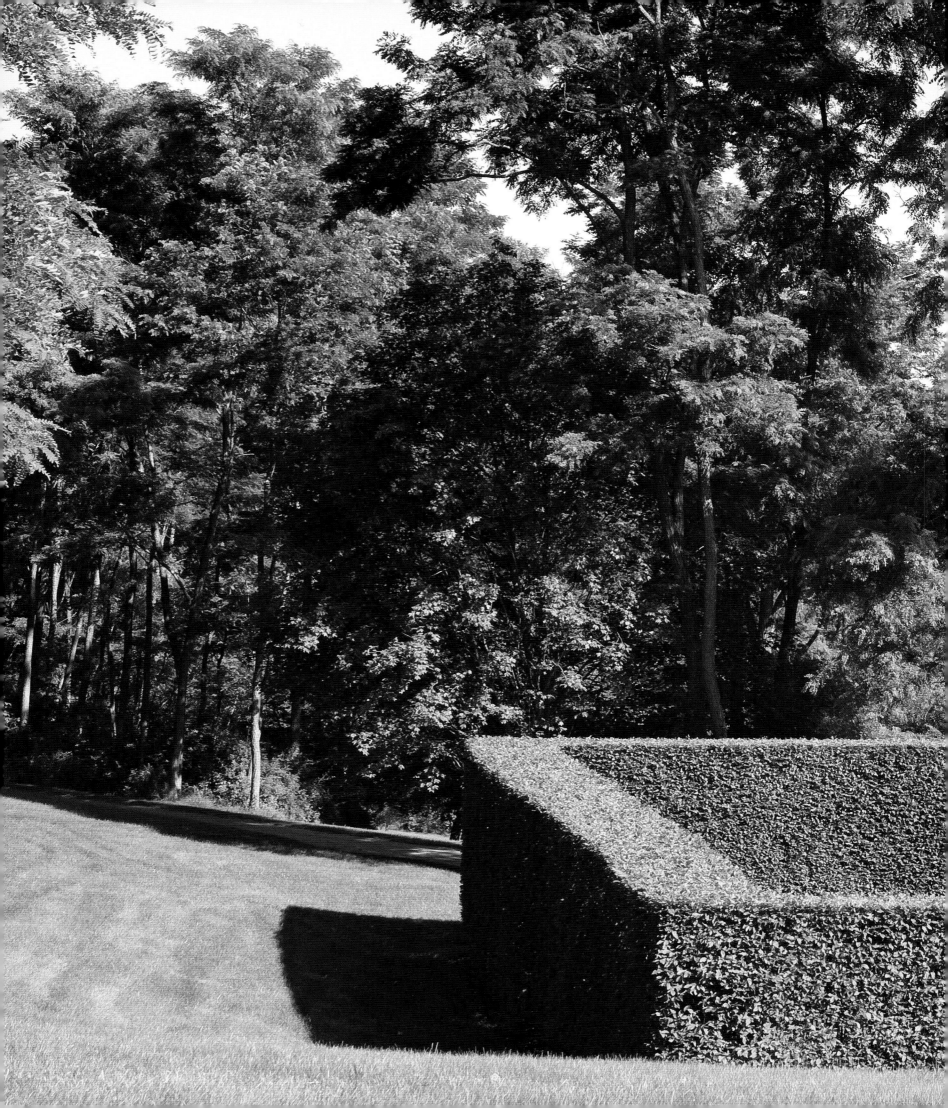

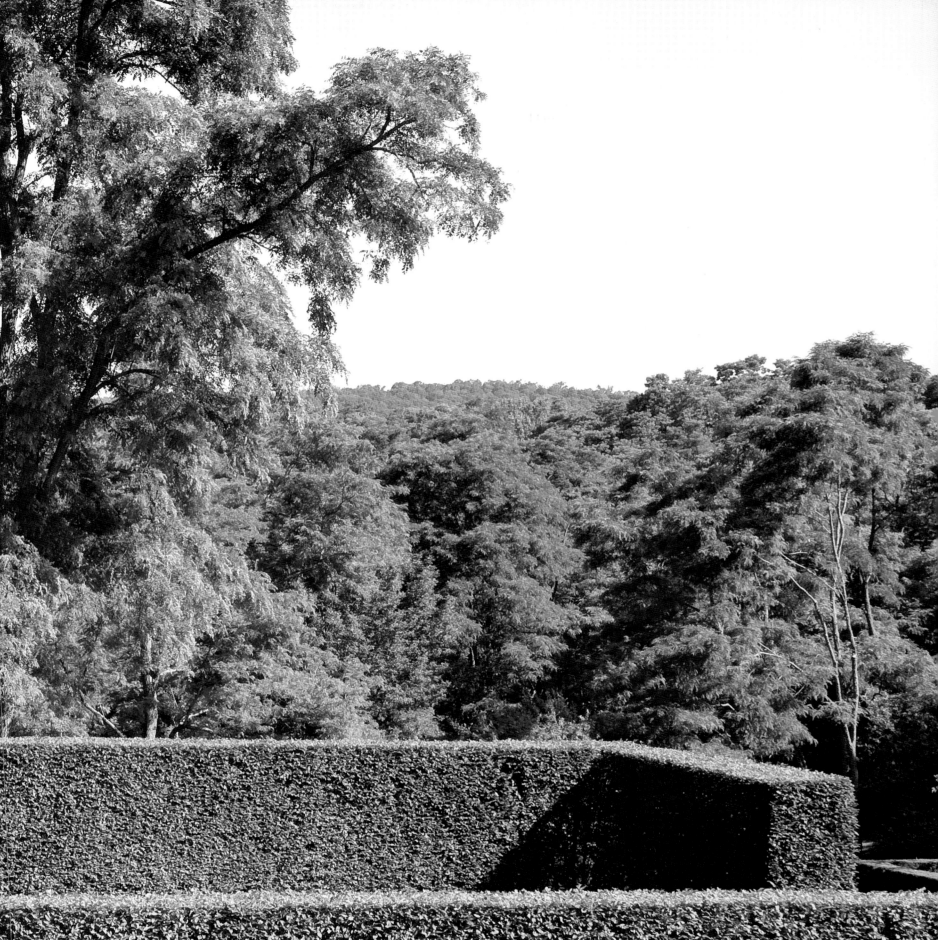

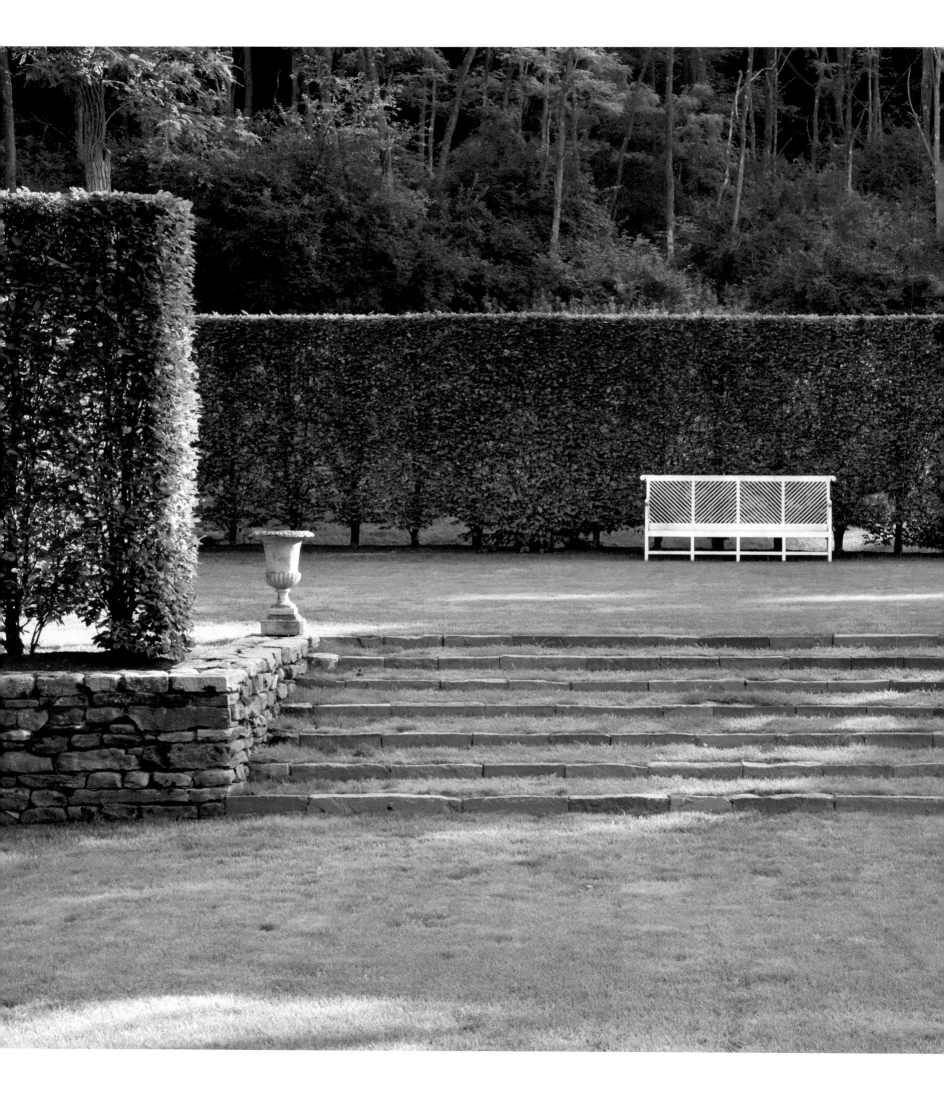

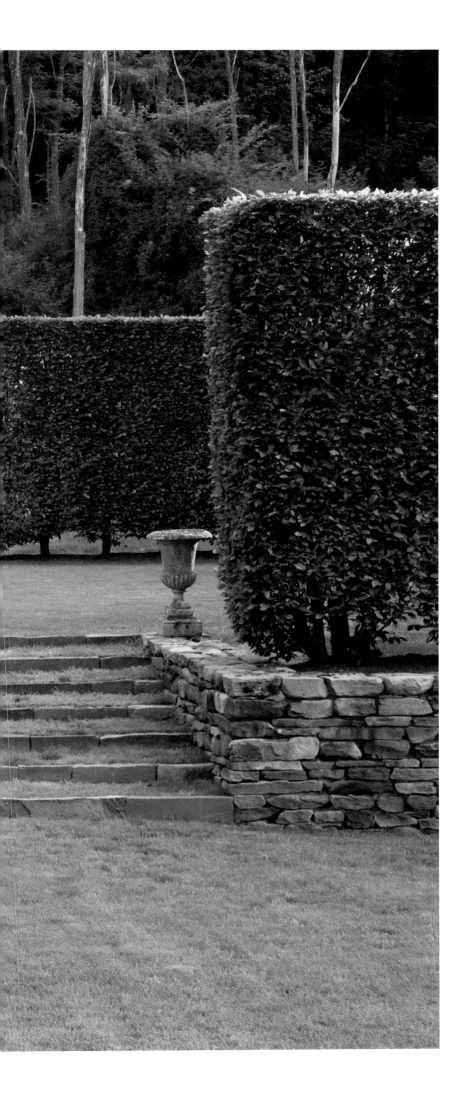

Becoming a Gardener

"My mother had a fabulous garden and when I wanted to have a garden of my own she gave me the best advice, telling me to go look at what grows for other people before starting out myself," says Betsey Ely, adding that at the time she was too young to pay enough attention to her mother's directive.

Ely grew up in Canada. When she and her husband, Jonathan, began their search for a house in the country, she told him that as a Canadian, water was her one non-negotiable. It was the winter of 1971, and when they found a house they both liked, the property was entirely covered with ice and snow. The broker assured them that there was a pond but, as Ely explains, "We had no idea how large it would be." When spring arrived, they were astonished and delighted to find that it was huge. "Technically a lake is five acres so it's actually just a large pond," says Ely. Maybe, but most people would think she has a lake. Although it is some distance from the main garden, thanks to a floating gazebo, the pond is an integral part of her garden landscape. Twenty years ago, the idea came to Ely when she purchased a gazebo kit at the Philadelphia Flower Show. She had it constructed and mounted on a platform under which a motor was installed. For her children, it was a giant water toy; for Ely it was and still is the perfect place to entertain; and for her guests it is a marvelous venue for cocktails and sunset boat rides.

There wasn't much in the way of a garden when Ely and her husband acquired their house—only a forlorn row of peonies. In 1982, Ely met designer Tim Steinhoff and asked him to lay out a garden. He placed two long beds between the house and the barn and took charge of the planting. "Thanks to Tim," says Ely, "the garden has bones and structure, and he still comes every year to give me suggestions about what to do." Steinhoff selected plume poppy, heptacodium, flocks, cotinus, and box, and also introduced her to *Calycanthus*. "Now that my garden is thirty years old, it's beginning to change," says Ely. "I have begun to pump it up with more shrubs. I love the contrast that comes from putting sawbuck next to *Sorbaria sorbifolia*, next to an oak leaf hydrangea." Peter Smithers's *Adventures of a Gardener*, which describes his move away from perennials to trees and shrubs has been a big influence on Ely, who credits her development as a gardener to "always hiring people to work in the garden who know more than me, and learning over time not to plant one, three, or even nine of something but to go for at least a dozen."

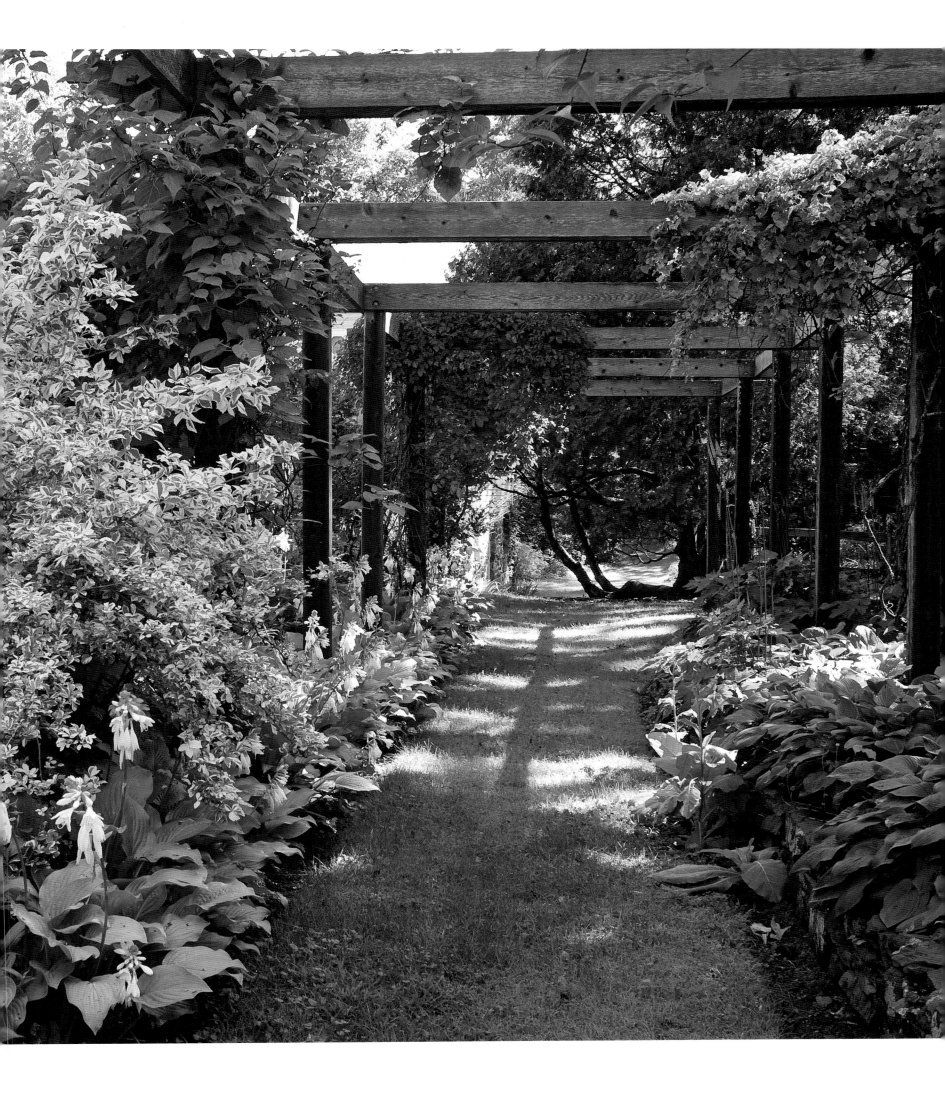

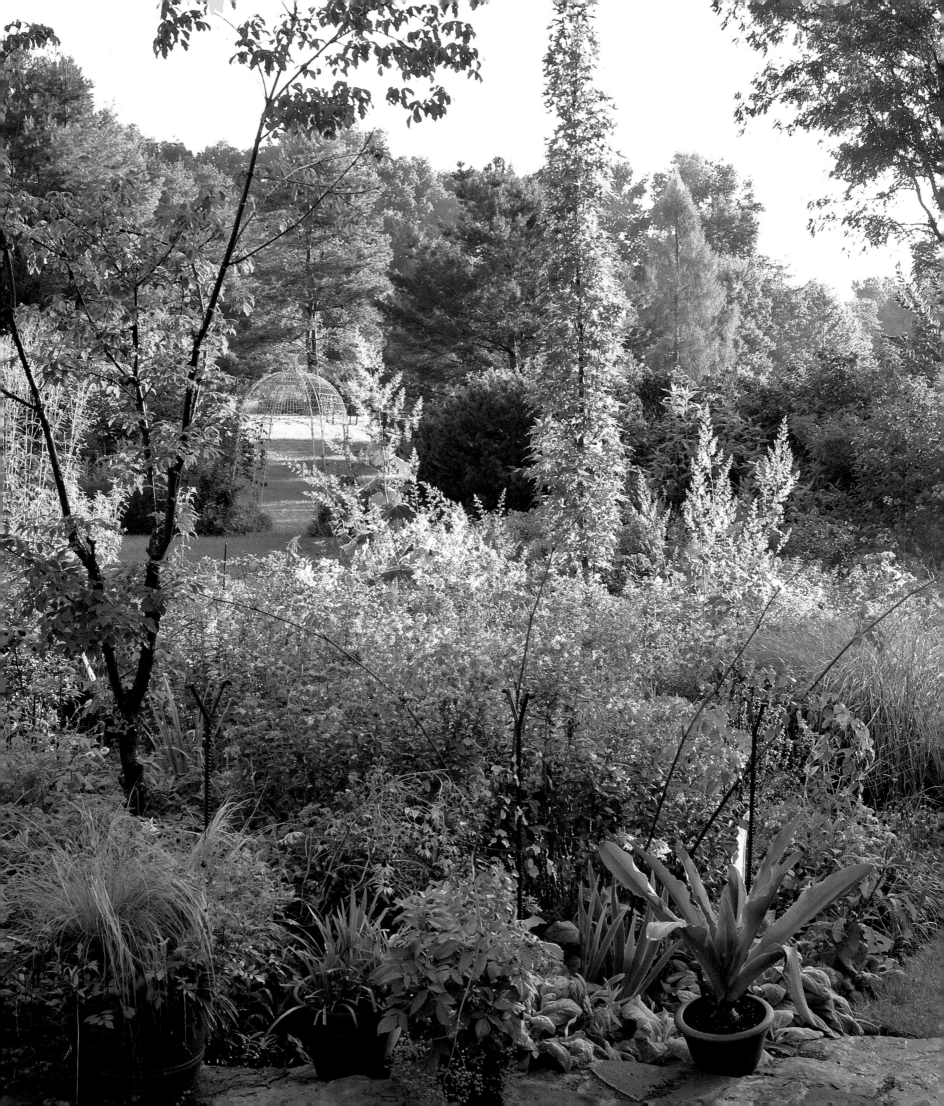

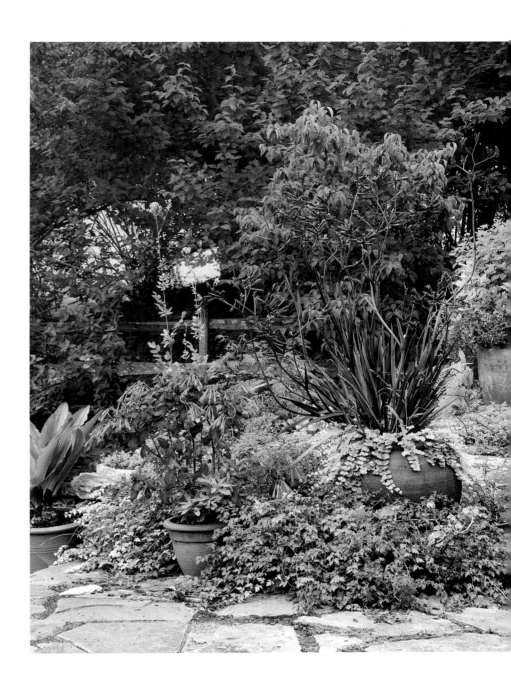

A few years ago, when Ely moved the driveway further away from the house, nicotiana and Verbena *bonariensis* began to self seed at the edges of the gravel and their quiet encroachment has been transformative. The terrace at the back of the house, filled with pots, is another special place, and Ely's most recent project is a set of rounded steps to make a gentler transition from the terrace into the garden.

Whether Ely is extolling the charms of a rare plant she has recently acquired, delighting that Mrs. Robert Brydon and Nelly Moser, the two clematis that by midsummer are romping over her antique wire arbor, have never looked so good, or deftly steering her floating gazebo to allow her guests a better view of the garden, her infectious enthusiasm is always evident and her garden responds in kind.

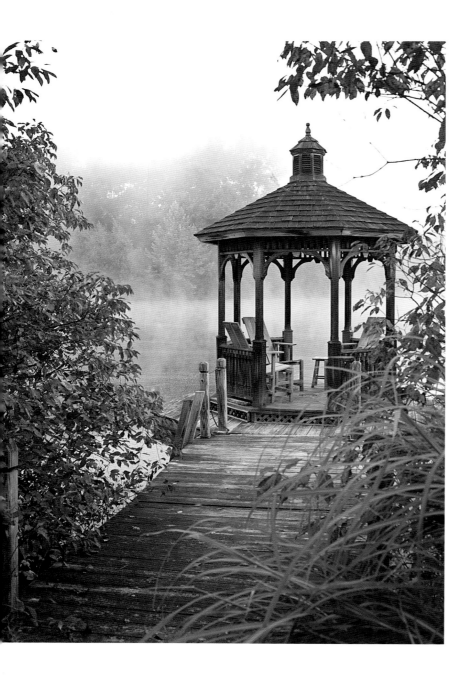

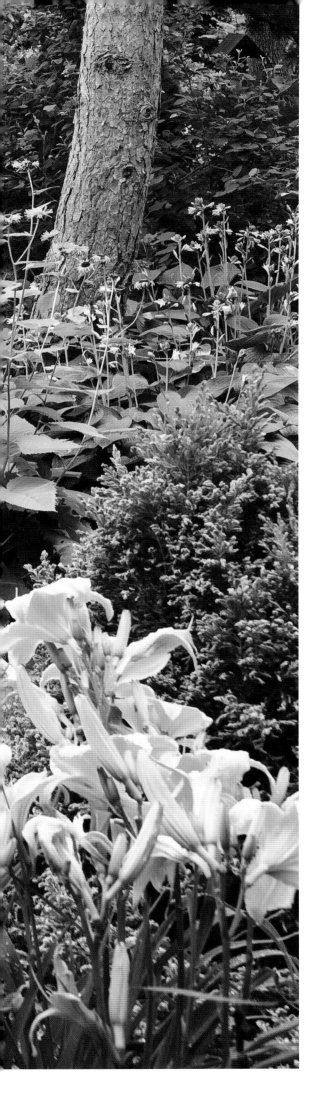

RICHARD GALEF AND SUSAN ANTHONY

❧ CRARYVILLE

Taming the Wilderness

"I was born in Manhattan and didn't know a tree from a lamp post. My wife, who grew up in Brooklyn, had about the same level of expertise," says Richard Galef, wanting to clarify his total lack of horticultural skills at the time he and his wife, Susan Anthony, purchased a small tenant farm in the township of Taghkanic. "It was a simple decision," she explains. "It was 1981, we wanted somewhere to go on weekends, the place was cheap, and it looked like it had hope." The house was surrounded by woods and scrubland, the space in front was filled with abandoned cars and trucks, and the only access to the front door was a steep slippery slope with no steps. Hardly prepossessing but Galef and Anthony were not deterred.

"There had once been a vegetable garden and I thought I would like to grow vegetables, but it proved something of a disaster," says Anthony, who next turned her attention to flowers. About that time, Galef decided to get to work on building a terrace and stone walls around the house and putting in some much needed steps. Never having done anything like this, he bought a book and taught himself the rudiments of stone masonry. While he built the walls, using only local stones, she began to plant beds around them, and their garden proper got underway.

Once the walls were finished, Galef, an industrial designer by profession, turned his attention to the garden. He began by clearing the dense woods nearest the house. "It just took off and became my obsession," he explains. Not only did a view of the distant Berkshire hills start to appear, but a giant rock began to emerge. It was a glistening pure white so he christened it "Moby Dick." After several years of cutting down trees, hauling away roots, and shoveling earth, Galef finally exposed the entire ledge. Over time and being exposed to the elements, Moby Dick (which measures 180 by 45 feet) has weathered to a gentle gray. Lichen, moss, and sedums grow in the crevices and some slender birch trees have sprouted out of its clefts.

Cutting into the woods behind Moby Dick, Galef has made an intricate woodland garden with twisting stone paths that meander into small clearings, hidden groves, and even a luxuriant moss garden. The native trees have been pruned to make a high canopy and Galef has planted many new trees and shrubs wherever space allows.

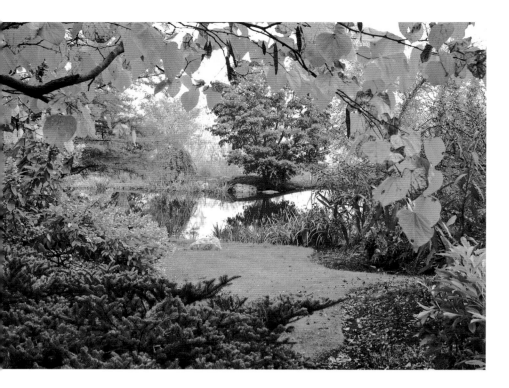

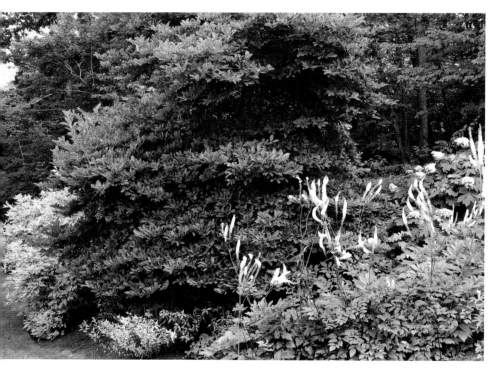

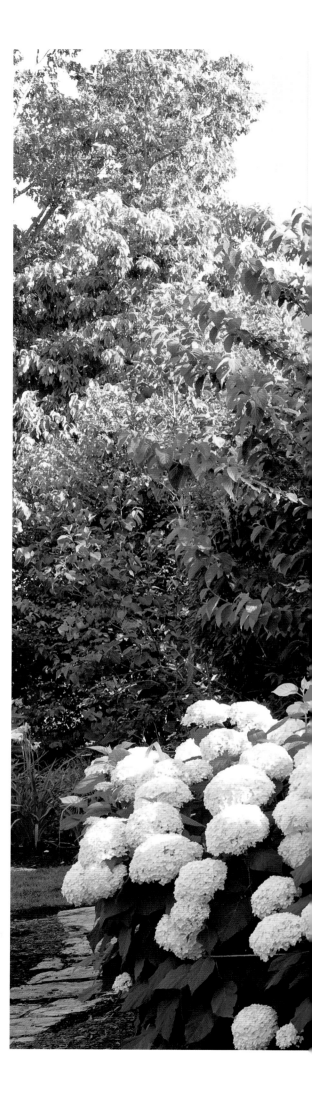

While Galef designs the landscape and selects the trees and shrubs, the large perennial border and the beds near the house are his wife's domain. "I'm getting interested in simplifying and cutting back," she admits, explaining that she spends less time in the garden than she once did. Galef, however, is probably spending more! He is never without a new project in mind and is in the garden from dawn to dusk, tending to his magic woodland. "Yes," he says with a smile. "For the present, I am Moby Dick's master, or at least it pleases me to think I am."

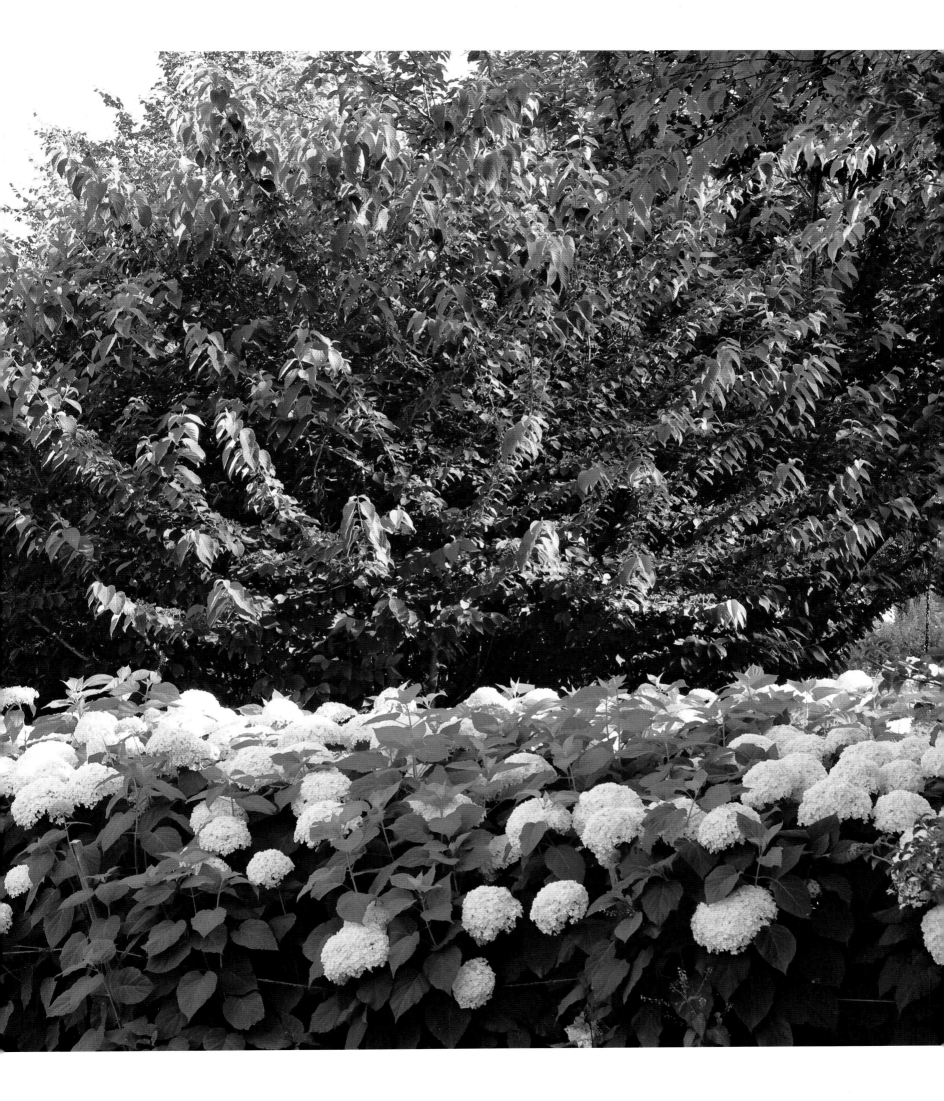

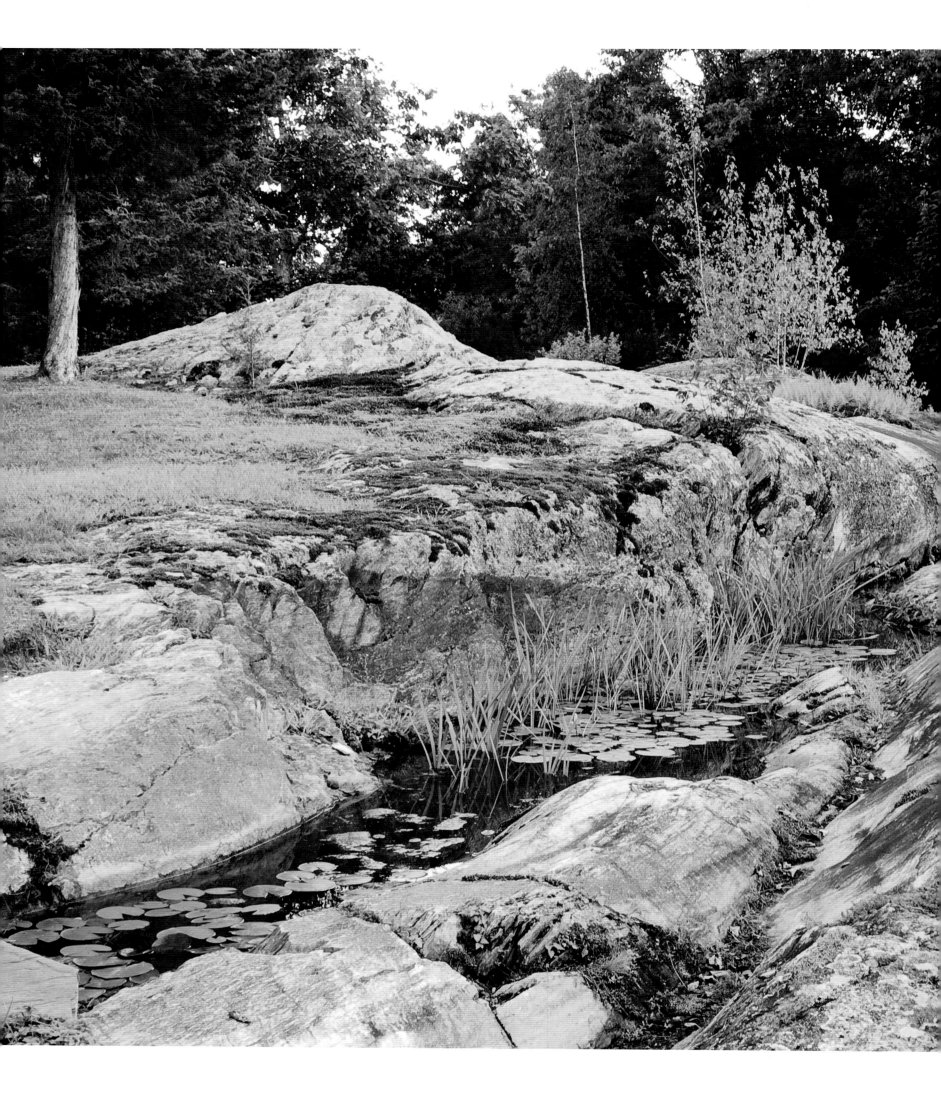

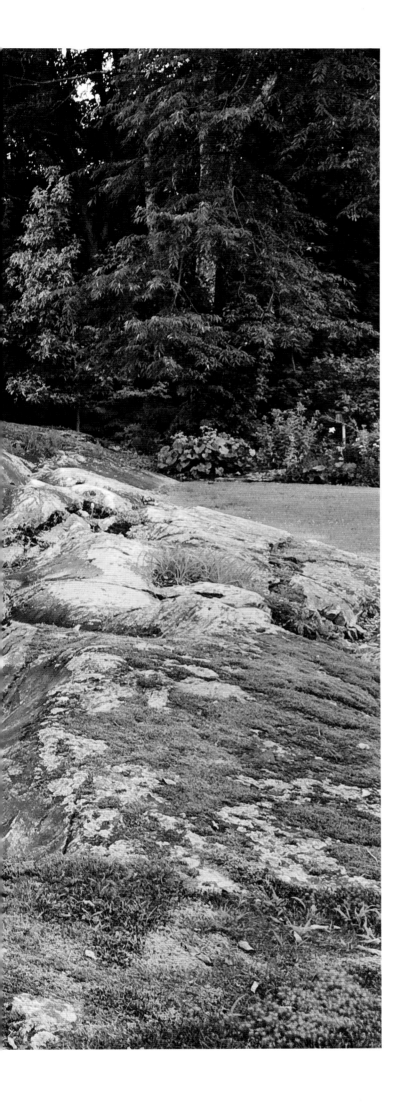

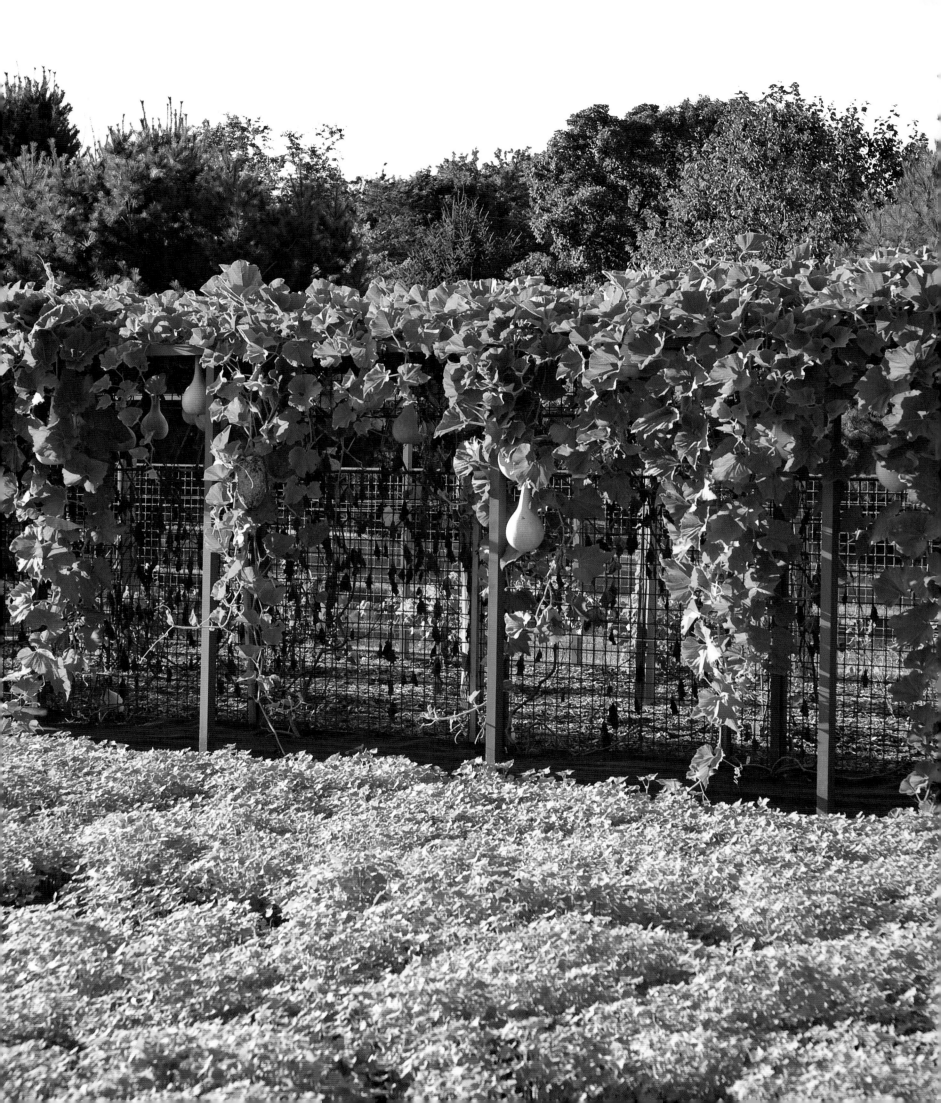

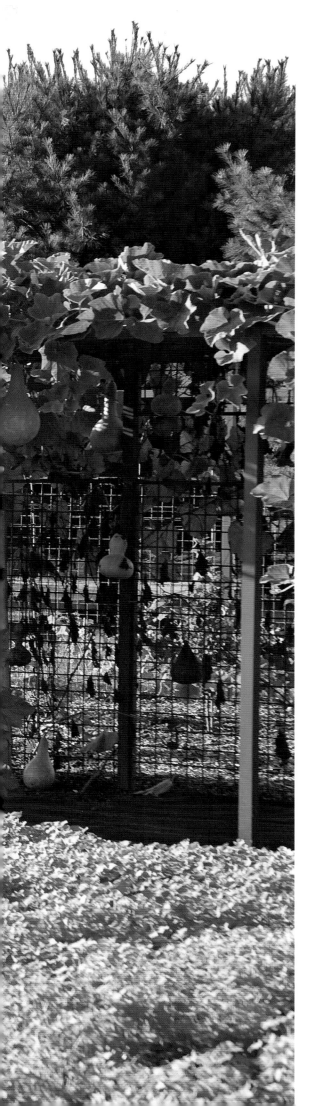

The Bountiful Garden

For Amy Goldman, winning the grand champion rosette in vegetables with thirty-eight blue ribbons at the 1996 Dutchess County Fair—a feat she admits she pulled off only after years of preparation—gave her as much satisfaction as earning her doctoral degree in psychology. A psychologist turned gardener, who idolizes zucchini, tomatoes, pumpkins, gourds, melons, and marrows, Goldman has emerged as one of the most vocal and influential advocates for heirloom fruits and vegetables, and is someone who, according to the *New York Times*, "has turned the act of growing them into an art form."

She has channeled her encyclopedic expertise into prize-winning books on tomatoes, squash, and melons, and is now at work on a book about peppers. This will take her four to five years since she plans to grow and profile about 250 varieties that come from both the old and new world. Just mentioning some of their names 'Hungarian Wax Banana,' 'Ring of Fire,' 'Masquerade,' 'Clouds'—her enthusiasm is palpable.

All summer long, Goldman dotes on her vegetables on her 200-acre property in the Hudson River Valley. Her main working area is an enclosed vegetable garden of one acre, which she began in 1989. In every respect it functions as a serious, technical laboratory. Most of its surface is covered with a sea of black plastic sheeting and the soil has been enriched with pond mulch and leaf mold. "Amy's Folly," she says with a laugh. All her crops are carefully labeled, and their progress, or lack thereof, is meticulously observed. Come many a summer evening, Goldman can be found painstakingly hand-pollinating her beloved squashes one by one since she knows that this is the only way to ensure the genetic purity of next year's crop. Each vegetable has its own restricted space. In one area, Goldman grows twenty different kinds of watermelons, and some are gargantuan. An important part of her husbandry is taping shut the female blossoms in order to control pollination. "Plants are very promiscuous and I don't want 'Moon and Stars' to cross-pollinate with another variety," she explains, as if this were a precaution any reasonable person would undertake as a matter of course.

The most visually dramatic part of Goldman's vegetable garden is a long pergola. By midsummer, it is laden with about fifty pendulous, hard-shelled gourds. Several varieties of warty bule and dipper gourds, a snake gourd, and bilobal bottle gourds hang from its trellised roof, and their luminous shades and twisted shapes have an eerie moonlike presence.

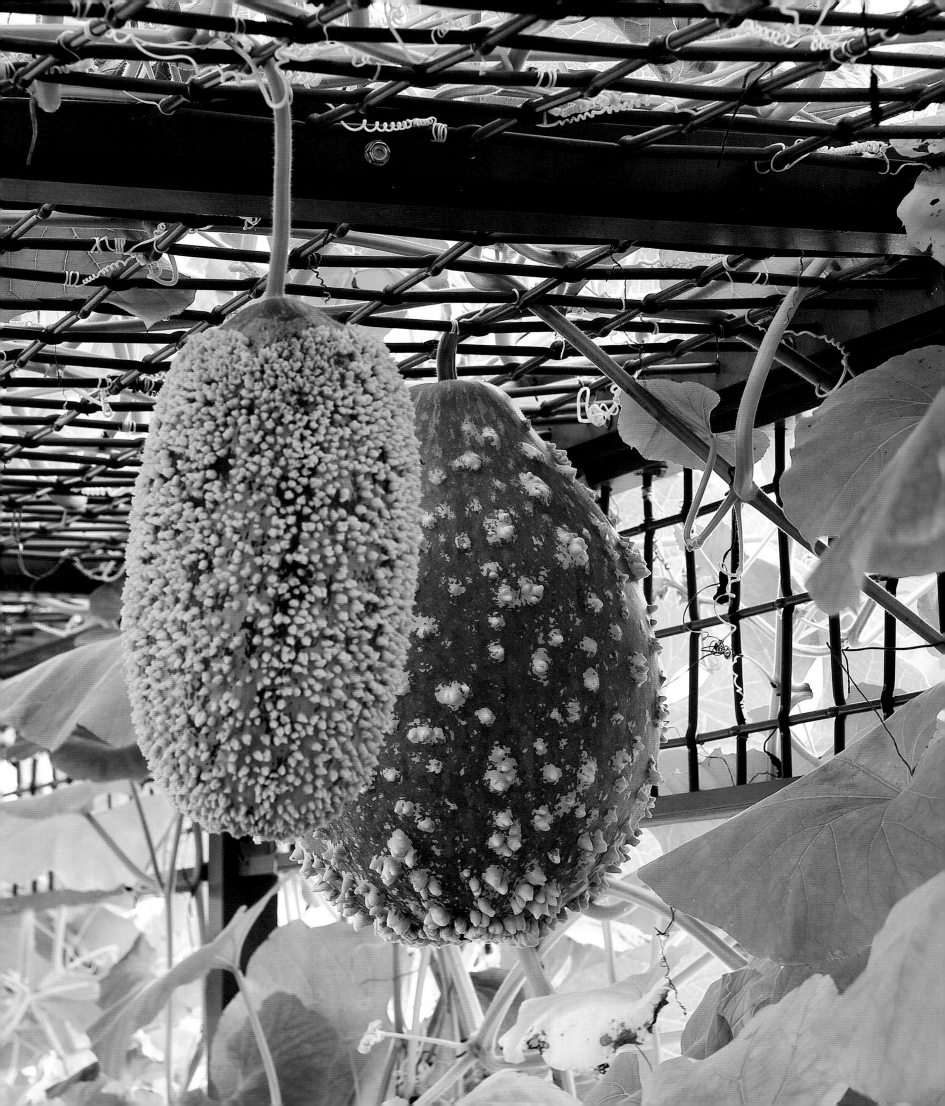

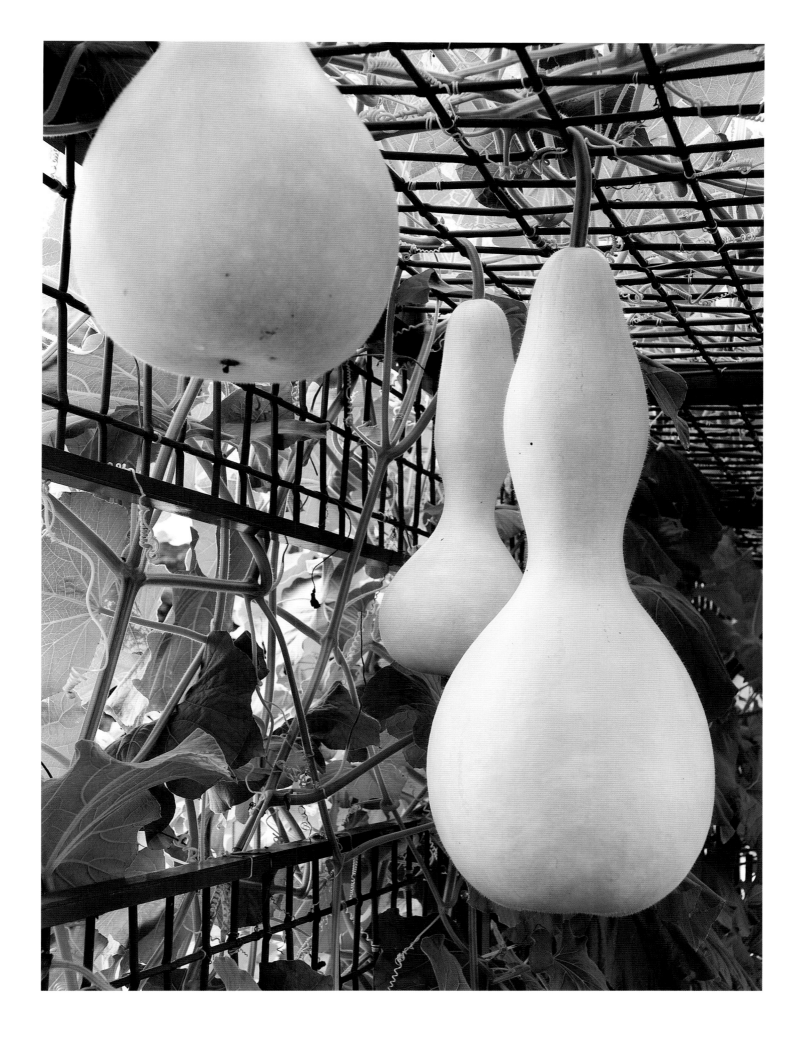

Goldman moved to Rhinebeck in 1978 to take up an internship required for her psychology degree. But then she fell in love with vegetables and decided to devote all her time to growing and studying them. In addition to her main vegetable garden, she also has a much smaller vegetable garden, much closer to the house. Here, she grows vegetables in small quantities for her own use. She recently remarried, and as her husband is a Southerner, she grows a spectacular red stalked okra (its flowers resemble hibiscus blooms) and mustard greens for him. There are also carrots, cabbages, leeks, eggplants, and Goldman's Italian-American tomato, a variety that she says, "has an inexplicable urge to spread its seeds near and far. It is voluptuous, red-ribbed, and very heavy in the hips, making sauce as thick and rich as any tomato I've ever grown." The seeds are from some tomatoes that she bought from a roadside grocery store near the Villa d'Este in Cernobbio in 1999, and she named the tomato for her father's grocery store in Brooklyn. Goldman's enthusiasm for this tomato, which she describes as having "an excellent, sweet, and luscious flavor and weighing about one pound," speaks to the intensity of her knowledge and expertise. Nothing is left to chance in Goldman's garden, where growing vegetables is an impassioned adventure.

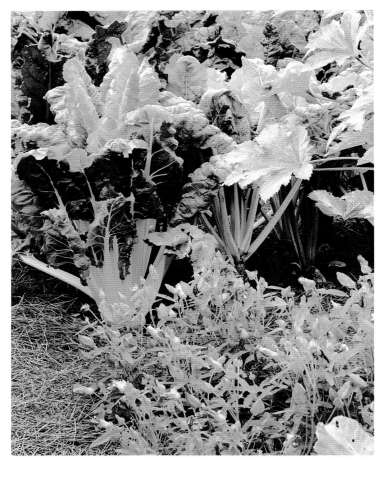

A Penchant for Color

Zibby Tozer has always loved flowers. She is the author of *The Art of Flower Arranging*, and for many years she worked in the flower business, at one time owning two shops in New York. Weddings were her specialty. Although she never kept a formal count, she thinks that she probably did flowers for more than one thousand weddings. However, although she moved in a world of heady and exotic blooms, Tozer did not have a garden of her own until 1987 when she and her husband, Jim, purchased a farmhouse in Dutchess County. Not surprisingly, she wanted a garden that would be vibrant with color, heavy with scent, and filled with flowers.

At that time, there was a wreck of a swimming pool and a few daylilies but not much else. The pool, sited in view of the house, was the obvious place to begin to make a garden. Rather than cutting it off from the rest of the property, Tozer screened it with a seventy-foot border that cleverly meshes into the larger garden. Banked with

grasses and perennials, including roses, artemisia, cimicifuga, yucca, salvia, and stachys, it does double duty as she has designed it to be seen both from the pool and from the larger garden. At the far end, there is an arbor with a latticed trellis inspired by a rustic teahouse Tozer saw at Kykuit, the Rockefeller estate in Pocantico Hills. Steps leading up to it are flanked by two decorative spruce trees and a pair of gargoyles brought back from a trip to Hong Kong. A good spot for sitting, this poolside arbor anchors the pool and gives definition to the space.

Tozer was the successful bidder on a white gate designed by landscape architect Charles Stick for one of the New York Horticultural Society's last flower shows in New York. It now opens into an enclosed flower garden, where Tozer has also placed a large white tuteur, two blue trapezoidal loveseats, and a blue Moorish-style gate designed by Madison Cox. Having two gates with different colors and different designs open into the same garden might raise eyebrows with some purists but Tozer's attitude has always been "Why not!" The garden, intended to be seen from a conservatory that the Tozers have added to the back of the house, was created around a hickory tree and planned to be a shade garden with restricted dappled light. A few years ago, the tree fell down and with it went the shade. Today, foxgloves, forget-me-nots, and lilies co-exist happily with hosta, dicentra, and other shade-loving plants. Two undulating coiled toparied Alberta spruces stand to attention on either side of one of the entrances to this garden. Once a pair of upright trees, "one of them almost died so the only thing to do was reinvent them," says Tozer cheerfully.

Five miniature horses graze contentedly in a large paddock—"Something of an impulse buy," she admits. Next to the paddock, a series of large arches, bordered by nepeta and covered with William Baffin roses, define the edges of a wide grass path leading to the meadow beyond. Tozer loves container plants, and there is a great variety of planters in her garden. These include old beer kegs, banded in black and white, stone pots, and imposing wrought-iron urns. All of them are planted with a dazzling array of annuals, predominantly blue and pink. "I probably use too many," she says, "but I love color and simply can't resist." And why not? It is color, bold and inviting, that creates the overriding impact in this well-ordered garden.

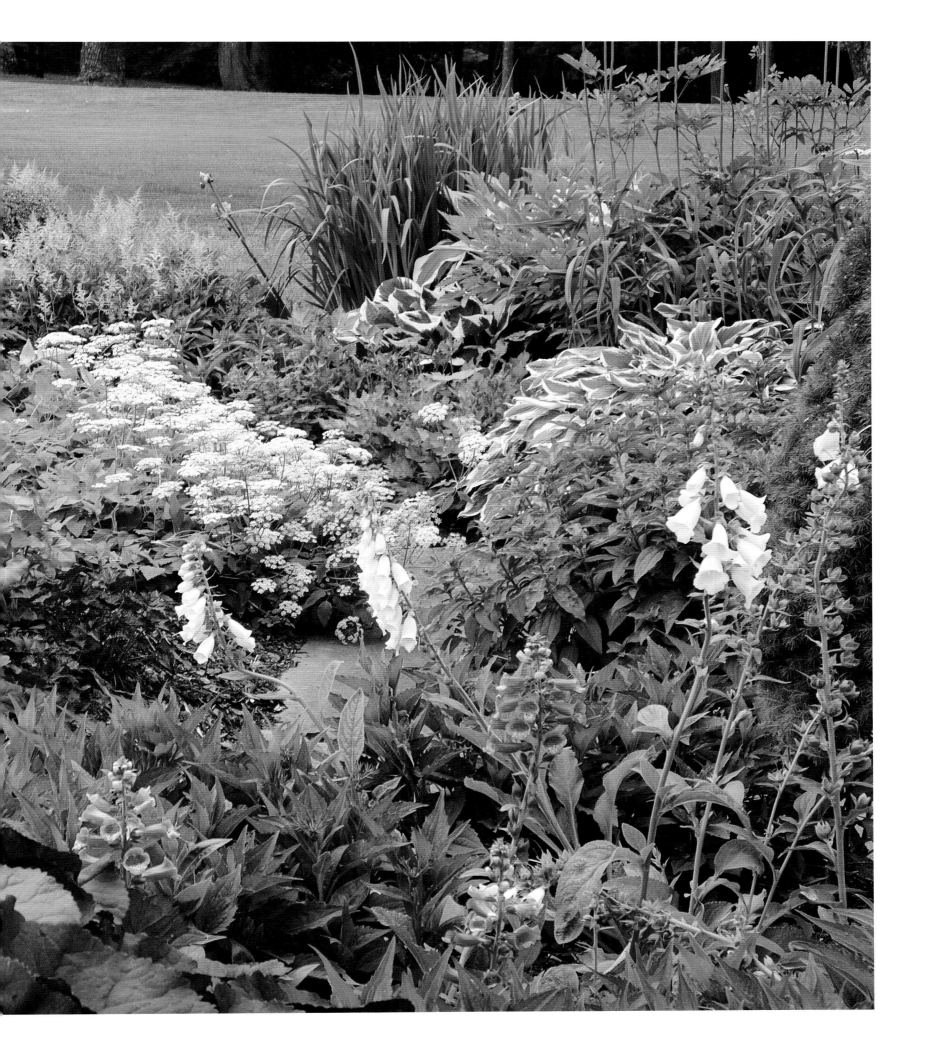

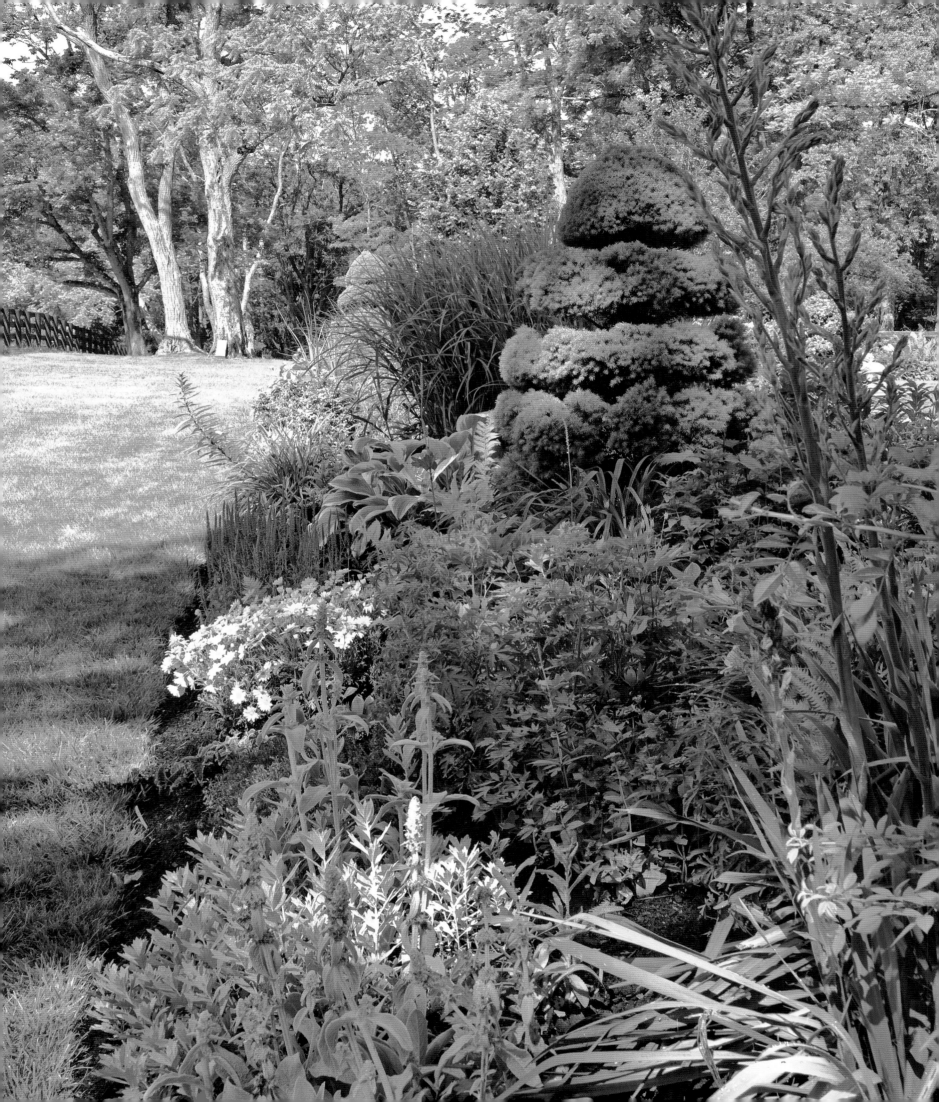

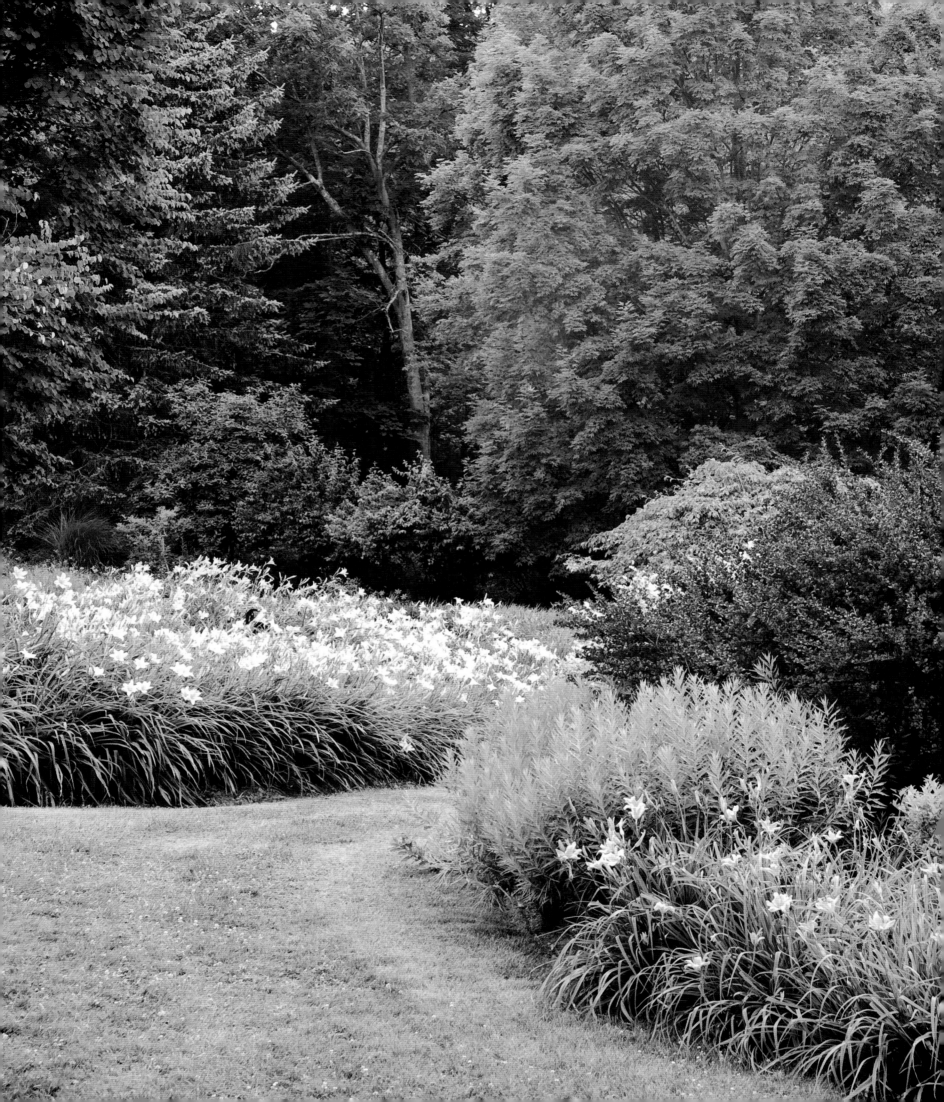

Blooms from Bressingham

When Leon and Ruth Back were looking for a house in 1967, their only stipulation was that the property should have a stream. It wasn't until a few years later that they began to think about gardening. Ruth is English, but growing up in England during the war, her only gardening memory is of the lawn being torn up in order to grow vegetables and berries. "It was only when my parents bought a cottage in Suffolk many years later that my mother began to take an interest in growing perennials," she explains. "That was when her energy and enthusiasm rubbed off on me."

Ruth still has vivid memories of a trip to England in 1972 when she visited plantsman Alan Bloom's garden at Bressingham. He was famous for pioneering the use of perennials and shrubs in curved, free-flowing island beds that could be seen from every side. It was a radical concept at the time, and for Ruth, who was just beginning to make a garden, it was an inspiration. She remembers thinking that the informality of Bloom's plantings and the way that his flowerbeds seemed to flow through the landscape were the perfect answer to "our rather wild slope." Back home, using Bloom's preferred technique, she and Leon got out their garden hose and let it snake over the ground to make a shape for their first island bed.

They filled this bed with a carload of daylilies, a gift from friends who were fed up with the deer eating all the buds. "This should have been a warning!" says Leon, "But, at that time, our deer were not too bad." The Backs divided the original plants over and over again, adding vinca, pulmonaria, lamium, pachysandra, and epimedium, until they had great swaths of color from May through August, and enough flowers to share with the deer. Over time, they have added two more island beds and a vegetable garden. Forty years on, their garden, which they take care of themselves, extends to almost three acres and the graceful curves and the naturalistic look of their free-flowing beds are ideally suited to the hilly terrain.

"If there has been any disappointment, it's the increasing size of the deer herds," says Ruth. "A fence is out of the question because we do not wish to separate the garden from the stream." The Backs are now removing all the plants that are deer favorites, such as hosta and phlox, and replacing them with more ornamental grasses and shrubs. "Like all gardeners, we are optimists. Maybe the deer will go away one day," she adds, perhaps a little wistfully.

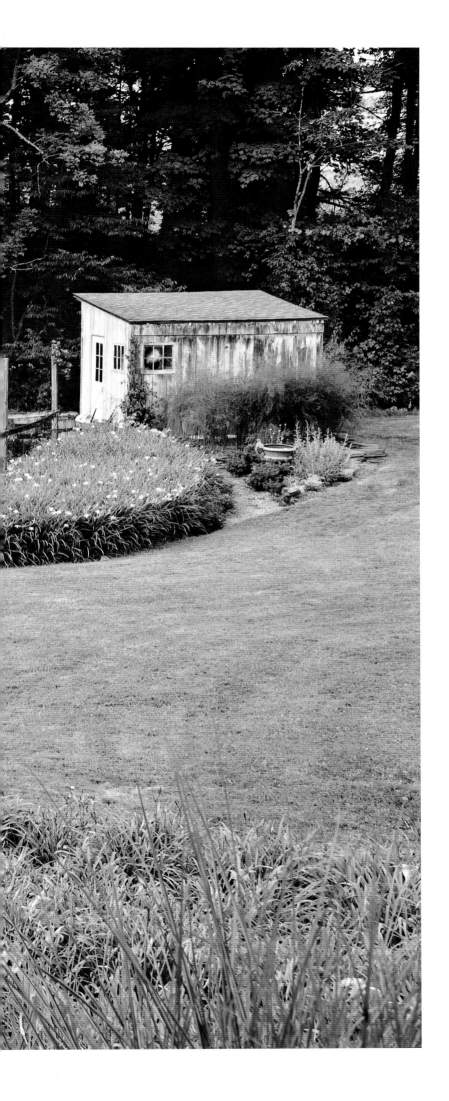

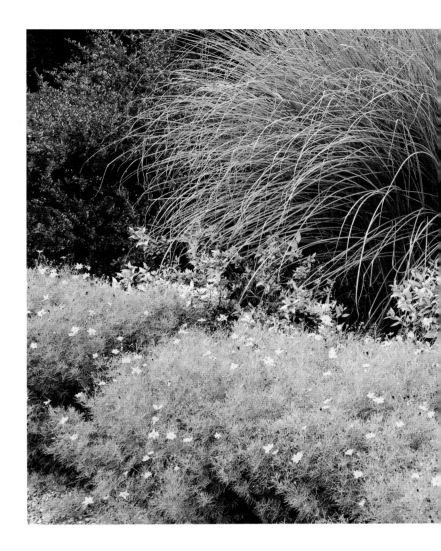

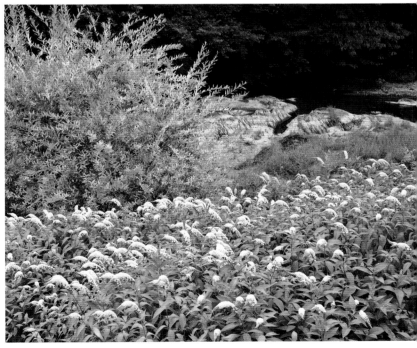

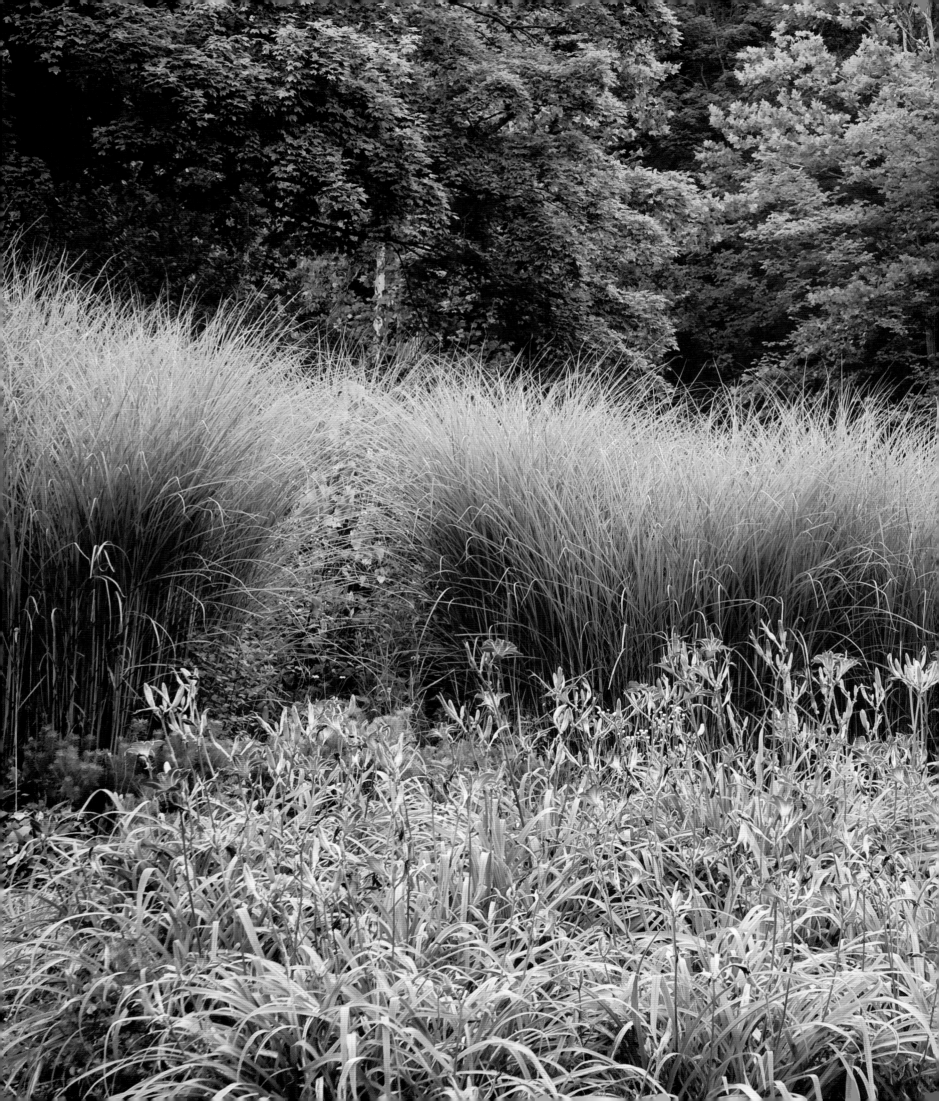

Small is Beautiful

In England, Bindy Kaye's garden would be called a cottage garden but the term is not that familiar in this country and she likes to call it her door yard garden. According to Mirabel Osler, the English garden writer, "There is a place for precision, scale, and architectural lines in any garden but the soul and spirit of a cottage garden lies in its seemingly unplanned profusion of color and texture." This is a perfect description of Kaye's garden, which she tends entirely herself.

Kaye and her husband, Stephen, bought their house in 1975 as a place to spend weekends with their children away from New York City. It was small, rundown, and the drive came up to the door. A huge pile of fieldstone holding a flagpole was the sole decorative outdoor feature. Once dismantled, the stones were used to make a delightful stone wall around the back porch.

By chance, the Cary Institute of Ecosystem Studies started up the same year that the Kayes moved to Lithgow. Only a few miles away, it offered a three-session course on planning a garden, and the Kayes enrolled. "Although I grew up on a farm near Baltimore that had a gigantic vegetable garden and had my own garden as a child," says Kaye, "I didn't know much about how or where to begin." When the course ended, she asked the instructor to draw her the outline of a garden to go in front of the house. It was very straightforward, and Kaye rigorously followed its layout as she began to plant a mixture of perennials and vegetables. Later, finding the vegetables "a little too utilitarian," she chose aesthetics over appetite and moved her edible plants to a fenced-in area behind the barn.

Today, the front garden is composed of a series of small beds intersected by a simple brick path. Perennials mingle with ornamental herbs, dahlias, and annuals. Grasses rub shoulders with salvia, nasturtium, and variegated comfrey. Huge maroon Scheherazade lilies with creamy yellow edges have spread their roots underground throughout the garden and tower over the peonies, hollyhocks, and hellenium. Kaye finds them a little overpowering, but they add marvelous panache and strong slashes of color to her beds during the height of summer. Further drama is provided by a prodigious stand of plume poppies growing in front of a Carpenter Gothic style potting shed facing the drive. A painted tin heron, purchased at a local nursery, presides over a small goldfish pond that Kaye put in for her children many years ago. She placed it there to ward off a real blue heron that was decimating the fish

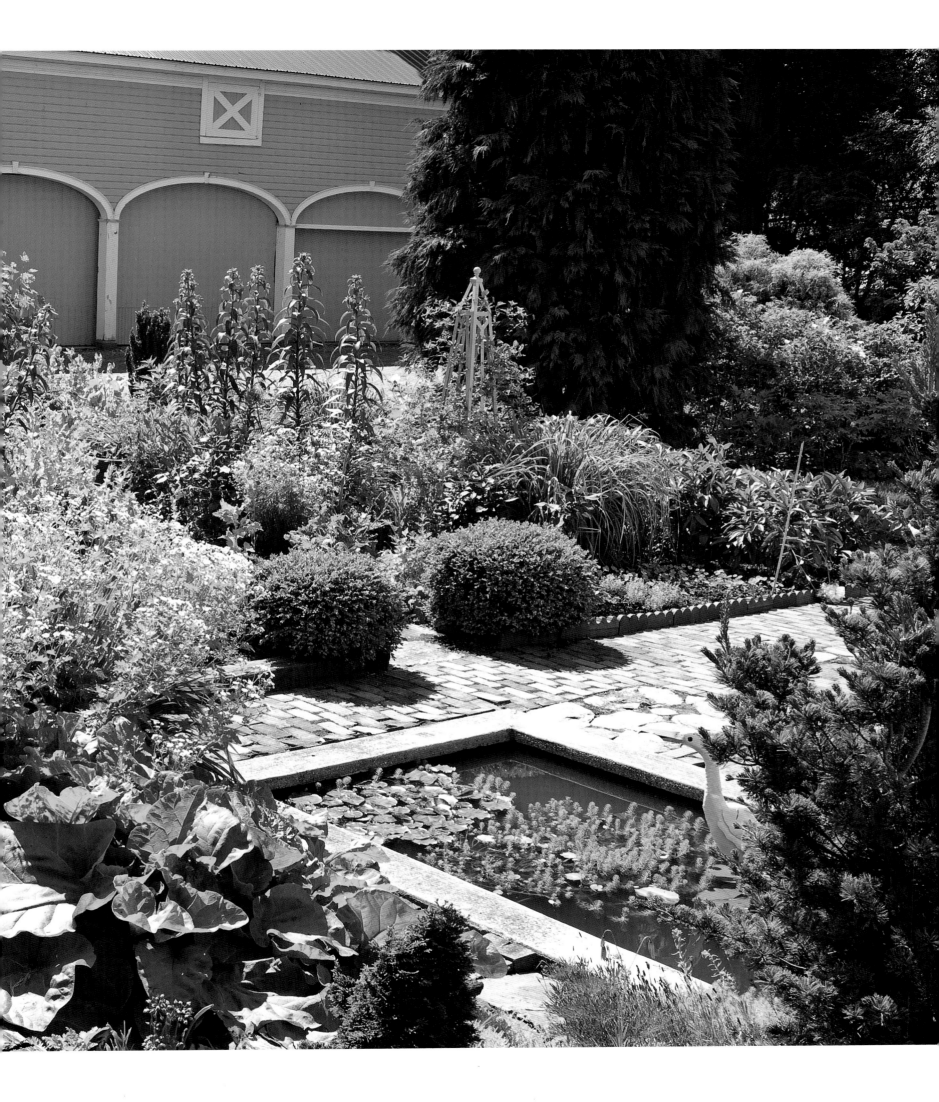

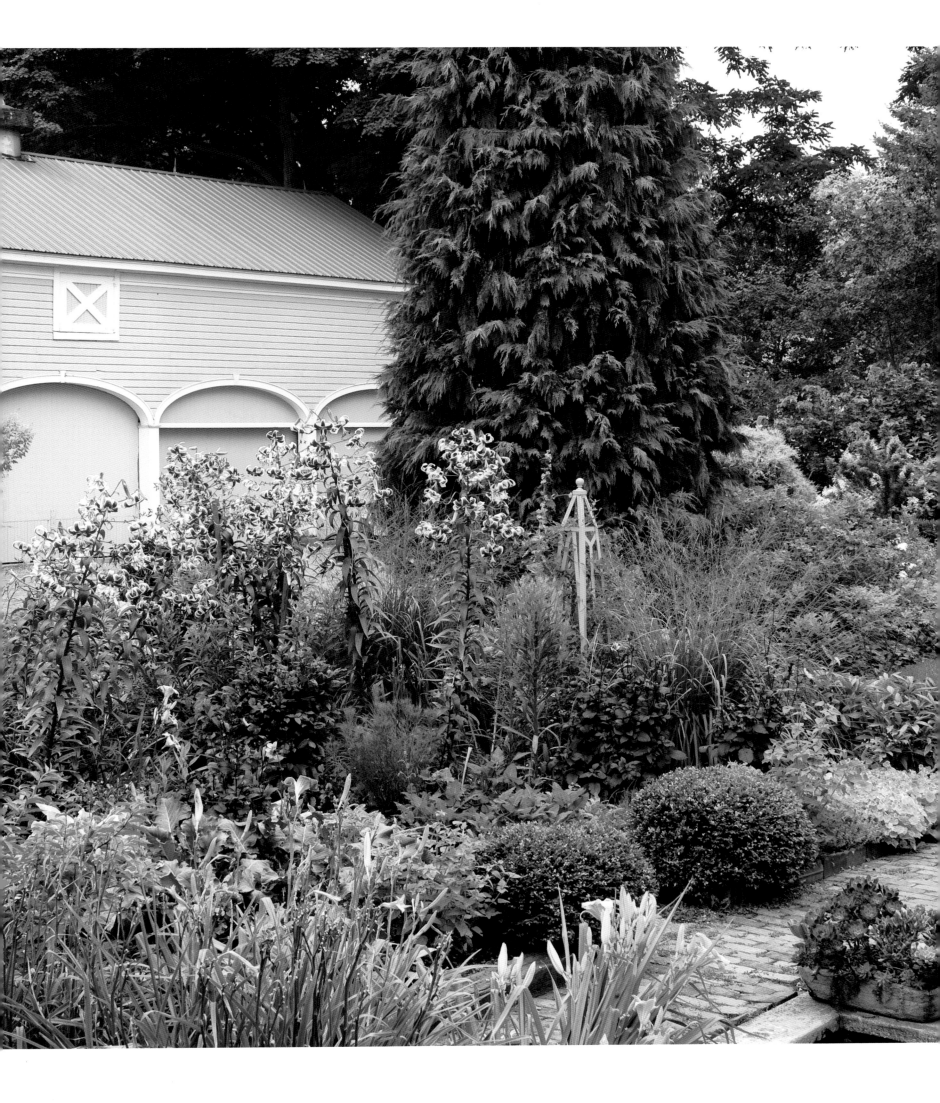

population and so far it's worked like a dream. Nearby, Kaye has created a tiny rock garden. Here, miniature varieties of gypsophila, geranium, penstemon, and dianthus grow in concrete troughs—two of them even made by her —"I took a class in how to do it," she says with a modest shrug.

There is a lawn to the left of the house. "The best thing I ever did," Kaye remarks, "was to make a berm along the edge nearest the road in order to give the garden more privacy." This also gave her a steeply raked bed, which she has planted with magnolias, redbuds, tiger eyes sumac, amsonia, hydrangeas, and a tree that she purchased at a rare plant sale. She finds the long spiny needles of *Cephalotaxus sinensis* "a little ugly but the deer don't like it and since it's probably the one rare plant in my garden, the seed having been collected in China, I absolutely love it." In spring, there are daffodils and in the fall there is a flamboyant display of asters. More shrubbery gets added every year, and petasites creep at will around the far side of the lawn.

A constant gurgle of water comes from a fountain designed by Lyndon Preston. It is set on a large deck at the back of the house, a place where the family eats and entertains. The sound of water is intended to drown out any sounds of traffic, but as Kaye wanted to hear the noise of the night frogs croaking, she has installed a timer that shuts off the fountain every night at 10 pm.

There is nothing trendy or contrived about Kaye's door yard garden. It has an intuitive flow, is beguilingly simple, and has great charm. A cottage garden par excellence!

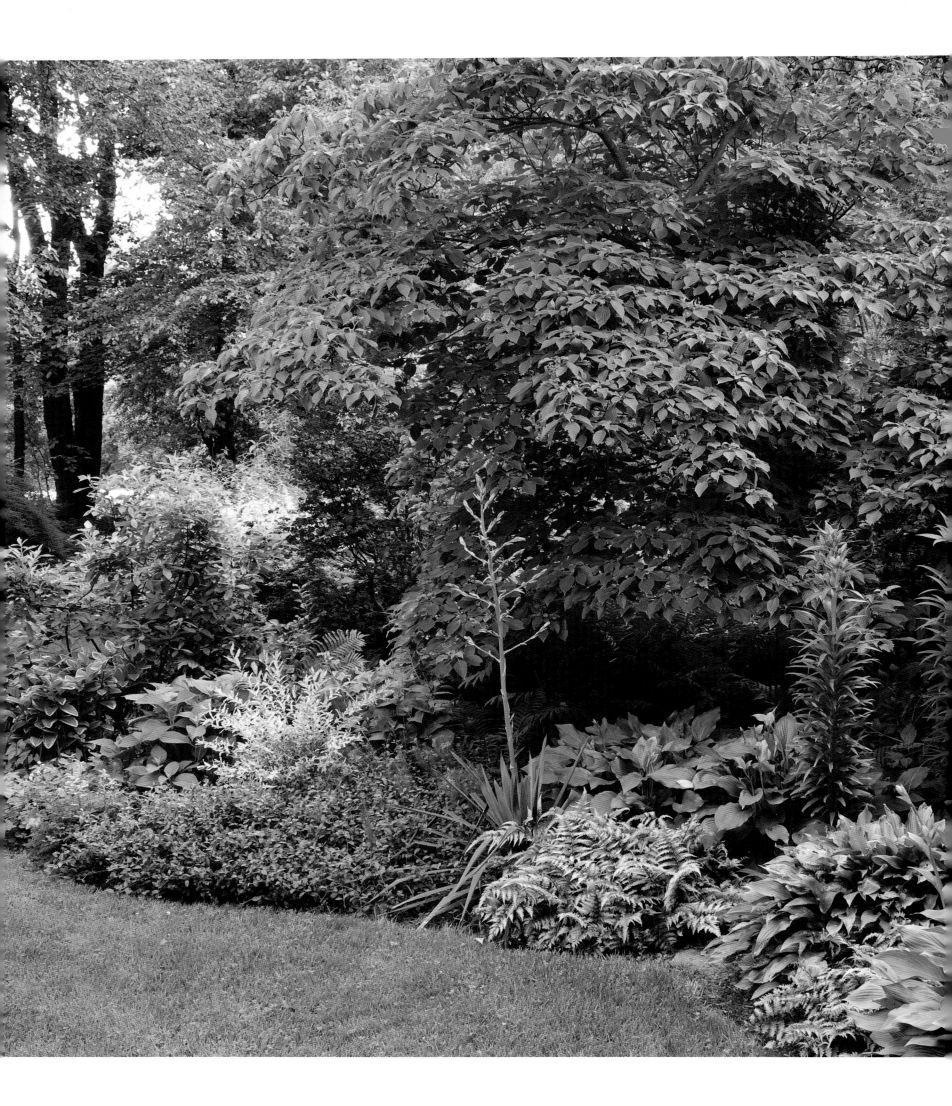

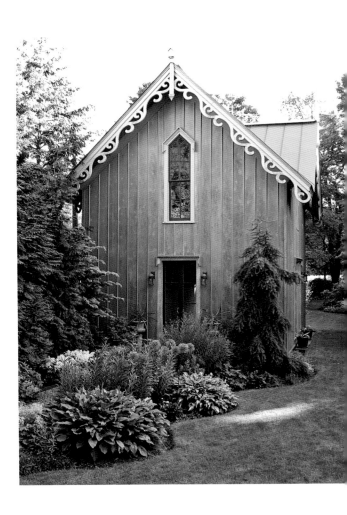

NICHOLAS HAYLETT AND TIMOTHY HUSBAND

🌿 KINDERHOOK

Backyard Enchantment

There's nothing to indicate from the street that behind the 1840s house belonging to Nicholas Haylett and Timothy Husband there is not just a charming garden but also a unique Gothic-style building. Haylett had always wanted to live in a village so when he and Husband began looking for a house outside New York City, they settled on Kinderhook. "A nice house that needs a bit of work," is how the realtor described the property that they bought in 2001. There was a long narrow garden in the back that, unlike most in-town gardens, opens to communal grassland—a borrowed landscape that affords it extra depth. The previous owner, an Englishwoman, had been an enthusiastic gardener. However, as she got older, the garden had become too much for her to manage and, like the house, it needed a bit of work.

"With houses on either side, this is a garden that cannot expand, so every decision has to be made with discriminating precision," explains Haylett. "Neither

of us was a brilliant gardener," adds Husband, "but I think a little of the garden at The Cloisters had rubbed off on me." Haylett and Husband's first important gardening decision was to replace an ungainly fence that ran down the property line, giving them very little privacy from the house next door. Their solution was to put in a thick screen of *Thuja* 'Green giant' and *Thuja* 'Emerald', which they have interspersed with hornbeam, dogwood, magnolia, prunus, Japanese maple, yew, and false cypress, using 'Fastigiata' varieties wherever possible. In all, Haylett and Husband planted seventy-two trees, and this has given them not only much needed protection but also a pleasing textured green tapestry.

Pulling down a dilapidated garage was not strictly speaking a horticultural decision, but creating in its place what Haylett and Husband refer to as their Garden Room has had a huge impact on their garden. Using the footprint of the former garage, they built a small studio—its downstairs is an all-season dining room, its upstairs serves as an office for Husband. Intentionally placing the structure at an angle so that its side can be seen from the house, Husband decided on a cross-gable plan, using the proportions and elevation of an 1840s carriage house that had been part of the Vanderpoel House in Kinderhook. Bargeboards taken from a Gothic Revival house in Hudson were used on the exterior, and on eBay he was able to purchase twelve stained glass windows, originally designed by John Moyr Smith for a house in Scotland. (Six of them had to be cannibalized in order to make the other six usable.) Husband was also able to find two small leaded diamond-paned windows from a nineteenth century house in Maine and a pair of French doors from a house in Lenox, possibly the Vanderbilt cottage. Being a perfectionist, his painstakingly careful assemblage of this assortment of found objects looks entirely authentic. It is a delightful place to eat in any season and has become the main focal point of the garden.

Wanting to place their garden on a diagonal to give the illusion of more space, Haylett and Husband have shaped the long border on the other side of the garden into three graceful curves, each curve extending a little further out than the preceding one. This border is thickly planted with shrubs and perennials, including *Kousa* dogwood, clematis, and a huge oak leaf hydrangea, inherited from the previous owner, white clethra, inkberry, caryopteris, epimedium, eupatorium, and astrantia. A profusion of lilies, some of them eight feet tall, provide luxuriant bloom from June to August.

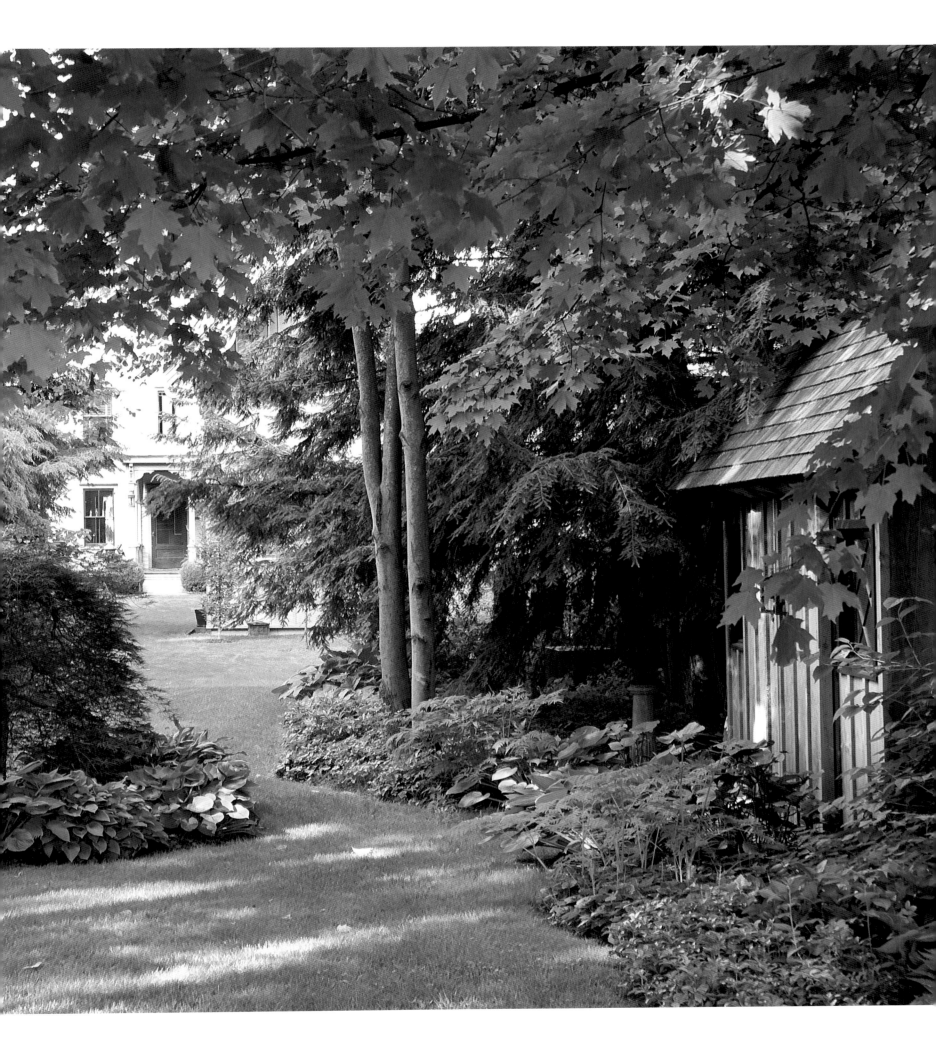

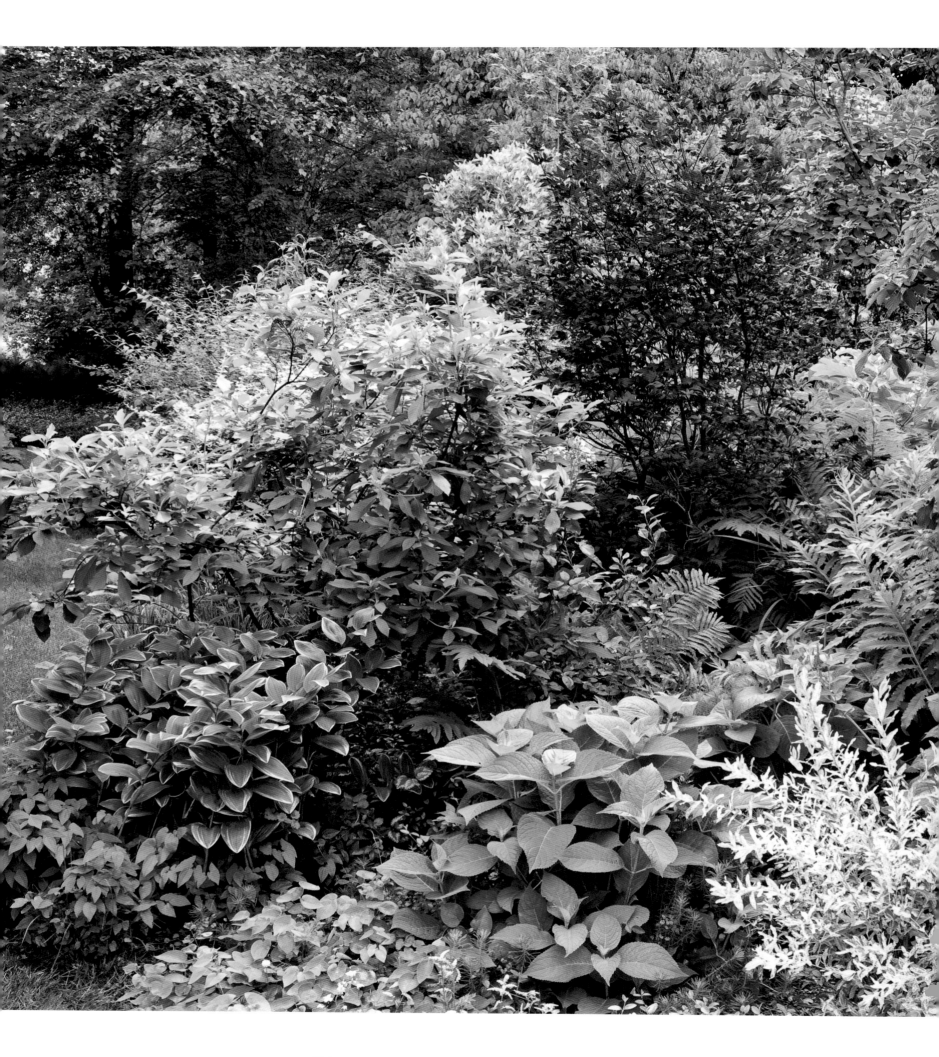

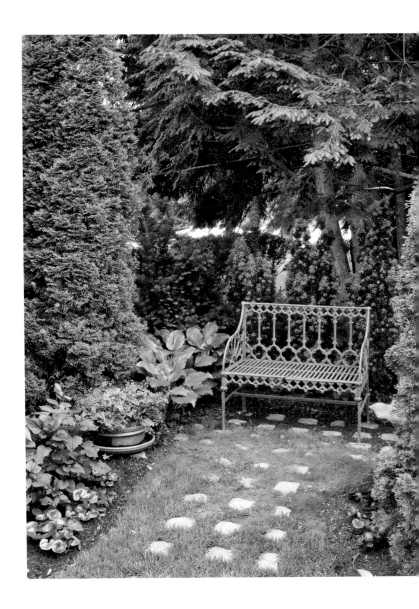

Haylett and Husband had originally considered limiting the garden palette to blue and white. "But we soon learned this was too hard to do," says Haylett. Perhaps by way of consolation, they have used blue and white salvia and a white euphorbia to overplant spring bulbs in nearly every bed. Further away from the house, a nineteenth-century cast-iron bench forms the center of a secluded alcove, where it sits on a carpet of cobblestones left over from the courtyard paving at The Cloisters.

As the garden matures, Haylett and Husband are starting to use more shrubs and grasses and becoming less dependent on perennials. They began work on their garden in 2001 but consider it still a work in progress. Although they don't always start out agreeing on what should be done next, as Haylett says, "We hammer it out, and we always seem to get there in the end."

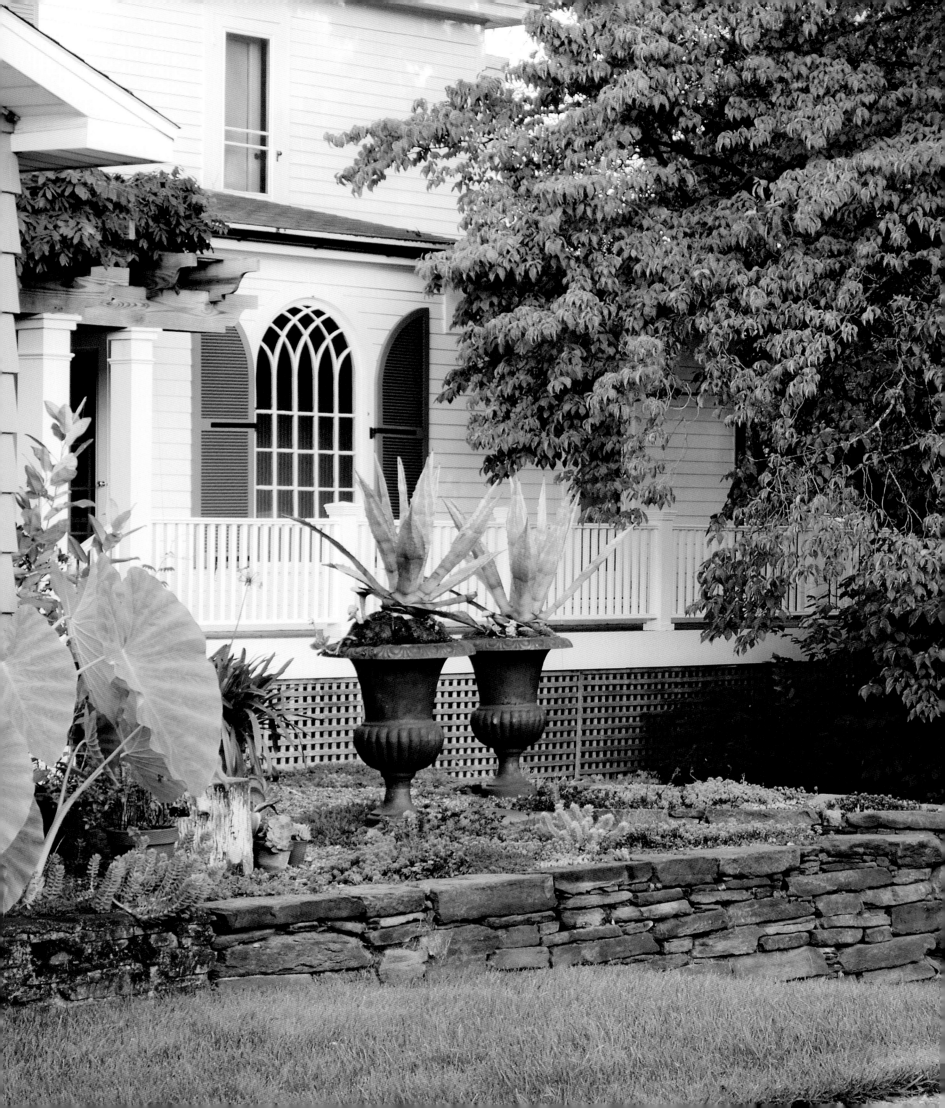

PETER BEVACQUA AND STEPHEN KING
❦ CLAVERACK

The Well-Tempered Garden

A high white wooden fence surrounds Peter Bevacqua and Stephen King's garden, affording it total privacy from the street. In front, next to a garage and small parking area, a paperbark maple, underplanted with thickly massed stachys, is set in a small square bed. Simple but distinctive, it puts visitors on notice that there is a special garden hidden behind this quiet street on the outskirts of Claverack.

A gate in the fence opens onto an elegant gravel courtyard, and the first thing to catch one's eye is a long narrow bed that, in spring, is a mass of graceful white tulips. In summer, it is planted with *colocasia*, whose giant leaves rustle and bend dramatically in the lightest breeze. "We copied the idea from a photograph we saw of Isola Bella," explains Bevacqua. Verbascum has firmly self-seeded itself in the gravel, and clipped boxwood topiary and two urns filled with agave add sophistication to the scene.

In 1989, Bevacqua and King, dreaming of a weekend retreat, purchased a small house that was alarmingly close to the property next door. However, it had a 1950s Lord & Burnham greenhouse and this tipped their decision to buy. It was not until a few years later, when their neighbor died, that they were able to purchase the house next door and link the gardens. This became the impetus to cut their ties with New York, leave their jobs in advertising, and move to Claverack full time. By then, Bevacqua's garden design business was up and running. The couple did a major renovation of both buildings, connecting them with a stone terrace, shaded by a pergola. When making the terrace, they left in place a wisteria tree close to the house. But as Bevacqua admits, "It is an ungrateful old thug and constantly sending runners all over the place."

The two gardens combined make for a very generously sized village garden. The heart of it is a large rectangular sun garden, enclosed with walls of yew and bisected by a network of gravel paths. At the far end, a statue of the goddess Demeter rises above a profusion of castor beans, tradescantia, cupflowers, variegated pokeweed, and many grasses. Closer to the ground, nepeta, lilies, and the peach and yellow blooms of two David Austin roses 'Abraham Derby' and 'Graham Stuart' add to the vibrant color and rich texture of the thickly planted borders.

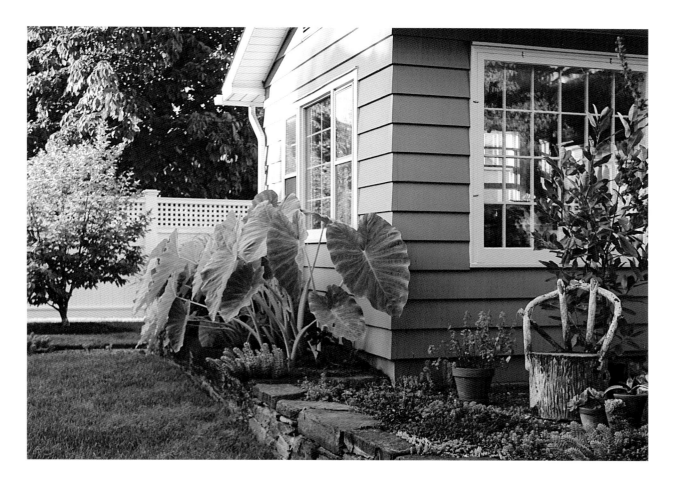

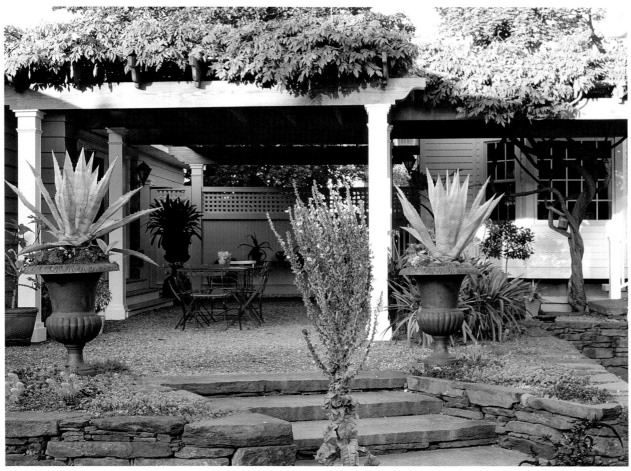

The greenhouse has been reframed and now has an attached storage shed and summerhouse. Tucked away from the gravel courtyard, it is reached by a winding brick path and its entrance is framed by two tiered yews. There are small perennial beds on each side of the walkway, and behind the greenhouse a large group of boxwood has been planted in cloud formation, leading to the remainder of the garden, where a succession of gently curved naturalistic beds offer constant interest. There is a long hydrangea walk, underplanted with vinca and, where once a Norway maple shaded a large area at the back of the garden, three gold metasequoia trees have been planted.

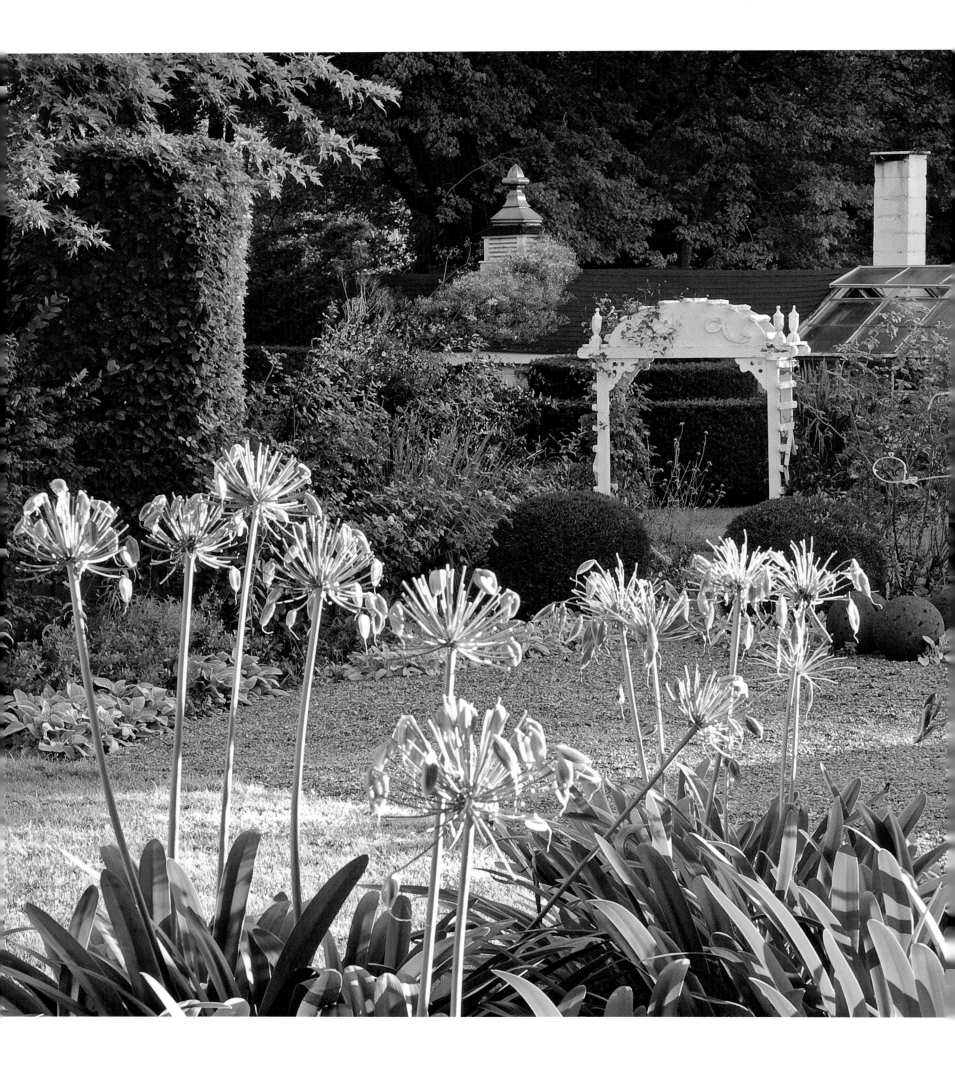

King credits his partner with being the master gardener, saying, "He chooses the plants while I handle the hardscaping." Bevacqua grew up in a family who gardened but insists that most of his real learning has been done on the job. A high point in his gardening education came in 2003, when he attended a week-long garden seminar with the great English gardener Christopher Lloyd. "It completely changed my focus," he says, explaining that working in the garden at Great Dixter made him appreciate the importance of combining plants for long seasonal interest. He also credits Lloyd's use of strong colors, such as orange and magenta, with making him bolder in his own choice of a garden palette. A few years later, Bevacqua spent a week studying with Helen Dillon in her garden in Dublin, and she has been another big influence. He remembers her saying, "Life's too short to stuff a mushroom." "What she meant," he explains, "is not to focus on the picky, fussy little things, but to set one's sights on the big picture and to go about fearlessly creating grand gestures in your garden."

There's not a false note in Bevacqua and King's garden. For a visitor, it breathes structure, charm, and maturity. For its owners, however, who have learned not to be afraid of changing what doesn't work, it will always be a work in progress.

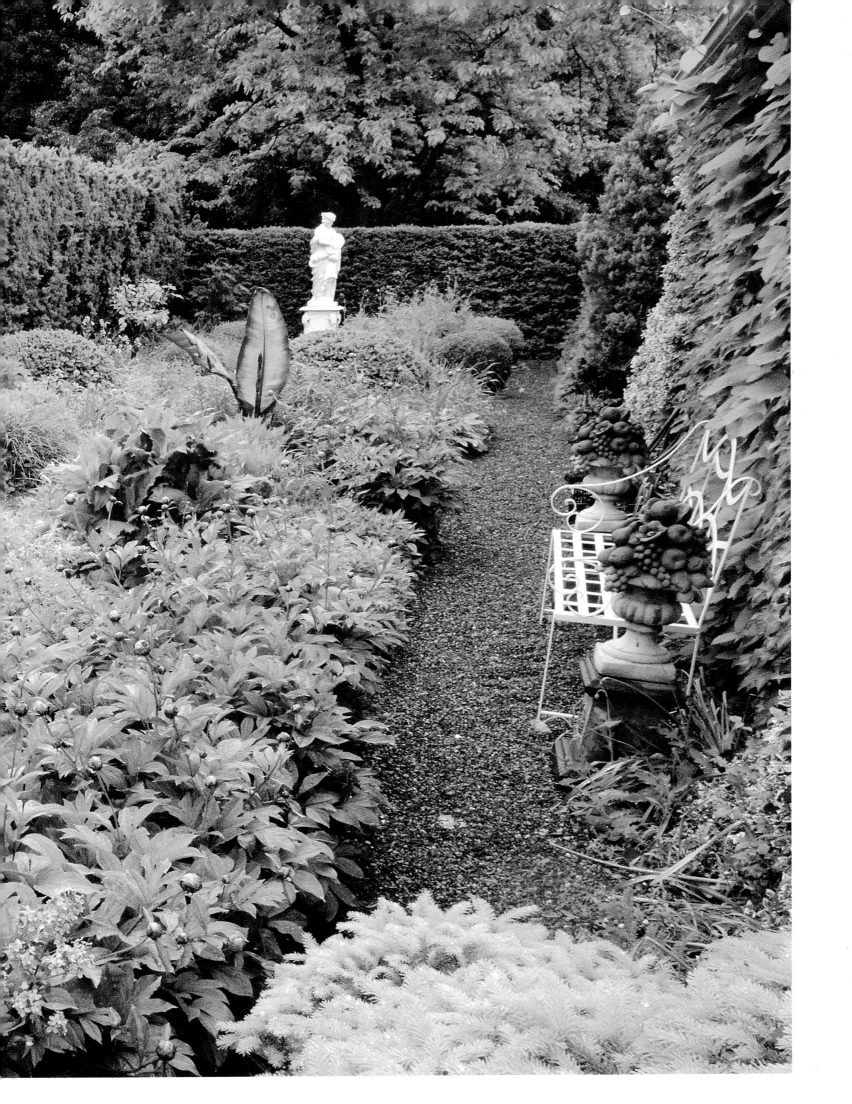

Acknowledgments

We want to thank all the garden owners who were so wonderfully generous with their time and their gardens—without them there would be no book. And a special thank you to Betsey Ely, Ian and Madeline Hooper, and Mark McDonald for their generous overnight hospitality to John, and to Brad Roeller and Robin Zitter for their assistance to him along the way. Many people helped in the search for gardens, but particular thanks are due to Peggy Ayers, Douglas Banker, Randy Bourscheidt, Joe Chapman, Eileen Cohen, John Danzer, Tony Freund, Cristina Grajales, Penny Gorman, Paula Hawkins, Grace Kennedy, Alice Platt, Vivienne Sharp and Tim McCormick, Mish Tworkowski, and Marilyn Young. We are truly indebted to Susan Evans for her astute sense of design and her willingness to always go that extra step to bring visual coherence to each and every layout. Finally, we are enormously grateful to Elizabeth White. She is not only a brilliant editor but has, with unfailing good humor, seasoned diplomacy, and endless patience, skillfully navigated this book from start to finish.